*Threads of Light*

# Threads
## *of Light*

**Chinese Embroidery from Suzhou**
**and the Photography of Robert Glenn Ketchum**

UCLA FOWLER MUSEUM OF CULTURAL HISTORY
LOS ANGELES

Patrick Dowdey, Editor

*With contributions by*
Zhang Meifang
Patrick Dowdey
Robert Glenn Ketchum
Jo Q. Hill

Published in conjunction with an exhibition of the same
name organized by the UCLA Fowler Museum of Cultural
History in collaboration with the Suzhou Embroidery
Research Institute

*UCLA Fowler Museum of Cultural History*
*Textile Series, No. 3*
*Published with the assistance of the Getty Grant Program*

UCLA
FMCH
*Textile Series*

Major funding for this publication
has been provided by
The Getty Grant Program

Major funding for the exhibition
has been provided by
The Lund Foundation
Anonymous
Mr. and Mrs. Herbert Belkin

The Ahmanson Foundation
The Times-Mirror Foundation
Manus, the support group of the
Fowler Museum

The Fowler Museum is part of UCLA's
School of the Arts and Architecture

Lynne Kostman, Managing Editor
Karen Jacobson, Manuscript Editor
Jim Drobka, Designer
Don Cole, Principal Photographer
Daniel R. Brauer, Production Coordinator

©1999 Regents of the University of
California. All rights reserved.

UCLA Fowler Museum of Cultural History
Box 951549
Los Angeles, California 90095-1549

All photographs by Robert Glenn Ketchum:
©Robert Glenn Ketchum.

Map (p. 19): ©David L. Fuller

Requests for permission to reproduce
material from this catalog should be sent
to the UCLA Fowler Museum Publications
Department at the above address.

Cover: Detail of *Pale Leaves in Blue Fog*,
cat. no. 30.

Title page: Detail of *Tree and Branch
in Deep Snow*, cat. no. 34.

Printed and bound by Toppan Printing
Company, Tokyo, Japan.

Library of Congress
Cataloging-in-Publication Data

Threads of light : Chinese embroidery from
Suzhou and the photography of Robert Glenn
Ketchum / Patrick Dowdey, editor ; with
contributions by Zhang Meifang ... [et al.].
   p. cm. — (UCLA Fowler Museum of
Cultural History textile series ; no. 3)
   Catalog accompanying an exhibition at
the UCLA Fowler Museum of
Cultural History.
   Includes bibliographical references (p.  ).
   ISBN 0-930741-70-6 (hard)
   ISBN 0-930741-71-4 (soft)
   1. Su-chou tz'u hsiu yen chiu so--Exhibi-
tions. 2. Embroidery—China—Su-chou
shih—Exhibitions. 3. Ketchum, Robert
Glenn— Exhibitions. I. Dowdey, Patrick.
II. Zhang, Meifang, 1946–
III. University of California, Los Angeles.
Fowler Museum of Cultural History. IV.
Series.
   NK9298.S8A4 1999
   746.44'0951'136—dc21        98-31905
                                          CIP

# CONTENTS

Chinese embroidery traditions have long drawn their inspiration from the exceptional history of Chinese painting with its strong focus on the love of nature and respect for the land. Although many artists worldwide have confronted the challenge of converting a painting into another artistic medium — often with mixed results — the process of translating the precision of a brushstroke into the exactitude of an embroidered thread presents its own unique set of problems.

Most of the world's important artistic traditions, however, involve translations or transformations of one sort or another. In most cases these transformations entail taking raw or previously worked materials and turning them into something more visually and intellectually arresting than they were initially. Photography is certainly a transformative art, but it occupies a unique position within this paradigm because most of us know many of the arts of the world — including architecture, sculpture, painting, and many of the performing arts — through the medium of the photograph rather than through direct experience.

Since photography is the primary mode of representing other arts, it would seem that the photograph should also be the ideal medium for representing itself. But is it? Transforming a photograph into something else is not necessarily new. A number of artists have worked from photographs to create paintings for many years now, but in most of these cases the photograph serves primarily as an intermediary, a tool.

When I first heard about Robert Glenn Ketchum's desire to metamorphose his radiant Cibachrome prints into silk embroidery, I had to ask why. His landscape photographs had always seemed to me an exemplary artistic end in themselves. Although early photography was initially admired because it was thought to be the ideal of objectivity, we have since learned that it can be as subjective as any other form of representation. It is a tribute to Robert's vision that he could look beyond his photographs and their landscape subjects and see other promising means of representation — the threads of light, if you will — that suggested the potential of Chinese embroidery. It is perhaps one of the ironies of this project that the embroideries have to be turned back into photographs in order to be reproduced in the present volume — a transformation accomplished with impressive skill by Fowler Museum photographer Don Cole. Despite the

superb quality of these reproductions, it is our hope that the readers of this book will have the opportunity to view the original works firsthand.

This project is the product of a very special series of collaborations beginning with the remarkable partnership between the Suzhou Embroidery Research Institute (SERI), headed by Zhang Meifang, and the environmental photographer Robert Glenn Ketchum. Those involved on both sides of this exchange have combined a high level of artistic skill with the practical experience necessary to carry out an extended international artistic collaboration. Significantly, it has been a people-to-people exchange without the official involvement of either government. The institute's embroiderers have worked hard to understand and incorporate other artistic traditions, including those of Western art, into their own work to create a new embroidery style. The pieces illustrated in this volume, both those resulting from the collaboration between SERI and Robert Ketchum and those originating with the institute, represent the pinnacle of contemporary Chinese embroidery—a combination of traditional practices and contemporary fine arts. The inspiration and accomplishment of both the embroiderers and the photographer are readily apparent in the pages that follow.

Dr. Patrick Dowdey agreed to interrupt the writing of his doctoral dissertation to pursue the research underlying the present volume. His sensitivity to Chinese culture and his understanding of artistic initiatives in that country are clearly evident in his work. His many efforts on behalf of the museum are greatly appreciated. Likewise, Fowler Museum conservator Jo Hill found time in an already extremely demanding schedule to investigate the technical aspects of the embroiderers' art. Her background and experience were a perfect match for this project, and we are grateful for her unique perspectives and impressive energy.

Our thanks must also go to the Getty Grant Program, the Lund Foundation, and Mr. and Mrs. Herbert Belkin for their generous support of this publication and the exhibition, and to Michele Lund and Mr. and Mrs. Gordon Street for lending works from their collections.

Finally, gratitude must be extended to the embroiderers themselves whose magic with a needle created these *Threads of Light*.

Doran H. Ross
*Director, UCLA Fowler Museum*
*of Cultural History*

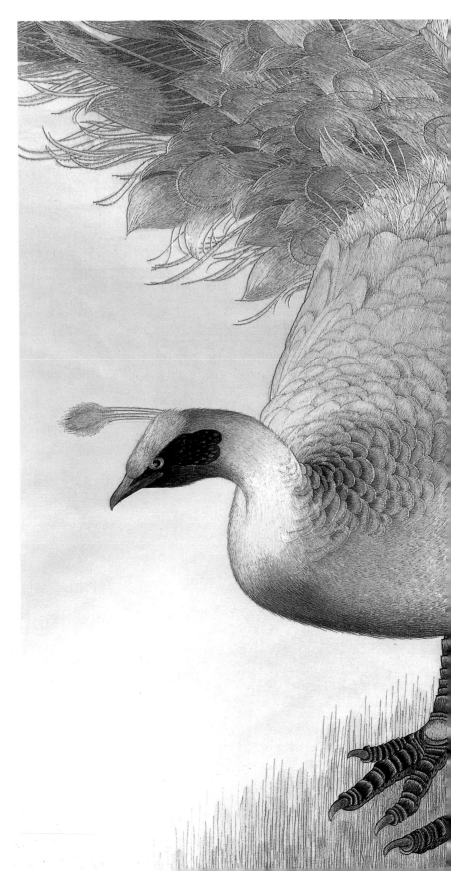

Detail of **FLUTTERING**, cat. no. 1.

The way art develops is by weeding through the old to bring forth the new; cultural prosperity relies on harmonious coexistence among people. Suzhou embroidery, a national treasure of China, combines the ancient industries of silk growing and silk making with the artistic tradition of inner chambers embroidery, in which women learned to create needle-work based on paintings. Integration of the accomplishments of fine art with Chinese women's traditional crafts produced embroidery art that is representative of Chinese civilization and Eastern culture. In the present exhibition ancient Chinese civilization and modern Western art are joined. Photography—with its delicacy, realism, and exquisite character—has developed rapidly in its relatively brief history and become a significant aspect of modern art. The fusion of embroidery and photography marks a synthesis between Eastern and Western culture at a high level.

In 1985, during the National People's Conference held in Beijing, Zhang Meifang, director of the Suzhou Embroidery Research Institute, and I talked about the American photographer Robert Ketchum's desire to initiate a creative collaboration. Since I am very fond of photography, I was very interested in this proposal. When Madame Zhang asked me to assist her in this international collaboration, I gladly agreed to become involved with the project. But faith is not yet reality; it is only after you start the work that you learn how difficult it is. Recalling the more than ten years since we began our project, there have indeed been countless difficulties and confusions. Every success was a manifestation of each participant's painstaking care. Reader, you can't imagine the extent of the difficulties we faced or how many young women's tears are condensed in this project! And now it has finally achieved great success, as the works in the exhibition attest. For Suzhou embroidery this brings spring and also opens up a splendid future.

Dr. He Shanan
*Director, Nanjing Botanical Garden*

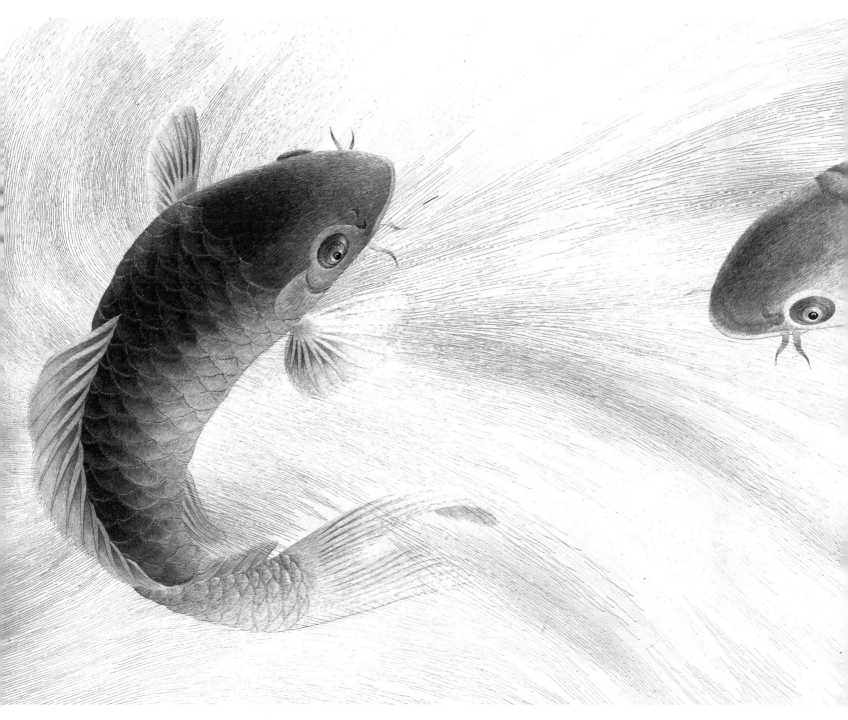

Detail of **NINE CARP**, cat. no. 3.

# ACKNOWLEDGMENTS

This volume documents a successful attempt to create works of art that express a modern sensibility while working within an ancient tradition, a project that is ongoing and that promises even more accomplishments and innovations in the future. Each of the four authors of the essays included herein brings a different perspective to an artistic practice that seems at once to be part of a historical tradition and almost independent of that tradition. In fact, it is just that combination of stability and development that the German philosopher Johann Gottfried von Herder recognized as the essential paradox of a truly living tradition. Without a historical context, art has less power to communicate effectively and fewer conventions by which to make itself understood to large audiences. Conversely, without invention and creativity, art becomes a relic from another age, with little meaning for contemporary audiences. The combination of tradition and change gives art its vitality.

This exhibition and its accompanying publication have benefited from the contributions of many people, and I want to take this opportunity to thank them. Two individuals—Robert Glenn Ketchum and Zhang Meifang, director of the Suzhou Embroidery Research Institute—have given unstintingly of their time, their knowledge, and their experience. From the inception of this exhibition, these two have extended the means at their disposal to the fullest in order to see it become a reality. In fact, this exhibition owes its existence to the collaboration between Zhang Meifang and Robert Ketchum, and I thank them both personally and on behalf of the Fowler Museum.

The project is also a testament to Robert Ketchum's artistic ability, organizational skills, and inexhaustible reserves of energy, which helped to power the rest of us on. Not only did he create the photographic works on which half of the embroideries in the exhibition are based, but he also developed the lines of communication and understanding on which the entire exchange has been predicated. He helped select and arranged for the loan of the institute's own pieces for the exhibition as well.

Zhang Meifang opened avenues of research not often accessible, even to Chinese researchers. On behalf of the Fowler research team, I want to thank her personally for the hospitality she offered us during our stay in Suzhou and for allowing us access to the institute's facilities and its employees. Zhang Meifang's spirit of openness affects everyone at SERI and is an essential ingredient in every embroidery in this exhibition. It was extraordinarily generous of the institute to lend such a large number of its

10

best works for the duration of this exhibition, and I extend thanks on behalf of the museum to the institute and its director.

I am delighted to have the opportunity to congratulate Professor He Shanan of the Nanjing Botanical Garden for his successful shepherding of this collaboration through many years of development. The abilities of a talented mediator are still more highly prized in China than in the United States, and deservedly so.

I owe a special debt of gratitude to Shen Guoqing, director of the Materials Section of the institute, for her guidance and help. She provided the Fowler research team with access to rare research materials, located historical photographs, explained everything from stitchwork to social conditions in the 1930s, and even photographed processes such as dyeing for us. I am extremely grateful to Shen Guoqing for much of the information found in my article and in the entries in the catalog of the exhibition. On my second visit to Suzhou, Xu Xiaoqin, also of the Materials Section, further deepened my understanding of the institute's organization and daily work. These two women, along with Zhang Meifang, served as invaluable guides, and I sincerely thank them for their help.

Ultimately, most of the credit for this exhibition needs to be given to the embroiderers who work in the institute's Random Stitch Embroidery Research Studio, where many of the embroideries in the exhibition were made. I wish I could capture the spirit of cooperation and discovery that exists in that room, and I will return as often as I can and remember it for the rest of my life. I want to thank all of the embroiderers for their hospitality, which made me feel a part of their group, and to applaud them for their artistic accomplishments, which are reflected in this exhibition and publication. I am especially grateful to Huang Chunya, head of the Random Stitch Embroidery Research Studio, for her patient explanations (and reexplanations). The Fowler Museum's director of conservation, Jo Hill, and I also worked closely with Zhao Liya, Cao Qizhen, Xu Jianhua, and Huo Xiuling and learned a great deal from each of them. Many of the embroiderers not only participated in interviews but also allowed us to photograph them at work. I want to thank all of them for their openness and patience.

I would also like to thank Cory Walsh and Mark Seigle of Robert Ketchum's office for their help in tracking down information and for their assistance in making the works available.

The Fowler Museum of Cultural History provides an ideal home for this exhibition. The museum's director, Doran Ross, has long recognized that the language of art not only knows no borders but often transcends category and history as well. Many thanks for his leadership and the commitment of the substantial and varied talents of the Fowler staff to this project. I want to thank the museum's curator of Southeast Asian and Oceanic collections, Roy Hamilton, for his coordination of this very complex project and for the sage counsel he offered me. The museum's director of conservation, Jo Hill—my partner on the Fowler research team—traveled twice to Suzhou and worked closely with the embroiderers to understand their techniques and methods. Her appreciation for the embroiderers' skill and her forthright manner won her many friends at the

institute and served as the basis for the establishment of a technical exchange as an outgrowth of this project. Jo helped introduce me to embroidery and to the Suzhou Embroidery Research Institute, and I will never forget the experience.

The exhibition was designed by David Mayo, who has made conjuring up brilliant installations an everyday miracle at the Fowler. Collections Manager Fran Krystock and Registrar Sarah Kennington were responsible for the handling and storage of these delicate pieces, and Fran was always willing to find a little time to unpack one or another piece (usually the largest) for me to check a character or some other detail. Director of Education Betsy Quick always kept our feet on the ground, conscious of our audience's interests. Traveling Exhibitions Coordinator Karyn Zarubica put in long hours to be certain that museum audiences in other cities had the opportunity to see these works. Dina Brasso and Kathlene Kolian handled travel accounts and vouchers. Our translators, Han Ying at SERI, Zhang Qing in Beijing, and especially Hai Miao at UCLA, are also more than deserving of our thanks.

Preparation of this volume was overseen by Director of Publications Danny Brauer and Senior Editor Lynne Kostman. In addition to her normal duties, Lynne had to deal with the challenges presented by Chinese character software, faxes to the North Pole, and express mail to questionable addresses in Chengdu. She handled each new situation with increasing aplomb. Karen Jacobson patiently edited and reedited the various drafts of the manuscript. Don Cole met the extremely difficult challenge of photographing photorealistic embroideries (in unremovable glass mounts) so that they would look like something other than photographs. Designer Jim Drobka molded it all into the elegant volume you hold in your hands. I wish to thank all of these people, not only for their problem-solving expertise but also for the plain hard work they put into the project.

This exhibition presents an entirely new kind of art to American audiences. The entire process that has been documented in these pages has been one of opening up and exchange, and I want to thank the visitors to the exhibition and the readers of this volume for participating in its last and most important stage.

Patrick Dowdey

Detail of **TREES AND BRANCHES WITH HEAVY SNOW**, cat. no. 38.

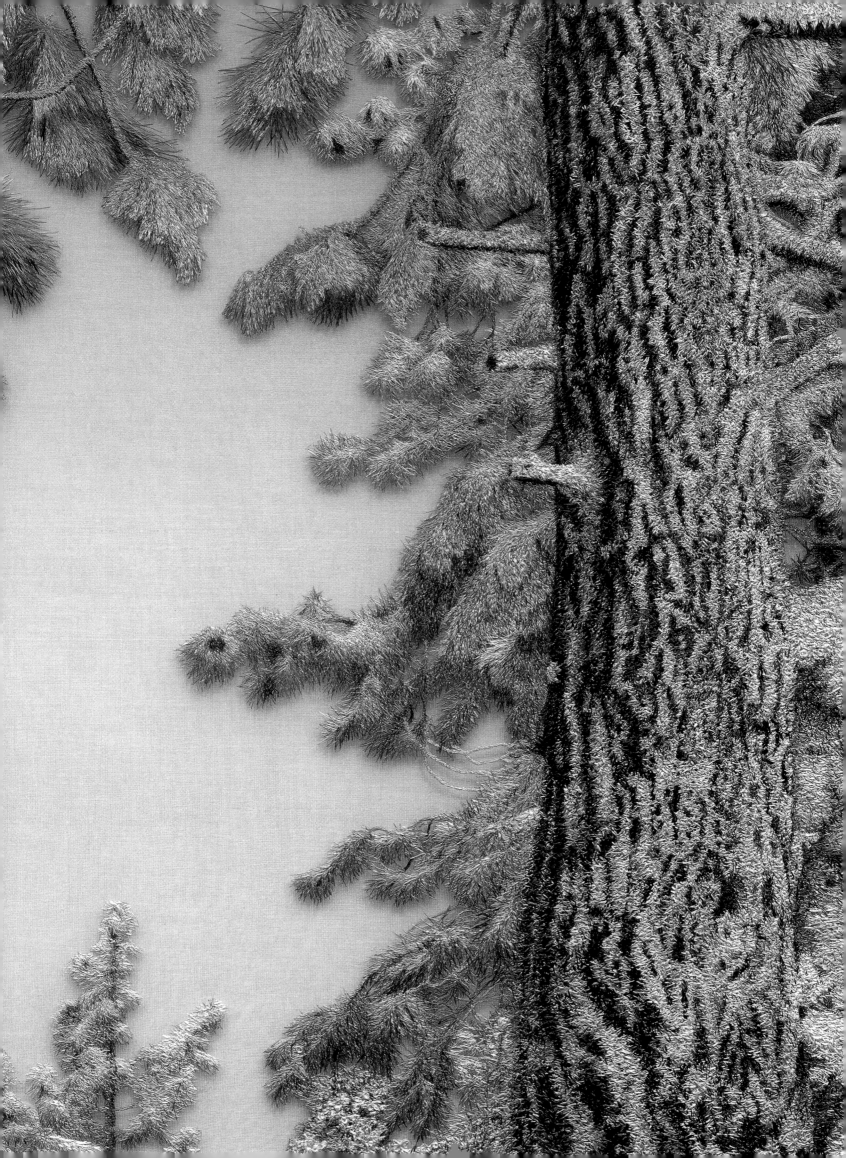

S ince 1986 I have had the pleasure of working with the Suzhou Embroidery Research Institute to produce highly detailed silk embroideries derived from my landscape photographs. Looking back at the works we have created, I am enamored of their beauty but overwhelmed when I consider the years of thought and effort that have gone into their production. How far we all have come since our first meeting and those initially vague and tentative concepts we discussed!

My relationship with SERI would never have been possible, nor would the initial invitation to visit ever have been extended, were it not for the enthusiastic support that I received for my ideas from Dr. He Shanan, the director of the Nanjing Botanical Garden. Dr. He recognized the potential for creative and social exchange latent in my unusual proposal, and he offered to act as an intermediary. Functioning as a negotiator, counselor, China scholar, translator, tour guide, and, most importantly, as my friend, he has sacrificed countless hours working with me and the institute to clarify and resolve the complex development of these embroideries.

The exchange itself could not have occurred without the willingness of the institute's leaders to attempt the new and to explore untried paths. From the very beginning, it was doubtless quite clear to them that the embroideries I proposed would require thousands of hours of production time and the devoted attention of many of their most skilled embroiderers. There was, in fact, some uncertainty as to whether my complex Western imagery could be embroidered at all. Zhang Meifang, now director of SERI, and the institute's vice director, Chen Caixian, made the initial leap of faith that allowed our endeavor to unfold. They exhibited great boldness in agreeing to pursue the ideas I proposed and in allowing the work to commence.

In our enduring relationship, Zhang Meifang has always proven as insightful and creative as she is professional. She has worked tirelessly to make this collaboration succeed. Always present during my visits, always active in every phase of the design discussions, and always concerned that I grow by learning more about the embroidery process and about China's complex culture, Zhang Meifang has become an invaluable counselor as well as my friend.

Above all, I am indebted to the embroiderers themselves, many of whom have literally dedicated years of their lives to my images, choosing to work on them nearly exclusively to assure their flawless continuity. Huang Chunya, head of the Random Stitch Embroidery Research Studio,

has lent her brilliant talents to the greatest number of pieces, and these were often the most complex as well. Her skills resonate throughout this exhibition, and her commitment has been as consistently inspiring to me as it has unquestionably been to her coworkers. Significantly, Ji Shaoping, who has also completed several pieces, paved the way for all the other works by embroidering the very first image, the success of which propelled the exchange. Xu Jianhua, and collaborators Huang Nanping and Guan Peiying, have all made important contributions to some of the most difficult and time-consuming subjects, and more recently Huo Xiuling, Zhao Liya, and Cao Qizhen have dedicated themselves to extremely complex and beautiful pieces that signal new directions in the work we are undertaking.

I would also like to thank Shen Guoqing, director of the Materials Section at SERI. Shen takes the photographs documenting the institute's daily activity, so perhaps it was the bond of the camera that first drew us together. She befriended me on my first visit and has always been there to receive me warmly when I return. Suzhou would not seem the same were I not to see her smiling face.

Equally important to the initiation of this collaboration was the UCLA-China Exchange Program, sponsored by the Center for Pacific Rim Studies. Program Facilitator Sue Fan, now assistant director of the Center for Intercultural Performance, has provided critical advice and supportive encouragement, as well as endless translations of letters and faxes, since 1983. As I am the only visual artist to have participated in the exchange program and the first non-Chinese artist to collaborate with SERI, Sue's invaluable support and unhesitating commitment to my untried ideas were essential to the entire process. It was Sue who first introduced me to Dr. He, and for that, I will be forever grateful.

I am also certain that the success of this creative exchange is a direct reflection of the education I received as an undergraduate at UCLA (1966–1970) and of the vibrant, multinational culture of Los Angeles and the Pacific Rim, my home now of fifty years. In the works that resulted from this collaboration, there is clearly a hybridization of Eastern and Western ideas regarding imagery and its presentation. There is also the fusion of embroidery with photographic illusion, a somewhat unorthodox manifestation of my continuing interest in exploring the photographic image-making process, but one that I feel was born in the rich environment of my student years. Much of what I am now doing has a clear legacy, which should be briefly detailed.

I was fortunate to have studied with Edmund Teske and Robert Heinecken, who administered the photography program at the UCLA School of Fine Arts during those years and who were, and still are, considered to be among the most experimental practitioners of the medium. Their courses transcended basic exercises in acquiring technical skills and challenged the way we each perceived and approached the photographic image, fostering an environment of exploration.

In greater Los Angeles earlier generations of artists had already begun to blur the boundaries of their disciplines, combining elements of painting, sculpture, photography, and performance in truly new and

interesting ways, and their "mature" (and exhibited) work fed our developing ideas. The sculptural installations of Ed Kienholz, the photographic work of painter Ed Ruscha, and major exhibitions of kinetic art and photorealism opened everyone's eyes and minds to the exciting breadth of possibility in such cross-bred image making.

No group was more inspirational to me, however, than the photographers themselves. Heinecken's elaborate images were often printed on emulsion-coated canvas, with hand painting over the photographic base, or assembled as sculptural pieces from photographic parts. Jerry McMillan not only brought a new vision to the traditional photographic print but also created such unusual objects as a photo-etched stainless steel coil of delicate, perfectly detailed leaves. Teske and Heinecken's presence at UCLA made the campus a magnet. Darryl Curran, Jerry Uelsmann, and Robert Fichter visited and occasionally taught graduate or honors programs, and Todd Walker was briefly an instructor in the UCLA Extension Program. Most important, however, were my remarkable group of peers, many of whom were students in the art department. Throughout my undergraduate years, during my postgraduate work at California Institute of the Arts, and while serving as a board member of the fledgling Los Angeles Center for Photographic Studies, I found myself surrounded by some of the most inventive image makers in contemporary American photography. Lewis Baltz, Ellen Brooks, Jerry Burchfield, Jack Butler, Jo Ann Callis, Eileen Cowin, John Divola, Judy Fiskin, Anthony Friedkin, Judith Golden, Anthony Hernandez, Suda House, Barbara Kasten, Gary Krueger, Victor Landweber, Kenneth McGowan, Grant Mudford, Patrick Nagatani, Sheila Pinkel, and Leland Rice were generating an unparalleled diversity of photographic ideas.

I am attracted to artwork that emphasizes technique as well as concept and vision, and I am especially fond of fine craftsmanship. Artists working in other mediums on campus—including printmaker Stephen Anaya, whose intricate etchings and lithographs reflected both his superb drawing and a veritable symphony of technical skills, and Ron Rezek, whose finesse with industrial tools and materials helped him to create his imaginative designs—fed my own interests. Among photographers, it was those working with textural and sculptural form, like McMillan and Heinecken, who seemed to have the greatest influence on me, and the eccentric, photographically derived sculptural forms of Lou Brown Di Giulio were also particularly appealing. My career reflects these wide-ranging interests to this day.

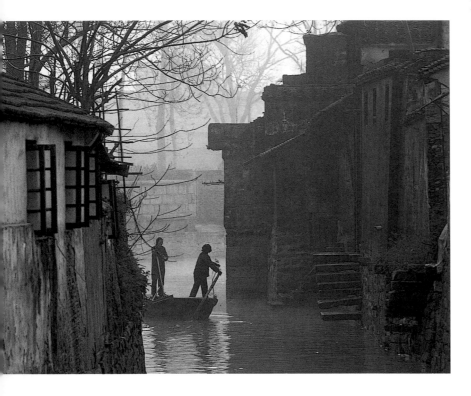

A small boat travels one of Suzhou's many canals. Photograph by Robert Glenn Ketchum, Suzhou, 1987.

Working together, my good friend and master printer, Michael Wilder, and I have produced a body of photographs that not only attempt to address important issues of our time but that also represent the most inventive edge of the technology in which we work, Cibachrome /Ilfochrome color print material. Our twenty-five years of collaborative work make our partnership one of the longest in the history of photographic printmaking, and it parallels similar relationships in other genres of print work wherein artists like David Hockney, Jasper Johns, and Robert Rauschenberg have collaborated with print workshops, master printers, and publishers such as Gemini G.E.L., Tamarind Lithography Workshop, Tyler Graphics, and Universal Limited Art Editions (ULAE) to produce their limited edition prints and portfolios.

This volume and the spectacular installation that it documents mark the first time that such an extensive exhibition of Chinese embroidery has ever been available for viewing in the United States. For this opportunity, as well as for their encouragement and invaluable support, I wish to thank the director of the UCLA Fowler Museum of Cultural History, Doran Ross, and Roy Hamilton, the museum's curator of Southeast Asian and Oceanic collections. I am particularly appreciative of the efforts and research contributed to this publication by Patrick Dowdey and by Fowler Museum director of conservation Jo Hill. Patrick's extensive knowledge of China's history and the nuances of its political system contributed significantly to broadening my own understanding, and his fluency in Chinese significantly enhanced communications. I am especially grateful to Patrick for the articulate essay he contributed to this volume and for his genuine understanding and appreciation of what I have been attempting to accomplish. I similarly value Jo Hill's insightful documentation of the technical aspects of the embroidery process as set forth in her essay. Jo traveled with me to Suzhou on one occasion, and her presence created an unexpected bridge that enhanced my own relationships to and communications with the institute's embroiderers. Jo also proved to be an excellent and adventurous traveling companion.

This exhibition has been made possible in part through contributions from friends and foundations that have long supported my efforts. In particular I would like to thank the Lund Foundation and Mr. and Mrs. Herbert Belkin for their generosity. Michelle Lund and Mr. and Mrs. Gordon Street also kindly agreed to lend embroideries to the exhibition so that the full extent of the collaboration between SERI and myself over more than a decade could be accurately reflected.

Lastly, I would like to thank my tireless staff, Mark Seigle and Cory Walsh. In a life filled with extensive travel and numerous overlapping projects, they keep me timely and focused so that all of the work can be completed. I would be lost without them.

Robert Glenn Ketchum

## Notes to the Reader

The *pinyin* system has been used to romanize Chinese characters throughout this volume. When another transliteration of a Chinese proper noun has wide currency, that spelling is placed in parentheses following the *pinyin* at the first appearance of the word, for example, Yangzi (Yangtze) River.

For those readers unfamiliar with *pinyin*, the following guide to pronunciation may prove helpful.

*q* denotes the sound *ch*
*x* denotes the sound *sh*
*c* denotes the sound *ts*
*z* denotes the sound *tz* or *dz*

Otherwise, consonants broadly resemble their English equivalents. Vowels, however, have the softer values of Spanish.

In the catalog, all measurements are given with height preceding width. The dimensions of Robert Glenn Ketchum's photographs refer to image size. The dimensions of the embroideries, unless otherwise indicated, are exclusive of frames.

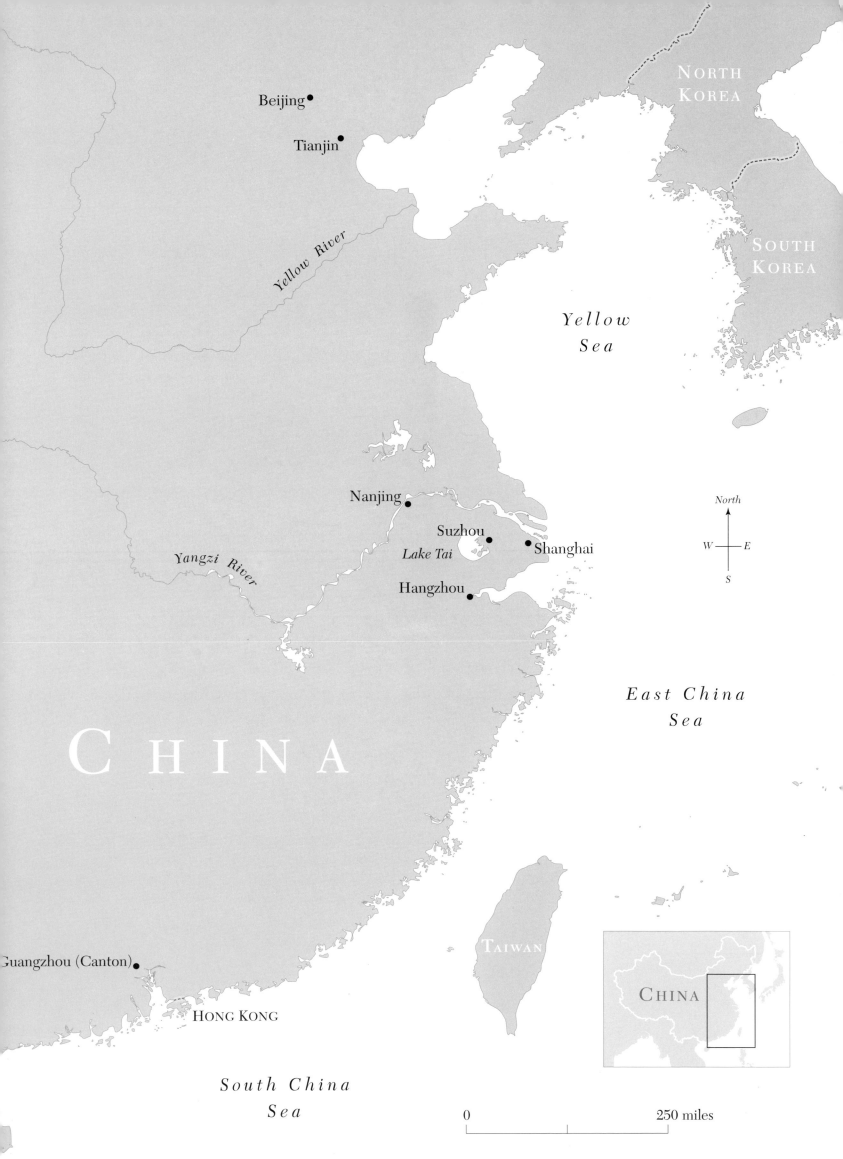

NORTH
KOREA

SOUTH
KOREA

Beijing

Tianjin

*Yellow River*

*Yellow
Sea*

Nanjing

Suzhou

*Lake Tai*   Shanghai

*Yangzi River*

Hangzhou

*North*

*W* — *E*

*S*

CHINA

*East China
Sea*

CHINA

TAIWAN

Guangzhou (Canton)

HONG KONG

*South China
Sea*

0                    250 miles

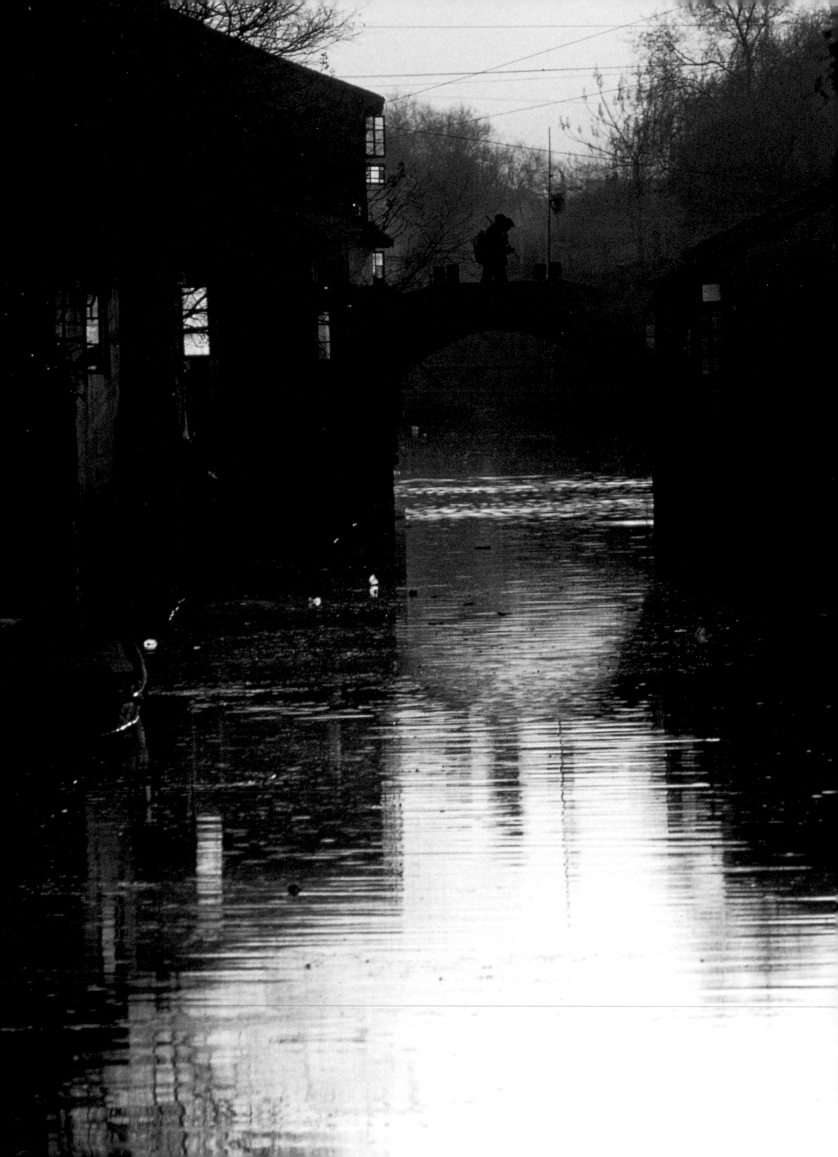

# Introduction

ZHANG MEIFANG

E mbroidery is one of the most beautiful of China's arts. Historically there have been different styles of embroidery in different parts of China: around the rivers and lakes of the lower Yangzi (Yangtze) Valley, in the border areas of China's northwest, along the Yellow River Valley, in the tropics south of the Five Ridges, and in the little-traveled minority nationality areas. This volume presents Suzhou's (Soochow's) world-renowned handmade embroidery, its beautiful and rich designs, its many stitches, and its exquisite and elegant technique.

### A Brief History of Embroidery in China

When did embroidery begin? This problem has fascinated later generations. It has been said that in remote antiquity people worshiped nature: the sun, which illuminates every corner of the land and sustains all living things; the bright moon, which provides light in the darkness; the stars, which point the way forward for people at night; and the pheasant, with its brilliant, multicolored plumage. For our forefathers, all of this together was the embodiment of beauty, and therefore they took the sun, moon, stars, mountains, and pheasants as national totems. Images of these totems were sometimes pricked and cut into or tattooed on human skin and muscle. When people began to wear clothing of flax, silk, and fur, they began to "tattoo" images on clothing, and this is how embroidery started. Designs of the sun, moon, stars, mountains, and pheasants were painted and embroidered on the ceremonial robes of rulers. Of course, such embroidered patterns have symbolic meanings. For instance, the sun, moon, and stars represent brilliance; the mountain stands for the ruler's widely known military power; the dragon is associated with the gods and change; and the pheasant represents beauty. Among the embroidered objects excavated by archaeologists from funerary tombs in Baoji City, Shaanxi Province, which date from the early Western Zhou dynasty (eleventh century–771 B.C.E.), are figures of dragons, phoenixes, tigers, and birds as well as flowers, leaves, and geometric vines. The technique used is braid embroidery, in which the stitches resemble braids of hair.

By the Han dynasty (206 B.C.E.–220 C.E.) the silk handicraft industry in China had reached a fairly high level. The development of silk fabrics also led to improvements in clothing and embroidery. In addition to splendid costumes, the feudal emperors had embroidered bedclothes and so forth. Merchants often wanted to have clothes on which designs were printed, dyed, painted, or embroidered in different colors. They

FIGURE 1
A bridge over a canal. Photograph by Robert Glenn Ketchum, Suzhou, 1987.

were very particular about the arrangement of the colors. Garments made for high officials were splendidly embroidered, primarily in red with layers of clouds, flowers, and leaves in dark blue, olive green, yellowish brown, or golden yellow to indicate the wearer's noble rank.

In 1972 Mawangdui No. 1 Han Tomb (c. 175 B.C.E.) was discovered and excavated near Changsha, in Hunan Province. More than forty articles of embroidered clothing and silk fabric were discovered in the graves. There was an abundance of textiles, including brocade robes, sachets, items for tea, gloves, and mirror bags. At the time of their excavation, these embroideries were still well preserved, and their bright colors and patterns fired the imagination. The stitches were based mainly on braid embroidery, with some woolen needlepoint embroidery. They were classified at that time as Xinqi embroidery, longevity embroidery, cloud-riding embroidery, Zhuyu veined embroidery, silkworm veined embroidery, and so forth, according to their decorative patterns. I made a special trip to the excavation site and, together with several embroidery technicians, studied the remains of the excavated silk embroideries and produced a set of reproductions, which are preserved at the Suzhou Embroidery Research Institute (see fig. 2).

A silk-embroidered image of Buddha from the Northern Wei dynasty (386–534 C.E.)—discovered in the Mogao Grottoes, outside Dunhuang, Gansu Province—is the earliest known embroidery done purely for appreciation rather than as embellishment for clothing or other practical items.

The Tang dynasty (618–907 C.E.) was one of the most prosperous stages in China's history, with a thriving economy and rapidly developing culture. More progress in silk embroidery skills was made during this period than during earlier generations. The many kinds of embroidered articles made at that time include dresses, quilts, bed curtains, and images of Buddha. For example, the six-foot-high *Picture of Sakyamuni Preaching the Dharma*, once stored in a cave room of the Dunhuang Mogao Grottoes, represents one of the most renowned legends of Buddhism. Sakyamuni is shown on Lingjiu Peak with the rock in the middle as background, two Buddhas and two *bhikkus* (monks) naked and standing at each side, and a sky-covered *bhikku* on the top with a pair of lions and men and women worshiping in the lower part. The coloring of this embroidered article is elegant and exquisite; the stitching is even, thin, and as smooth as if it were done with a writing brush. In this respect it has the character of the famous Dunhuang frescoes.

During the Tang dynasty emperors often gave embroideries as gifts to their favorite subjects, and Tang embroideries were therefore regarded as precious articles. For example, according to a beautiful legend from that time, Wu Zetian (r. 690–705), China's first female emperor, bestowed an embroidered robe on her prime minister, Di Renjie (606–700), which was decorated with twelve Chinese characters embroidered with golden thread.

During the Song dynasty (960–1279) China's historiography, literature, art, science, and technology all made great progress. Emperor Huizong was an artist who both painted and did calligraphy. He promoted schools, founded an imperial art academy, and carried out a series of enlightened policies to support painting, creating a favorable atmosphere for artists. There were a number of famous artists in that period whose themes were wide ranging and whose painting skills were precise and penetrating. Whether the subject was mountains, water, trees, rocks, gourds and fruits, flowers and plants, figures of gods, or images of Buddha, all were depicted carefully, neatly, and beautifully.

It was also in this period that embroiderers began to cooperate with artists and painters, copying paintings and calligraphy onto silk fabrics with needle and thread. In particular, some "girls of the inner chambers" embroidered the works of famous artists (see fig. 3).[1] Their embroidery (called "embroidery of the inner chambers" [*guige cixiu*] by later generations) was absolutely lifelike. In that period good embroidered articles were praised for their accurate depiction of subjects such as the human figure, mountains and rivers, buildings and towers, and flowers and birds. The needlework was fine and close but without border stitches. Using needles like hairs and just one or two pieces of fine silk embroidery floss, the embroiderers produced vibrant and dazzlingly brilliant pieces, with a palette as sophisticated as that of paintings (see fig. 4).

FIGURE 3
The Huizong emperor of the Song dynasty painted the picture upon which this embroidery is based. Titled **A GROUP TOGETHER IN SPIRIT (YI TUAN HE QI)**, it depicts three people who became very close friends. This image is still very popular in China. Photograph courtesy Suzhou Embroidery Research Institute.

FIGURE 4
Embroidery used to cover Buddhist scriptures, Northern Song dynasty (960–1127). This work was excavated from the Yunan Temple atop Tiger Hill in Suzhou. Collection of the Suzhou Museum. Photograph courtesy Suzhou Embroidery Research Institute.

In the Ming dynasty (1368–1644) the imperial court set up a government-run weaving and dyeing bureau in Suzhou. An embroidery workshop was established under this bureau whose specialty was the production of household embroidered goods such as robes, shoes, and bed curtains. "Art embroidery" was made mainly by "girls of the inner chambers," who might also be skilled at music, chess, calligraphy, and painting. As a result of their cooperation with artists, embroiderers developed their own characteristic stitch styles, coloring, and design. The Suzhou embroidery circle of that period was full of famous embroiderers, for example, Han Ximeng, who embroidered many works by the famous artist Dong Qichang. She became an outstanding embroiderer and was highly esteemed and admired by the literati and scholars of that period.

## Suzhou Embroidery and the Establishment of the Suzhou Embroidery Research Institute

The artistic thought of Shen Shou and Yang Shouyu, two embroidery artists who played an important role in promoting and developing Suzhou embroidery in modern times, lies at the foundation of the Suzhou Embroidery Research Institute (SERI).

Shen Shou (1874–1921; see fig. 5) was born into an antique dealer's family in Suzhou and was exposed to painting and calligraphy when she was young. At the age of fifteen she was already referred to as a "thousand golds of the inner chambers" embroiderer.[2] Her talent also attracted the attention of the court, and she became a teacher in the imperial embroidery workshop in Beijing. In 1905 the Ministry of Agriculture, Industry, and Commerce sent Shen Shou and her husband to Japan to observe and study embroidery. They went first to Tokyo and then to Kobe and

FIGURE 5
Shen Shou (1874–1921). Photograph courtesy Suzhou Embroidery Research Institute.

FIGURE 6
**PORTRAIT OF CHRIST**, embroidery by Shen Shou. This piece represents Shen Shou's mature style and openness to foreign ideas. Collection of Nanjing Museum. Photograph courtesy Suzhou Embroidery Research Institute.

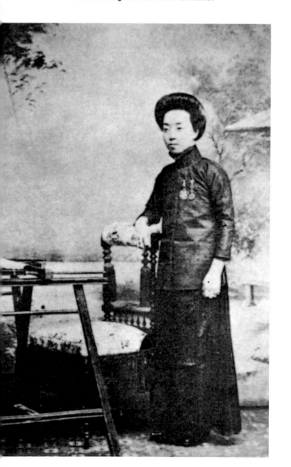

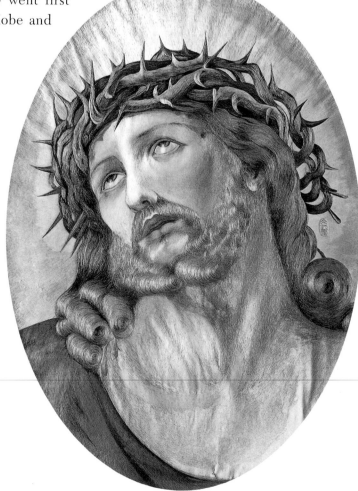

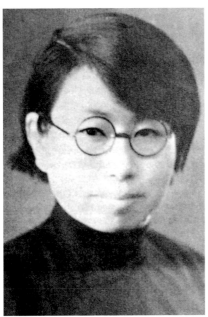

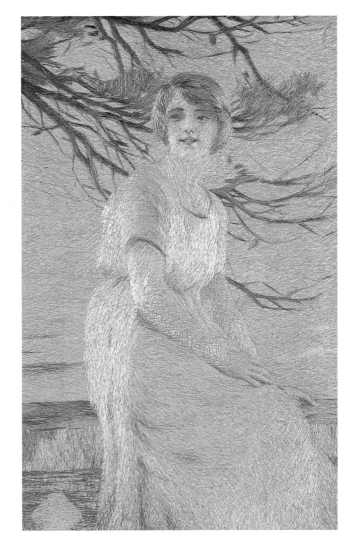

FIGURE 7
Yang Shouyu (1896–1981). Photograph courtesy Suzhou Embroidery Research Institute.

FIGURE 8
**YOUNG GIRL**, embroidery by Yang Shouyu. Yang's development of random stitch embroidery opened up new creative possibilities for the art. Collection of Suzhou University. Photograph courtesy Suzhou Embroidery Research Institute.

Nagasaki, where they saw Japanese handicrafts, embroidery, oil painting, photography, and the other arts of that period. Shen Shou felt that Japanese embroidery was far inferior to Chinese embroidery in the precision, penetration, and spirit of its needlework, but it was in Japan that she began to study the use of chiaroscuro and perspective in Western painting. After her return she developed a new style of embroidery, which she called "imitation of reality embroidery" (*fang zhen xiu*). When she presented her embroidered portrait of the Italian empress to Italy as one of the Qing court's gifts, the piece created a stir throughout Italy. Her work won the gold prize at the Turin International Fair in 1911.

In 1911 Shen Shou founded the Independent Women's Training Institute in Tianjin. In 1914, at the invitation of Zhang Jian, an industrialist from Nantong, Jiangsu Province, she returned to Nantong and was employed to teach: first as head of the Nantong Needlework Training Institute and then as director general of the embroidery bureau, and so forth. In 1915 Shen Shou's masterpiece, the *Portrait of Christ* (fig. 6), won the first prize at the Panama-Pacific International Fair in San Francisco. She also trained a number of students, among whom was Jin Jingfen, SERI's first director.

Yang Shouyu (1896–1981; see fig. 7) developed a style that was unique in the history of Suzhou embroidery. She was different from other famous historical embroiderers in that she graduated from an art school,

Changzhou Normal University's Painting and Design Department. Afterward she served as a drawing and embroidery teacher at Zhenze School in Danyang, Jiangsu Province, and as an associate professor at the National Academy of Fine Arts. In the 1950s she lived in Suzhou and, with her two best pupils, took part in the founding of SERI.

Yang Shouyu believed that embroiderers needed to be trained in painting in order to produce the finest quality embroidery. She preferred that students learn painting before studying embroidery. This theory represented a breakthrough in the development of traditional embroidery but also served as a link between the past and the future.

Yang Shouyu was also highly creative in the way she employed her embroidery skills. She integrated traditional needlework with the brushwork and coloring of oil painting and sketching. She altered traditional Chinese embroidery techniques, such as close needlework and parallel stitching, by using unequal lines of stitches and by building up layers of different-colored thread. This kind of creative embroidery technique is called "random stitch embroidery" (*luanzhen xiu*). Compared with traditional embroidery techniques, random stitch embroidery has more variable lines and rich, layered colors (fig. 8). It has become a vital part of Suzhou embroidery. Taken together, traditional embroidery techniques and random stitch embroidery complement and supplement each other, creating an entirely new and exciting set of possibilities for Suzhou embroidery.

Here I can't refrain from recalling my chats with Yang Shouyu in her later years. She had a facile imagination and could recall all the details of her creation of random stitch embroidery in the 1930s. She also had a very impressive manner of speaking. She told me that she had been very vivacious when she was young. While studying traditional embroidery skills, she found that her spirit rebelled against the rigidity of the technique. She couldn't follow the rules, and so she introduced the essence of sketching to embroidery and used a similar method of building up lines when she was embroidering. The old lady was witty, good-humored, and modest and made a deep impression on me. The creations of the older generation of artists are an invaluable legacy. They have opened up a path for us to develop new embroidery skills, techniques, and ideas.

The Suzhou Embroidery Technical School was founded in 1952 with the help of the local government. Yang Shouyu was employed as a teacher, along with her best students: Ren Huijian, Zhou Xunxian, and Zhu Feng. On the basis of this school, a folk art embroidery research group was set up in 1954 and gradually became an embroidery cooperative. In the early 1960s the Suzhou Embroidery Research Institute was formally set up. To meet its goal of "raising human talents and producing fruits," the institute engaged a number of talented senior embroidery artists and developed high-grade Suzhou embroidery articles, which were welcomed in Asia, Europe, and the United States.

SERI continues to pursue this mission. At present the institute carries out embroidery research, production, design, mounting, dyeing, preparation of educational materials, and similar tasks. The fact that the embroiderers brought together here are from different families and have

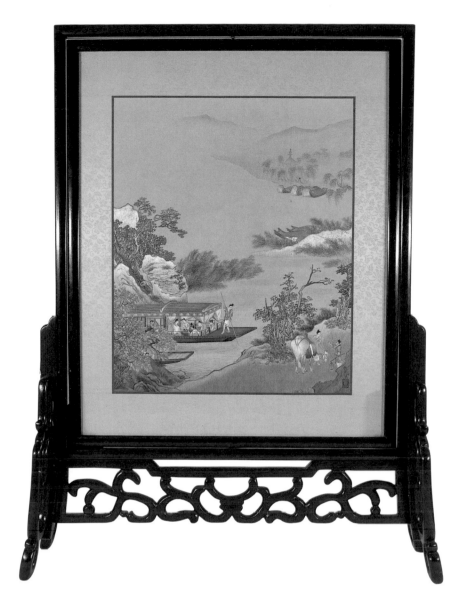

learned different techniques enhances their opportunities to learn from one another. At SERI it is possible to systematically study how the use of preparatory sketches, different thread colors, and different mounts affects finished embroidery products. When embroiderers begin to work on their preparatory "sketch" embroideries of an artist's work, they can usually talk to the designer about his or her original intent and thus can use this knowledge to guide their own embroidery process. For the artists, learning more about the language of embroidery may help them create works that are well suited to translation into that medium. Thus, working collaboratively benefits everyone.

In this atmosphere the institute has successfully developed embroidery techniques such as double-sided embroidery (*shuangmian xiu*; see fig. 9), which is embroidered in the same manner as a single-sided embroidery but can be enjoyed from both sides, and double-sided three-difference embroidery (*shuangmian sanyi xiu*), in which the colors, forms, and stitches are different when seen from each side. As a result, the ways of presenting embroidery have been broadened.

Suzhou, a city with a long literary and artistic history, has produced many scholars and artists, and this environment has nurtured Suzhou embroidery's artistic style. Take the palette of Suzhou embroidery as an example: particular attention is devoted to abundance and harmony of colors. The desired effect is one of quiet elegance and beauty. In the

1960s the institute began to dye thread itself because the market supply of colored thread lagged far behind the demand. Now the institute can dye thread in beaker lots according to its own need. On average, a set of threads in one color is dyed in thirty to thirty-six increments from light to dark and in more than ten steps from warm to cool shades. This method of dyeing in small batches is well suited to embroidery since it allows natural blending of colors and also makes the colors uniform within a piece. The colors of the embroidered works present a rich and varied effect.

When we embroider a new work of art, we sometimes find that we need a color of thread that is not within the spectrum of available colors. It is often necessary to set up a special dyeing research project so that the embroidered work can more accurately capture the colors of the painting. Because each element must serve to heighten the effect of the embroidery, this standard is a prerequisite for the creation of an ideal piece. As a result, people say that Suzhou embroidery is splendid but not vulgar, elegant but not cold.

### SERI's Educational Philosophy

Since the founding of the institute, we have gradually improved and perfected our means of training embroiderers. As I have already mentioned, the finest Suzhou embroidery artworks traditionally came from the "inner chambers." The usual way to learn embroidery is "mother teaches daughter, elder sister-in-law teaches her husband's younger sister," and in this way it is handed down from generation to generation. Although this teaching method has its strengths—the closeness of the relationship enhances the influence of teacher on student and the ability to keep the pupil's mind on studying—it may limit opportunities for development because of the small scale of production and the generally small pieces

FIGURE 10
The painter Yuan Yunfu of the Central Institute of Crafts and Fine Arts in Beijing with Zhang Meifang and other embroiderers during a creative exchange at SERI. Photograph courtesy Suzhou Embroidery Research Institute.

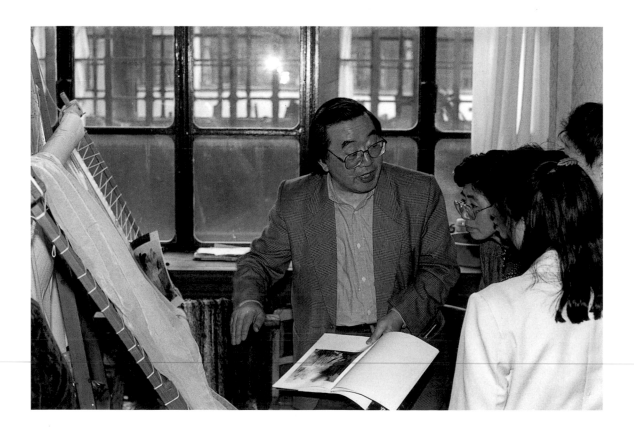

that result. It is rare to find a large piece from ancient times. By assembling embroiderers to work together, we can make up for this deficiency.

At SERI we stress two points in the training of embroiderers: one is basic needlecraft skills, the other is the development of artistic accomplishment. These two aspects are inseparably interconnected, and neither can be dispensed with. When we recruit new students, we look for youths who have nine to twelve years' schooling and a talent for needlework. Then we provide them with painting and embroidery teachers who give them formal training in these basic skills. Painting lessons include sketching from life and nature and traditional Chinese ink painting. In embroidery classes the students must learn forty traditional Suzhou embroidery stitches.

During the three years' training, the students' focus is not only on finishing a piece of embroidery work but also on practicing. In this way they can grasp the basic skills necessary for their future career in embroidery. They can also get a better understanding of how to integrate stitch techniques and aesthetics. So, unlike students who learn only embroidery skills, they will not be satisfied with simple "mechanical copying" but will learn to use their analytical skills and to draw upon their past experience to solve problems. To produce fine embroideries, it is important to have a quick understanding, which one must accumulate bit by bit. To help develop this understanding, we often go out to see exhibitions of both traditional and modern art. In order to increase both our breadth of knowledge and our capacity for knowledge, we regularly invite local and foreign professors of art to lecture. Painters who come to speak at the institute also give rise to new ideas, pushing us to explore embroidery's language and blending stitches and their use into sketches for painting (see fig. 10).

One of our visitors was Yang Deheng, a famous painter from Liaoning Province, in northeast China. Yang devoted a great deal of time to the study of cranes, haunting the places where they live. He often stood up to his knees in marshy swamp water for several hours, silently watching the birds taking off, resting, and dancing. When I read the introduction to an article he wrote about this project, I was deeply moved and reflected on the fact that cranes have often been the subject of embroideries. So I invited him to come to our institute for a series of lectures on the behavior and habits of cranes. Since the painter had watched cranes so carefully, his lectures were vivid and interesting. The embroidery researchers listened to him with keen interest and applied what they had learned to their embroideries of cranes. As a result, their technique improved. For his part, the painter gained a deeper understanding of embroidery, and he produced new sketches that displayed a broader range in their depiction of cranes.

In much the same way, Robert Glenn Ketchum has become our teacher and friend. During our mutual cooperation of more than ten years, I have been impressed by his persistent pursuit of art; he struck a deep chord in my mind. With the further development of our cooperation, we may find more common interests. We continue to learn more about the expressive potential of embroidery and photography and about combining Eastern and Western approaches to art. Sharing a common artistic language has connected us.

## Embroidery Research and Development

Dozens of years have passed since the founding of the institute. Since its establishment SERI has sent its artists and technicians to the Palace Museum, the Shenyang Museum, the Nanjing Museum, the Shanghai Museum, and other institutions to conduct research. We have also collected folk embroideries in our region, particularly in the lower reaches of the Yangzi River. Based on our study of these folk embroideries, we have classified more than forty kinds of Suzhou embroidery stitches and recorded every kind of embroidery, from the earliest stitch to a simple complete design, in study pieces (see figs. 67–69). The record of these stitches is the study album "Collection of Stitches." The institute developed the "Collection of Fine Stitches," the "Collection of Random Stitches," the "Collection of Pierced Yarn Stitches," and others, which include a few hundred pieces of embroidery in all. Each of these collections of stitches has its own particular focus. The "Collection of Fine Stitches" mainly addresses the order and logic of stitches, the "Collection of Random Stitches" chiefly involves the order and logic of embroidering images realistically, and the "Collection of Pierced Yarn Stitches" is not only the summary of the technicians' experience but also a collection of model study materials. These materials help students digest what teachers have taught and provide visual information that can't be expressed in lectures or in written materials.

When given the task of embroidering a new tableau, the technicians work to select the right stitch and a set of techniques to express their ideas. In this context the collections can play the role of a "dictionary," helping them find the right vocabulary for a particular project. As for the development of stitches, we encourage a thoughtful approach. For example, in Robert Glenn Ketchum's *Rock in Lake with Fog* (1997; cat. no. 36), the artist's original intention was to express the solid character of the rock, which had been pitted by the action of the water and was covered with moss. While embroidering, we used the random stitch as well as such ancient stitches as the "seed stitch" (*dazi zhen*), "knot stitch" (*jiezi zhen*), "pine nut stitch" (*songzi zhen*), and others for embellishment. The application of these stitches, which involved both original and traditional arrangements, strengthened the surface textures, creating artistic effects that were virtually identical to those of the original photograph. Some effects were even better than we had anticipated.

After we have applied traditional stitches in new combinations, we generally mount the embroideries produced as trials for preservation and place them in files together with the embroiderers' technical summaries. We make a practice of doing this because these files serve not only as summaries of the technical records for all embroidered goods but also contain specific reference materials for the development of new techniques. Written descriptions are less specific and more abstract than examples with actual handiwork. These study pieces function in much the same way as artist's proofs, providing a means for us to record the techniques and combinations of stitches employed in every piece and preserve them for use in the next creation, thereby extending the capabilities of the art and its expressive range.

Throughout my many years of embroidery practice, I have believed that we should treasure the valuable heritage of Suzhou embroidery. We should not rigidly adhere to it, however, as it is not advisable to regard it as an immutable process. Certainly we should attach importance to training in basic stitches and techniques and have a thorough knowledge and understanding of them, but the application of traditional methods must be combined with creativity. As Suzhou embroidery is deeply rooted in a long history of more than one thousand years, it is essential that we find ways to extend its life, rather than looking at it as an "antique," as that approach can only result in work that appears stiff and lacking in spirit.

For many years SERI has been exploring new ways to approach tradition. There is no denying that this thinking is considerably different from other attitudes toward the inheritance of traditional skills. Although there are those who fear any deviation from tradition, we have seen many indications that our exploration is acceptable to more and more people in art circles. Encouraged by the increasing interest in our work, we have expanded our repertoire to encompass new subjects. We have also become more creative in our application of stitches and techniques, learning many different embroidery languages. Every new effort can show the vigor and vitality of this living art.

Today the institute embroiders not only works of art from throughout China's long history but impressionistic and abstract works as well. Although the styles of these works are all quite different, there is a resonance among them. Of course, we will continue to face difficulties in producing new works of art. I remember that there was such a feeling when we accepted *The Beginning of Time* (1994; cat. no. 26), a work ordered by Robert Glenn Ketchum. Once we accepted it, however, we treated it carefully. Before starting, we repeatedly discussed the technical plan for embroidering this work. While embroidering, we studied the application of color and stitches many times, seeking the approach that would best realize the embroiderers' creative intentions. When finished, this embroidery received many favorable comments, which gave us great joy. Clearly we have taken Chinese embroidery to a very high level of accomplishment, but we are continuing to seek ways to advance our art. There are many as-yet-unknown areas that we will explore.

Today opportunities for artistic exchange are increasing throughout the world, giving us much room to learn and grow. This is an area in which we have great interest. In this regard, I think that ideas will be far more important than technique in shaping the future of Suzhou embroidery.

●

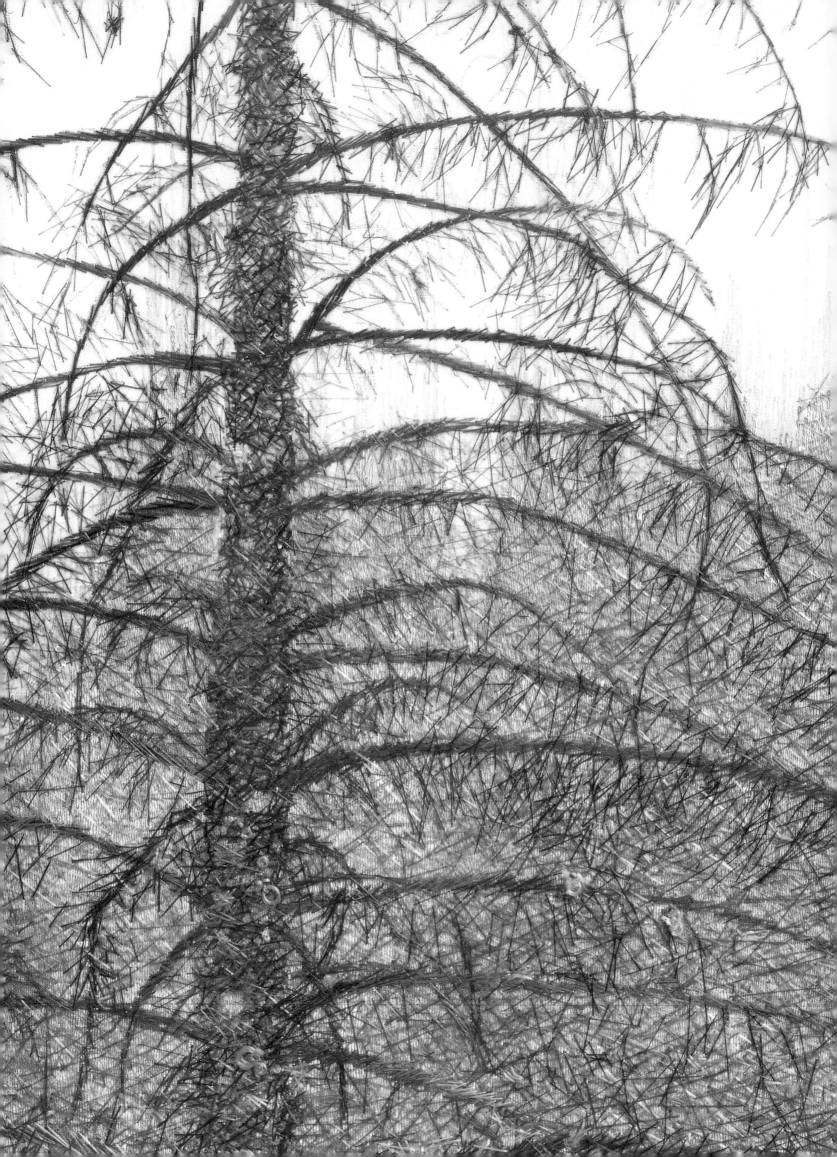

# But Will It
# Still Be Beautiful?

**PATRICK DOWDEY**

One of the first times I met Robert Glenn Ketchum, he told me the story of his initial trip to Suzhou in 1986. He went there to explore the possibility of commissioning the Suzhou Embroidery Research Institute to make embroideries from his photographs. He had been warned not to expect any firm commitment, but after ten days without any substantive progress, he was upset and "venting" in his hotel room as he packed to return to the United States. His wife tried to calm him, reminding him that collaboration on an artwork could have political repercussions for the institute that he might not be aware of. Ketchum calmed down a bit, and in fact, during the long drive to the Shanghai airport the next day, he entered into serious negotiations with Zhang Meifang, the institute's director, and Professor He Shanan of the Nanjing Botanical Garden. As Ketchum tells the story, the three of them agreed that, for the institute's first attempt to make an embroidery from one of his images, it would be best to work from the photograph *Snowfall* (cat. no. 15) because it was black-and-white and because its effect in many ways resembled that of traditional Chinese painting. Even then, Zhang Meifang hesitated: "It will be too abstract." To which the photographer replied, "But will it still be beautiful?"[1] This was a criterion that they could all agree on, and so the institute went forward with the piece. Its success became the basis for a long collaboration.

Later I talked to Zhang Meifang about Ketchum's story, and she remembered the encounter in a slightly different way. She told me that indeed she was not entirely comfortable dealing with a foreigner but that her worries about the collaboration were not political (although I am sure that this was still a consideration in the mid-1980s), but aesthetic. She was concerned about whether this foreigner would be satisfied with the completely new and untested style of embroidery the institute would have to produce. From her perspective, this American artist seemed both particular and volatile, and she wanted to be certain that she and he understood each other, especially on aesthetics, before she agreed to have the institute make an embroidery from one of his photographs. Over the course of their collaboration, Robert Glenn Ketchum and Zhang Meifang have learned a great deal about each other's aesthetics and outlooks, and both have grown in their art as well.

FIGURE 11
Robert Ketchum, Dr. He Shanan, and Zhang Meifang discuss a book of Ketchum's photographs. Suzhou Embroidery Research Institute, 1997. Photograph courtesy Suzhou Embroidery Research Institute.

FIGURE 12 (OPPOSITE)
Detail of **SNOWFALL**, cat. no. 16.

### The Suzhou Embroidery Research Institute

The Suzhou Embroidery Research Institute (SERI) occupies a place at the pinnacle of Chinese embroidery, a state-organized institute in what has historically been the most famous center for embroidery in China.[2] Suzhou has long been famous for its silk, and it also became known for its embroidery after its rise as an important city in the Song dynasty (960–1279 C.E.). The contributions of the embroidery artists Shen Shou and Yang Shouyu in this century, which broadened the horizons of traditional embroidery, underline the essentially progressive and cosmopolitan nature of the Suzhou embroidery tradition. SERI is the inheritor of that tradition and carries on not only the techniques of earlier masters but also their spirit of discovery and excellence. More than a few SERI embroideries decorate Jiangsu Province's hall in the Great Hall of the People on Tiananmen Square in Beijing; others have been presented as diplomatic gifts to leaders all over the world and decorate Chinese Foreign Ministry offices. Before the reform and opening up in China in the late 1970s and early 1980s, the institute produced innumerable portraits of political leaders, especially Communist party chairman Mao Zedong, along with more traditional work and original designs.[3] Many of the older embroiderers at the institute have been recognized as embroidery masters by the Chinese government.

Since its founding in 1954 the institute has grown to more than two hundred employees, more than one hundred of whom are embroiderers. It handles every phase of embroidery production: construction of frames and mounts, dyeing of silk thread, weaving, design of new pieces, embroidery, shipping, and business arrangements. It is part of the Suzhou Handicrafts Bureau, which is under the Chinese Ministry of Culture. Zhang Meifang is the institute director, an unusually high position for a woman in China. In fact, many (but not all) of the institute's leaders are women, a continuation of the historical tradition of accomplished women in embroidery. Chen Caixian, one of the institute's vice directors, was also closely involved in the exchange project with Ketchum. Shen Guoqing, the director of the institute's Materials Section, along with Zhang Meifang, provided much of the information for this essay.

SERI produces embroideries for many different audiences, and its market has grown rapidly in the twenty years since Deng Xiaoping's reform and opening up. Many of the largest pieces are ordered by overseas Chinese and Japanese. Successful designs are often re-created several times, although this is not, of course, the case with Ketchum's works, which are unique pieces commissioned by the artist. Smaller works are made for the gift shop on the institute's grounds; kittens, goldfish, and portraits of Prince Charles and Princess Diana are particularly popular. Zhang Meifang must also answer requests from government agencies. She told me about an importunate Foreign Ministry official who flew down from Beijing to lobby her for a piece, which she was hesitant to make because of scheduling problems. She finally took on the work as a favor, and the embroidery now hangs in the Foreign Ministry's offices in Hong Kong. The ability to find foreign markets has allowed the institute to participate in China's economic rise and to invest in capital improvements of its facilities.[4]

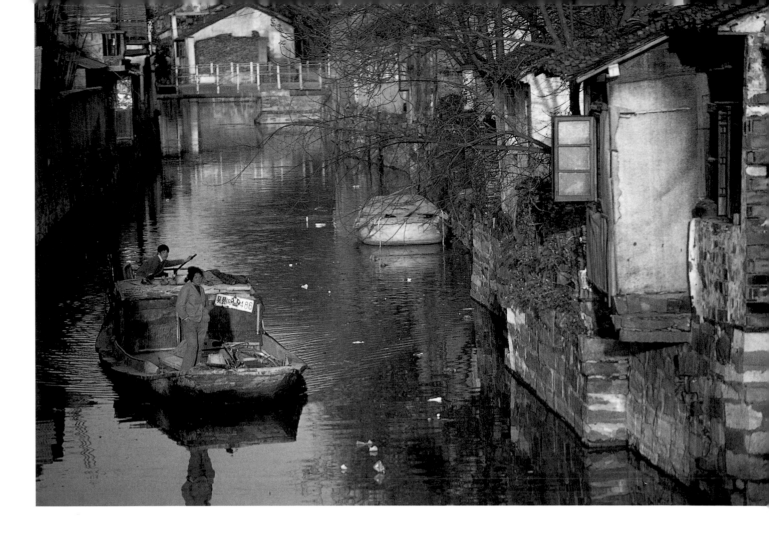

### Embroidery in China

The embroiderers at SERI have inherited a rich artistic tradition that dates back millennia and has been closely linked to Suzhou since the eleventh century. While collaboration with an American photographer might seem like the height of modernity, it can just as easily be seen as another step in the evolution of embroidery.

Embroidery has been one of the most prestigious arts in China, surpassing the fame even of painting during some periods. From its earliest development, around 800 B.C.E., roughly half a millennium before the terra-cotta warriors were buried in the grave of the first emperor, outside what is now Xi'an (c. 210 B.C.E.), embroidery has evolved rapidly during those periods when social conditions favored it. The earliest embroideries known are, like the warriors, grave goods, interred with a member of a noble family for his or her use in the next life.[5] Embroidery was a prestige art, produced for the court and imperial family and also associated with religious ceremony and worship.

As Zhang Meifang notes, the establishment of court workshops during the Song dynasty brought embroiderers into contact with other artists, with a resulting refinement of their work. During the Ming dynasty (1368–1644) the court in Beijing established official embroidery workshops in Suzhou.[6] Late in the Ming the embroiderer Han Ximeng became well known for her extremely fine copies of paintings in a style known as Gu embroidery (from her husband's family name). The Gu family had produced a number of degree holders (meaning, at that time, government officials), but by Han Ximeng's time its fortunes had fallen, and it came to rely on sales of embroidery to remain respectable. In the seventeenth

century economic reversals like that suffered by the Gu family were common, and other families, of more modest means, established what became craft lineages, in which techniques were handed down from one generation to the next. The potential to earn money from embroidery also drew men to the art. Throughout this period embroiderers continued to develop the aesthetics and techniques of their art, achieving new effects and styles.

By the mid-eighteenth century the Qing Imperial Weaving and Dyeing Offices in Suzhou, Hangzhou, and Nanjing together employed seven thousand workers (Wilson 1986, 98). While that number would have included not just weavers, but all workers, it makes clear the enormous scale of court production. By the late nineteenth century there were 1,050 people doing embroidery professionally in Suzhou, most of them women (Wilson 1986, 106). These workers were mainly engaged in commercial embroidery work, which by this time was often destined for overseas as well as Chinese consumers. Embroidery remained an important prestige art throughout the imperial period in China, and elite patronage aided its development, especially in the imperial workshops, where embroiderers from different parts of China were gathered to work together.

### Embroidery, Women, and Society

Stitchwork, techniques, the kinds of embroideries made, and the conditions of production have all evolved during the long history of Chinese embroidery. The historical record reveals little about embroidery among common people, yet we know that by the nineteenth century embroidery was used for a wide variety of purposes—from the creation of prestige objects for gift-giving and display to the decoration of items for daily use—each of which had a specific social context. A look at the social aspects of embroidery gives historical and social depth to its creative tradition and helps dispel the notion of Chinese embroidery as a fixed, changeless practice.

For any family during the imperial period, from landowners' and officials' families to those of the people who worked the land for them, embroidery was a vital part of a daughter's education. If the girl was from a wealthy family, she learned embroidery as a worthy occupation for a woman and, not incidentally, as a way to pass the time. (Until the late nineteenth century many women did not learn to read or write.) If the girl was from a common family, she learned to embroider in order to decorate articles of daily use or, if her family lived in or near a city, to earn some cash. The quality of a girl's embroidery was seen as a good index of her general ability and was important in peoples' estimation of her virtue (*meide*), as two SERI workers explained to me:

> — Before in Suzhou, in those days, everyone could embroider, if you couldn't then they'd say ...
> — You're not clever.
> — You're stupid! No one would like you. Before, we'd say a Chinese woman should be virtuous, very capable, very willing to discuss things, very mild.[7] Then people would like you.[8]

A skilled embroiderer was called *qiao shou*, a "clever hand," or *neng shou*, a "capable hand." Some girls were just nicknamed "clever." If her elders called her clever, a girl might be flattered to the point of blushing. This was especially true in Suzhou, a city that was known throughout China for the quality of its embroideries and brocade. The ability to embroider well was considered one of the most desirable attributes in a woman, and the respect accorded a good embroiderer often led to a prominent role in the community of women.

It is surprising how much embroidery was made in China and how widely it was used, even for the simple decoration of items for daily use. Besides embroidering decorations on household goods like curtains, quilts, pillows, and tablecloths, women embroidered clothing and accessories, including detachable sleeves and collars and elaborate embroidered borders. There were embroidered bags for fans, jades, glasses, name cards, small scales, scissors, snuff bottles, chopsticks, knives, and, of course, money. Perhaps the most typical embroidered article in the Suzhou area was the diamond-shaped apron (*weidou*) worn by common women during the day.[9] These aprons were made of bright red, white, or pastel-colored silk embroidered with flowers, an occasional bird or butterfly, and a decorative border. Two loops were made at the top for a band to fasten the apron around the neck, and a loop at either side was buttoned to a belt, also embroidered, which reached around the woman's back and held the apron snug. Use of the aprons has declined, but rural women can occasionally still be seen wearing them today.

Another category of embroidered goods was those made for weddings. These included pillowcases, bedding, window valences and curtains, door curtains, and a wide variety of other items that the bride took with her when she moved to her new home with her husband's family. All of these were also produced for daily use, but a wedding required a special display as the bride, seated in a sedan chair, was taken in a procession with these items to her new home. The bride's entire extended family was called upon to help prepare the trousseau. Wealthy families, who needed to provide the most impressive display possible as a matter of prestige, often "invited embroidery girls" (*qing xiuniang*) to come and work. This was an important occasion for the cross-pollination of folk and elite embroidery practices and styles.

The bride herself produced the most important embroidered articles: three pairs of intricately decorated silk shoes, one for her husband's father (or grandfather), one for his wife (her mother-in-law to be), and one for her new husband. In the days before manufactured shoes were generally available, before most people could afford such manufactured goods, families had to make their own shoes.[10] More was involved than simple need, however. The bride demonstrated her very best needlework as a means of establishing her worth to her new husband and his family, especially her new mother-in-law. The gift of the three pairs of shoes at the time of marriage showed the girl's usefulness to her new family and her willingness to take on the meanest of tasks.

FIGURE 14

In the homes of wealthy Chinese families, the "dew platform" was a second-story room
in the inner chambers where the women of the family could gather to embroider, play
musical instruments, or even paint or practice calligraphy. From Shundai Nakagawa,
**SHINZOKU KIBUN** (Tokyo: Horinoya Nihe, 1799).

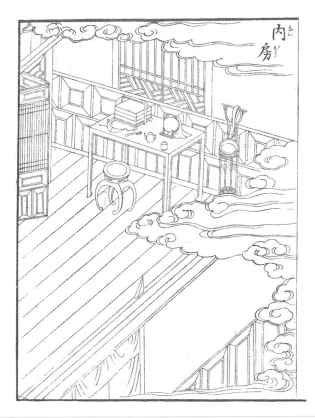

FIGURE 15

A typical room in the "inner chambers" for the wife of a wealthy man. Unless her husband
was unable to go out, the room would be the woman's own during the daytime. From Shundai
Nakagawa, **SHINZOKU KIBUN** (Tokyo: Horinoya Nihe, 1799).

A third type of embroidery was produced by women in the families of officials and literati, who brought to the art a sophistication that has had a strong influence on the kind of work done at SERI today. While they did the kind of functional embroidery described above, they also produced work "for appreciation," which differed from other embroideries in that they were usually mounted and framed and were often based on paintings. The cultural life of the great families emphasized an atmosphere of leisured industry: women were busy, but in a relaxed and pleasant setting, with culturally prestigious tasks. Besides devoting time to music, calligraphy, and painting (some of China's most famous women artists are from Suzhou), these women often made embroideries based on the best paintings in the family's collection. This category of work is referred to as "embroidery of the inner chambers" (*guige cixiu*). (The inner chambers of a Chinese home were the rooms set aside for the exclusive use of the family's women, which in larger houses often included a large second-story room where the women, especially the unmarried daughters, spent their time [see figs. 14, 15].)

The influence of painting on the embroideries in this exhibition can be seen in their content, styles, and large format. These traits also identify them as inheritors of the inner chambers embroidery tradition, to which both Shen Shou and Yang Shouyu belonged. It's important to remember, however, that this tradition and folk embroidery constantly influenced each other throughout embroidery's history.

Each of these three types of embroidery—embroidery for daily use, for weddings, and for appreciation—was produced in its own unique social setting. One of the most interesting aspects of these social settings is the way that people, even people from different classes, came together in social contexts such as preparation for a marriage, where they were able to exchange ideas and techniques. These exchanges contributed appreciably to the development of all kinds of embroidery even as social boundaries remained very strong. For women in traditional China and especially for Suzhou women, embroidery lay at the center of their sense of identity and self-worth. After the bearing of sons, it was many women's proudest accomplishment.

The most basic context for embroidery was the home, and girls were taught embroidery by their mothers and by their elder brother's wife.[11] This was true for girls at every level of society, from farm girls to the daughters of court officials and literati. As Zhang Meifang notes, this sort of learning was warm and could proceed at a comfortable rate because it was an integral part of home and family life. Embroidery techniques and patterns were handed down from generation to generation along with the family stories and great-grandmother's best dishes. The drawback to this system was its small scale and insulation from other forms of embroidery: exchanges between embroiderers were relatively few, and consequently this part of the tradition developed slowly. Home embroidery was neither systematized nor reflexive. You embroidered the way your mother embroidered, and accurate imitation was more important than innovation.

The imperial embroidery offices, which were first established in the Song dynasty, brought together girls from all over the empire to make the many embroideries needed by the imperial family. These embroiderers were trained by embroidery masters like Shen Shou, who were famous for their skill. The combination of imperial support and creative exchanges led to breakthroughs not only in technique but also in modes of depiction, subject matter, and style. From the eleventh century on, imperial embroidery offices also brought embroiderers into contact with court painters, whose sophisticated concepts of representation the embroiderers incorporated into their own works. At the same time, the imperial court made a concerted effort to learn about the creative expressions of the common people, and folk embroidery had an influence on court products. While the production of these offices consisted primarily of clothing, items for daily use, and ritual objects, embroideries for appreciation were both produced and collected by the court. Imperial embroidery offices were often established in Suzhou and participated in the embroidery tradition there.

During the late Ming and Qing (1644–1911) dynasties, embroidery became a commercial article, bought by the wealthy to be given to officials as a way to gain their favor, to be presented to monasteries or Daoist priests as objects of religious devotion, or for the decoration of their own homes. By the late Qing there was a robust commercial embroidery market that produced not only prestige items for the wealthy but also more common objects such as shoes, insoles, and decorative ribbon borders for families of more modest means. By this time many women (and men) in Suzhou embroidered to earn cash for their families. It was easiest for women who lived in towns to do this kind of work because of their access to good transportation. This kind of production was brokered by embroidery shops (*cixiu zhuang*), which contracted for production of work and sold it. Women contracted with the manager of a shop and were paid a set amount for each piece they made. The work was still done at home, but designs and standards were set by the shop.

The ability to sell embroidery for cash gave women a measure of freedom that was unusual in China, but there was a downside to the piecework system. According to Shen Guoqing:

> It was not good because those workers were not respected before Liberation. This was true not only of embroidery workers but of all workers at that time.... When they were young, their lives would be so-so, but when they got old, their life wouldn't be good.... They were just workers with no property; they had almost nothing and were exploited by the capitalists. The only thing they had was physical ability. Now we have medical insurance and old-age pensions, and so there's not a big problem when [embroiderers] get old.[12]

The piecework system left the embroiderers at the mercy of a market that grew increasingly bad in the first half of this century. The conditions faced by the common people were generally very difficult.

Increased commercialization was also apparent in the growth of an overseas market for embroidery in the late nineteenth and early twentieth centuries. This market was more sophisticated than the local ones

served by the embroidery shops mentioned above, and most of the women who worked for it were from better social backgrounds. The growth of this market was closely allied to China's expanded international trade, and it was increasingly served by women who had been educated in the Western-influenced schools that began to be established at this time. Shen Shou's Nantong Needlework Training Institute was such a school where women learned embroidery, which offered a respectable way to earn a living, as an integral part of their education. Even some of those students who were wealthy enough that they would never have to work used their needlework to supplement their family's income after graduation. Since women could support themselves by doing embroidery or teaching it, it became an important route to independence for women at many social levels.

Chinese embroidery had two interlocked traditions, distinguished largely by class differences but bound together by similarities in technique. Embroidery at the schools was mostly "for appreciation," while that done by most Chinese women was for daily use. Because of the social context of its practice, most parts of the embroidery tradition were conservative and changed very slowly, but there were still important innovations. The creative possibilities for embroidery increased rapidly with China's opening up in the late nineteenth and twentieth centuries but were held back by the inequality of relations fostered by imperialism and the conservative reaction against reform within China. Nevertheless, women like Shen Shou and Yang Shouyu, whose contributions I will discuss in the following sections, showed the way to a modern embroidery practice that lost nothing of the skill and refinement of earlier embroidery even while incorporating innovations that helped it make a unique contribution to international culture.

### Shen Shou and Suzhou Embroidery at the Turn of the Century

Shen Shou (1874–1921) was a native of the Suzhou area, a precocious embroiderer who took up the needle at seven and was producing works for the market by the time she was fourteen. Her marriage to a well-connected middle-level official brought her into a highly cultured family, which had large collections of paintings and antiques. Since her husband had a good social position and a lot of friends who were literati, they had the opportunity to make contact with the court.[13] When she was still very young, she presented a set of embroideries of the Eight Immortals as a birthday present to the Empress Dowager Cixi, at that time the effective ruler of China. The empress herself had embroidered when she was young, and she was so struck by Shen Shou's work that she gave her two pieces of calligraphy in her own hand. One said "good fortune" (*fu*); the other, "long life" (*shou*). Shen, whose name until then had been Shen Yunzhe, took the character for "long life" as her own name and became Shen Shou. This exchange opened the way for her to go to Beijing, where she served as a teacher in the Qing court's embroidery office. Her embroidery up to this point was accomplished but conventional.

In the early part of this century, Shen Shou and her husband traveled to Japan. She was introduced to Japanese embroidery and became

very interested in the Western oil paintings she saw there, especially the way that the artists handled volume and light.[14] At the Qing court she had been exposed to photography, and it too had affected her artistic thinking very deeply. When she returned to China, she was invited to start a school in Nantong (in the same general area of China as Suzhou) by an official and entrepreneur named Zhang Jian. He had come to know Shen Shou's work in the course of his duties, which included overseeing exports and imports, and had a great respect for her. The Nantong Needlework Training Institute supported by Zhang Jian, was established to train young women in "home economics," of which embroidery was a part. The school was a typical innovation for China during this period and represented a conscious adoption of Western ideas about the education of women. The students came from both wealthy and middle-class backgrounds, and many of them probably intended to use their training to make embroideries commercially after graduation. Nevertheless, the school itself did not participate in commercial activity but gave the students' embroideries away to charitable organizations.

Shen Shou's embroidery developed a great deal after her trip to Japan. Her new embroidery style, which she called "imitation of reality embroidery" (*fang zhen xiu*), brought elements of Western pictorial convention into the practice of embroidery. It represents an important development in Chinese embroidery for two reasons. Shen Shou recognized the realistic possibilities of Western depiction and had the skill and experience to be able to adapt them to the medium of embroidery. Secondly, the introduction of these new elements into embroidery opened up the practice of embroidery to change and development. The institute today is part of this creative and syncretistic tradition in Suzhou embroidery.

Shen Shou died when she was only forty-eight. She dictated her notes on embroidery from her sickbed to Zhang Jian, who transcribed them and compiled them into *Xueyi's Embroidery Handbook* (*Xueyi Xiupu*).[15] This book is one of the first in Chinese to record the practices of an art other than those, like painting and calligraphy, practiced by elite men. It covers arts associated with embroidery, hygienic practices ("don't wet the thread with your mouth before threading the needle"), and care of one's health ("take breaks every two hours, exercise your eyes by looking at things far away, take care not to strain your neck").

Shen Guoqing gave me some perspective on Shen Shou's life: "At that time [embroiderers] were just known as someone's wife and couldn't be called Madam; all they knew was how to make embroidery.... Women then didn't have a very good social level.... But [Shen Shou] had very good luck, she had the opportunity to see Empress Cixi and visit Japan and won awards at international exhibitions."[16] Shen Shou showed the way to creative development in embroidery: realism, a syncretistic practice that retained the essential characteristics of traditional embroidery, an international consciousness, teaching, learning from painting (both Western and Chinese), and keeping written records. The ideas and methods introduced by Shen Shou are part of contemporary practice at SERI.

### Yang Shouyu and Random Stitch Embroidery

Yang Shouyu's (1896–1981) cultural horizons were also substantially wider than those of most embroiderers. Her family was wealthy, and she had learned to paint and wrote poems and calligraphy, unusual accomplishments for a woman at that time. She was "unlucky" in that her engineer husband died not long after they married, and she never remarried. By the standards of Republican period China, Yang's position as a educated widow made her perfectly suited for teaching, and she taught embroidery, first at Danyang Training School for Women and then at the National Arts Academy (when it was in Chongqing during World War II), before helping to found SERI in 1954. The school at Danyang was an arts school for women, and Yang Shouyu taught not only embroidery but painting, under the painter Li Fengzi, who encouraged her creative research.

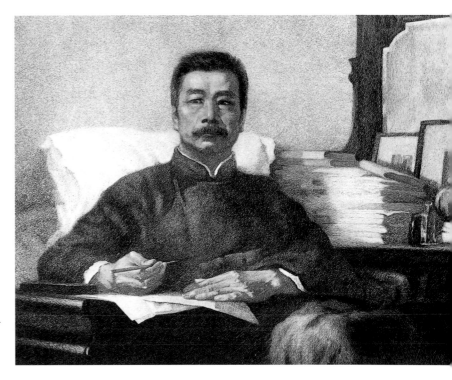

Yang was independent, well educated, vivacious, and above all creative. As Zhang Meifang noted: "Yang Shouyu was the sort of person who cared very much about her reputation (*jie shen zi ai*), who refused to be contaminated by evil influence and preserved her purity ... the kind of person who cares about her own character and also respects the character of others and never does bad things."[17] Yang Shouyu's upright behavior matched the ideal among women of her class, but the society to which that class belonged was rapidly disappearing. The best minds, especially intellectual youth, were intimately involved in the struggle to create a new China.

In the 1920s and 1930s China was in the grips of an intellectual revolution exemplified by patriotic progressivism. The leading light of this movement was Lu Xun (Lu Hsun; see fig. 16), certainly China's most brilliant writer of this century. His advocacy of the use of vernacular Chinese in writing was decisive in the adoption of that reform. "The ancient language is dead, and the vernacular is the bridge to reform: humankind is still progressing. Even writing can hardly have rules that will never be altered" (Lu Xun 1957 [1926], 2: 248). It was the mood of the times: if writing could be reformed, why not embroidery? Lu Xun was also a dedicated advocate of equality for women. In one of his essays he observed that women were even lower than slaves, for even a slave had a wife who had to obey him. The liberation of women held an important place in progressive politics in China. Yang Shouyu grew up in this social and political atmosphere, an intellectual woman of the privileged class. Her own act of self-liberation was her creation of random stitch embroidery (*luanzhen xiu*).

As Zhang Meifang writes in this volume, Yang Shouyu developed random stitch embroidery partly out of frustration with the tedium and discipline of traditional embroidery. She told Zhang Meifang, "Doing

traditional embroidery demanded too much patience." Her own personality was not easily governed, and she looked for a way to express more in her embroidery. "She thought that the lines and the threads in traditional embroidery technique were very plain.... With ... random stitch embroidery she thought she could do embroidery work more quickly and apply colors in layers, as in paintings.... From this we can see she was a very smart person who gave us an invaluable asset."[18]

Random stitch embroidery is a major contribution to embroidery, a radical advance in technique and, as we will see, in conception. All of Robert Glenn Ketchum's pieces are embroidered in this technique, as are *Spectacular Spring* (1997; cat. no. 14) and parts of *Splashed Ink Lotus* (1993; cat. no. 9). This technique allows Suzhou embroiderers to depict scenes, objects, and people naturalistically. "In random stitch embroidery the lines of thread cross one another and are added layer by layer, gradually, from very thin to very dense.... Like Western oil painting, [random stitch embroidery] has the ability to emphasize the contrast between light and dark and between different colors. It's suitable for interpretation of photos, oil paintings, and landscapes."[19]

In random stitch embroidery, individual stitches vary in length, direction, color, and thread weight. These variations are anything but random, but compared with the close, parallel stitches of traditional embroidery, they appear chaotic (the literal translation of *luan*), and Yang Shouyu was undoubtedly criticized by more traditional embroiderers for her technique. Nevertheless, random stitch embroidery should be recognized as part of a continuum of developments in traditional embroidery styles, especially that of Suzhou embroidery, a creative outgrowth of earlier developments.

Yang Shouyu mastered the technique of layering thread, introduced by Shen Shou, and developed it further by creating a style of needlework in which the stitches went in different directions and were of different lengths and in which threads of different weights were used. As the embroiderer builds up threads from coarse and dark to thin and light, she can create the impression of volume just as an artist does in a sketch—by building darker colors in the shadows, which graduate to lighter colors in the highlights. Embroiderers can also manipulate the way the threads reflect light to create a more complex visual impression than a photograph or a painting can offer. Not only the coarseness of the threads but also their color and layering affect the quality of their reflection. Random stitch embroidery makes it possible for an embroiderer to work in the idiom of oil painting or even photography and to achieve dimensional effects that cannot be attained in those media.

Random stitch embroidery borrows from the representational traditions of Western art, especially the use of chiaroscuro, or the interplay of light and shade, to model form. Traditional Chinese painting is essentially linear; the depiction of volume is secondary to the delineation of shape and texture. The effect is very clear in traditional embroidery, in which different stitches are used to convey shape and texture. For instance, in *Loofah Gourd Flower* (1994; cat. no. 10) the directions of the stitches reinforce the viewer's sense of the shape of the leaves and flowers.

44

In *Fluttering* (1985; cat. no. 1) the embroiderer was more concerned with capturing the texture of the peacock's tail than with creating a space for it to occupy. In the Ketchum piece *October 24, 1983/2:10 p.m.* (1991; cat. no. 22), however, the way the embroiderer uses shading and contrast to create a sense of space and depth would not be possible with traditional embroidery or, in fact, traditional Chinese painting techniques. At the same time, the textural effects in the photograph are expressed even more strongly in the embroidery. *October 24, 1983/2:10 p.m.* is a sophisticated breakthrough in embroidery, expanding the possibilities of random stitch embroidery to improve upon photographic realism.

Yang Shouyu's understanding of the principles of sketching and oil painting were essential to her creation of random stitch embroidery. But random stitch embroidery is more than just a technique; it is a creative process. As Zhang Meifang explained, "The characteristic of random stitch embroidery is that you have freedom of creation."[20] Random stitch embroidery frees the experienced embroiderer from the most restrictive parts of the practice. Unlike traditional embroidery, in which areas are slowly filled in with stitches, random stitch embroidery requires a creative decision each time the needle passes through the fabric. Another time Zhang Meifang told me: "Random stitch embroidery... is very flexible; there are no defined or recurring objects or areas.... We work with different needlework according to each different character or object. There are some traditional components, but they must meet the need of expressing the object's own character. Even or parallel arrangement is not necessary; arrangement is determined by the content or topic of the embroidery work."[21] Despite its freedom, random stitch embroidery requires discipline and experience for success. Embroiderers practice for years before they can work well in the technique; it engages every aspect of their ability and affords them maximum range for their talent. Consequently, the embroiderers look upon random stitch embroidery as more of a process than a technique.

Because Zhang Meifang specialized in random stitch embroidery, she had an opportunity to interview Yang Shouyu.

> I visited her several times when I was very young and she was over eighty. I asked some questions, and I took a small notebook and wrote something in it. Yang Shouyu asked me, "Why did you ask this kind of question?" and also told me, "Don't write it down, don't write it down." So afterward I made my record under the table.... She was very modest and diligent. That day when I visited her, in the morning I saw a small painting of a small boat on the seashore on the wall. I asked her, "Do you still do paintings?" And she said, "It's not good, it's not good." When I visited her in the afternoon, I found the painting had been taken down.... She was so industrious and diligent; she kept the habit of making Chinese paintings and writing calligraphy into her eighties.... When she practiced calligraphy, she never did it on paper, but on bricks. She just used water, but no ink. Water dries easily, and she could write a character again and again. She said that people could be served in this way. She was a very good person, and there are many of these kinds of stories.[22]

Perhaps the best testimonial to Yang Shouyu's contribution is Zhang Meifang's:

> I was touched by her; I think she was so great. She was self-confi-
> dent and respected herself. We have [Yang Shouyu's] students in
> our institute, and they brought her principles to our unit, and we
> kept them. She was very strict with herself and had a significant
> career goal. She never demanded something from the govern-
> ment. I think that our country should have taken better care of
> her since she made such a big contribution to the development of
> embroidery, but she never asked for that. The most impressive
> thing she showed me was her creative idea or creative spirit. She
> was not satisfied or limited to what was traditional or usual.... We
> need to have people who are very smart or bright in order to have
> creativity and variation.[23]

### Suzhou and the Tradition of Suzhou Embroidery

Suzhou is one of the most famous of China's beautiful locales, a city often noted for its houses and small bridges over flowing waters, pavilions, platforms, and storied buildings. One of the best-known proverbs in China is, "Up in the sky there is a heaven, down below there are Suzhou and Hangzhou." Founded as early as 508 B.C.E., Suzhou was a walled city run through with innumerable small canals. After 610 C.E. the construction of the Grand Canal linked Suzhou with north China and led to its growth as an important transportation center for rice and later, beginning with the Song dynasty in the eleventh century, as a center for the production and consumption of luxury items, especially silk.

Suzhou's history revolves around the wealthy and cultured families who made the city their home, especially after the flight of the Song court from north China to Hangzhou in 1127 C.E. Patrons of the arts, literature, and religion, Suzhou's families brought a refinement and sophistication to their lives that made them the envy of China. Among the favorite projects of this elite were Suzhou's many gardens, two of which today rank among the five most famous in China (Clunas 1996). While Suzhou's walls are for the most part gone, its canals, gardens, ancient buildings, and remaining city gates give it a charm few other Chinese cities can claim. The city is equally noted for its artists. Many of China's best-known painters are from the region around Suzhou, including virtually all of the famous women painters, such as Wen Shu. Today the gardens and canals of Suzhou draw tourists from all over the world to what is now a medium-sized but still elegant city on the banks of the Grand Canal.

The contemporary writer Lu Wenfu specializes in stories about the common people of his native Suzhou. "Tang Qiaodi" (1986) takes its title from the name of an illiterate city woman who works in a silk mill. The name is common among lower-class women born before Liberation and reflects the low social position of women. As Lu Wenfu explains, Qiaodi sounds like "clever little brother" and conveys his character's family's wish that she had been male. Her work in the silk mill allows her to earn a bit of cash, and Liberation improves her life considerably. Lu Wenfu writes of how proud mill workers were when they dressed up in

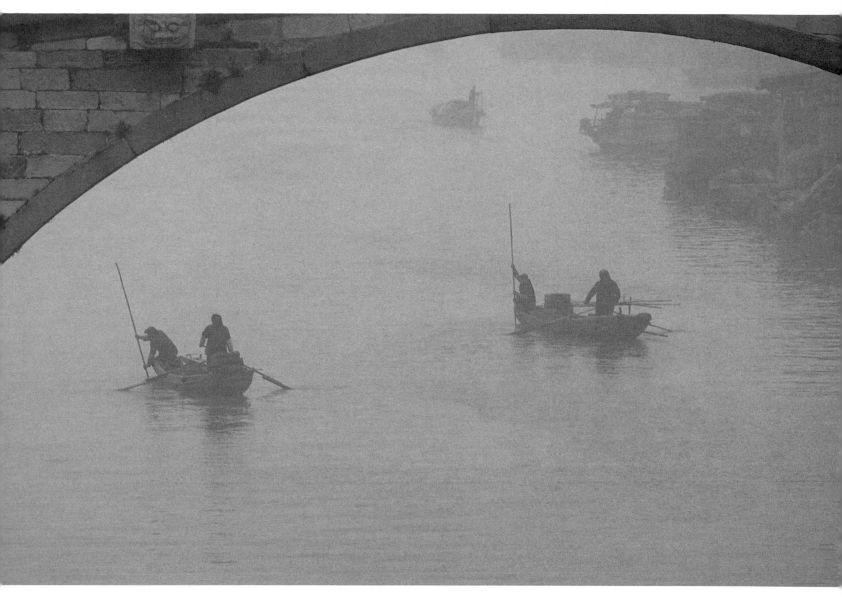

FIGURE 17
View under a bridge. Photograph by
Robert Glenn Ketchum, Suzhou, 1987.

FIGURE 18
A woman tends the small garden outside
her home next to one of Suzhou's canals.
Photograph by Robert Glenn Ketchum,
Suzhou, 1987.

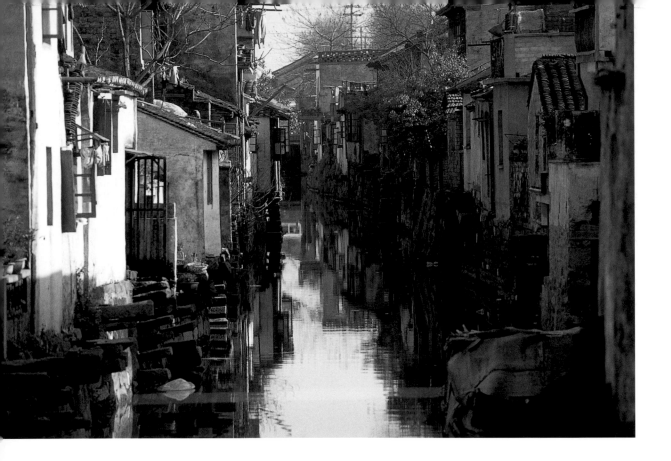

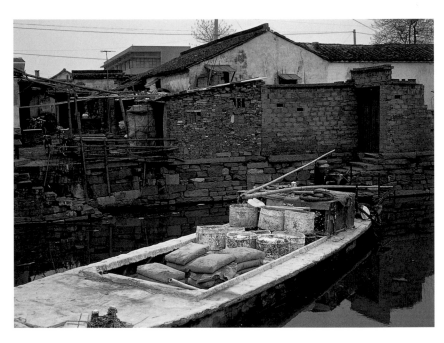

FIGURE 19
The whitewashed walls and black tile roofs typical of houses in the Suzhou area. Photograph by Robert Glenn Ketchum, Suzhou, 1987.

FIGURE 20
A boat carrying building materials, one of the thousands that travel Suzhou's canals and have made the city an important commercial center for more than fifteen hundred years. Photograph by Robert Glenn Ketchum, Suzhou, 1987.

the clothes they bought with their wages, finery most girls of their class could only dream of. But political movements prevent Tang Qiaodi from having the time to learn to read and write: "While the Kuomintang had been famous for too many taxes, the Communist party had too many meetings" (Lu 1986, 48). But this "fault" of illiteracy also saves her from the political persecution that causes the narrator much suffering: "Now I knew the advantage of no education—without education you cannot have any underlying motives, you certainly cannot stress the importance of your own job, nor would you want independence from the party — nothing can happen to you!" It is true that the Great Leap Forward (1958) and the Cultural Revolution (1966–1976) affected many activists like the narrator profoundly, and in the story he is twice sent to the countryside for reeducation.

Because she is illiterate, however, Tang Qiaodi remains untouched and continues working in the mill. The story ends with the now-rehabilitated narrator teaching Tang Qiaodi's daughter to read and write, while Tang Qiaodi's other children ignore their mother and devote their time to "disco" and mah-jongg. This story, written in the period after Deng Xiaoping's reform and opening up, is a good introduction to the "little people" of Suzhou and to the enormous changes that have taken place in the lifetimes of even middle-aged people.

FIGURE 21

**THE YUNAN TEMPLE ON TIGER HILL IN SUZHOU,** double-sided embroidery by the Suzhou Embroidery Research Institute. Works like this show the pride institute embroiderers take in their city and its history. Photograph courtesy Suzhou Embroidery Research Institute.

The Fowler research team was in Suzhou just before the Spring Festival (Chinese New Year) in 1998. Everywhere you could see the preparations for the family get-togethers and feasting that are typical of the holiday. Firecrackers echoed through the streets, and from my hotel window I saw five men carrying fish so big, one in each hand, that they had to crook their arms to keep the tails from dragging on the ground. Shen Guoqing told me that when she was young Spring Festival was the biggest meal of the year and every family would have the biggest fish they could get *and* a ham on the table. Nowadays, however, people often make reservations at a restaurant for Spring Festival. This change reflects the rising standard of living over the last twenty years. We had the conversation at an excellent small restaurant, and when I asked her what her family had eaten at ordinary meals during those years, she pointed to each of the simple vegetable dishes among those on our table.

Suzhou people do not seem to travel very much. Many of the people I spoke to said they had been to only one or two other places; Suzhou is felt to be so fine that there is no reason to go elsewhere. Streets are crisscrossed by little canals lined with whitewashed houses. On a day following a week of rains, laundry was hung out on any available stick to dry. Pagodas punctuate the horizon—North Temple Pagoda, Auspicious Light Pagoda, Twin Pagodas—but increasingly they have to compete with high-rise hotels and office buildings. Many of the older, picturesque houses are being demolished to make way for modern apartment buildings    not as photogenic but much preferred for conveniences like running water, toilets, and especially space by the people who have to live in them. In the commercial districts it seems like silk and fabrics are for sale everywhere, and where they aren't for sale, milling machine parts stores line the sidewalks with their spools, bobbins, and shuttles. The street leading to SERI was being widened when we were there; currently two buses passing stop traffic cold. There seemed to be a large number of musical instrument shops on the street, and they all offered costumes and drums to rent for Spring Festival spectacles. The street was crowded and lively, but the turn into the institute's driveway was a turn into another world.

## FIGURE 22

The traditional garden in the rear of the SERI compound, with its large Tai Lake Stone and crooked walkways. Photograph by Robert Glenn Ketchum, Suzhou Embroidery Research Institute, 1986.

## An Atmosphere of Collaborative Creation

Just through the gateway that leads to the Suzhou Embroidery Research Institute lies a little island of trees and bushes that were still leafy in January. Often there would be a bus that had brought foreign visitors to tour the workrooms and perhaps buy a few pieces. Sometimes there would be Toyotas and Volkswagen Santanas, which would mean that a delegation was visiting. We would walk back to the institute's lovely reception rooms and begin our work for the day. The institute is set in an old garden, which still has the large Tai Lake Stone as its centerpiece (see figs. 22–25). Arcades and windows ring the garden, and children play in it in the afternoons, but during the winter it is mostly bare. Shen Guoqing pointed out a tree and told me that in the fall it turns a brilliant red, which reminded her of the red in *Sumac along the Chattahoochee* (cat. no. 20). Squirrels and magpies nest in the trees in the winter's golden light.

When I left the reception rooms to walk back to the workrooms, I always worried that I was going to get lost among the courtyards and arcaded walkways. To get to the workrooms, we'd cross several courtyards, climb a flight of stairs, and then either continue straight ahead to the workroom where visitors were usually taken or cut back to the one where the Ketchum pieces were being embroidered. To enter, you'd push aside a heavy leather blanket used to keep the cold out and then push through swinging double doors marked "No Visitors" in English and Chinese.

The workrooms are beautiful. Like many artists' studios I've been to in China, they have very high ceilings (about twelve feet) and windows that run from waist height up to the ceiling. The light was indescribable; brilliant and warm, it was colorless and yet met and freed the colors on the embroiderers' frames and thread caddies. It made you smile just to walk through those doors. The workrooms were quiet, with conversations carried on among the embroiderers at their frames, sometimes rising in volume and often leavened by laughs, giggles, and exclamations. During my visits the atmosphere in the workshops always seemed exceptionally pleasant. Embroiderers walked from frame to frame, made and asked for comments, and spoke to us readily. There was the unmistakable atmosphere of collaborative creation.

As I have noted, embroiderers have worked with painters since at least the Song dynasty, when collaboration with court painters led to advances in the vocabulary of embroidery. One of Yang Shouyu's most basic principles was that embroiderers should learn to paint so that they could better understand color and form. Her close professional association

FIGURE 23
The patterned pebble walkways of the garden, a Suzhou specialty. Photograph by Robert Glenn Ketchum, Suzhou Embroidery Research Institute, 1986.

FIGURE 24
Another view of the garden, showing the arcade with its variety of latticed windows. Photograph by Robert Glenn Ketchum, Suzhou Embroidery Research Institute, 1986.

with the painter Li Fengzi strengthened her own artistic abilities and assisted in her creative growth. The symbiosis between embroidery and painting has continued up to the present day, and as society has changed, so has the relationship between the two media.

SERI has organized many collaborative projects involving exchanges between painters and embroiderers. Its own design staff is made up of professionally trained painters, who provide many of the designs for institute embroideries. Although the embroiderers have the skill to create pieces based on almost any image, they have more room for expression if the image lends itself to embroidery. Painters who have seen their designs translated into embroidery are more likely to produce compelling images for embroidery than those who have not. Painters from outside the institute have been invited to work with the embroiderers from as early as the 1960s, when Cao Kezha's paintings of cats were the basis for many successful embroideries. His "worn-out brush" (*pobi*) style rendered cat fur especially well. Collaborations continued through the 1960s and 1970s; one of the institute's catalogs shows some of the works that were done as part of an exchange with a group from North Korea during that period.

Since the reform and opening up in the late 1970s, collaborations and international exchanges have increased. Curiosity about the world outside China has been especially strong among artists, and exposure to abstract and impressionist works in particular has challenged and fascinated them. While some artists have tried to imitate Western styles, most have adopted a more thoughtful approach and, as in the case of the institute, adopted what they felt useful while reserving judgment on other styles. This has been especially true of abstraction, which has exerted only a moderate and tangential influence on Chinese art. There has, however, been a rapid evolution of traditional Chinese genres. For example, "flower and bird painting" has an enormously long history, reaching back at least to the beginnings of a recognizable China, with deeper folk roots than perhaps any other style of painting. *Spring Returns to the Great Earth* (cat. no. 2), with its freehand (*xieyi*) brushwork, is a good example: the expressiveness, color, simplicity, composition, and, above all, freshness of the best flower and bird paintings are actually heightened in this extraordinary embroidery. Many other pieces in the exhibition belong to this tradition, which is unified as much by an approach to nature as by a particular style. The only other tradition in Chinese visual art that can compare to flower and bird painting is landscape painting. It too is based on nature, but unlike flower and bird painting, landscape painting has always been an art of the upper classes, appreciated as an expression of the loftiest thought in symbolic terms. A consciousness of these traditions of Chinese painting lies behind all of the institute's work on Ketchum's photographs.

There are three pieces in the exhibition that can be categorized as flower and bird paintings but that also explore the artistic freedom of the 1980s and 1990s in the language of embroidery: *Silver Star Crabapple* (1995; cat. no. 13) and *Ball Cactus* (1995; cat. no. 12), which are based on paintings by Chang Shana, and *Splashed Ink Lotus*, based on a work by Yuan Yunfu. As Zhang Meifang noted, these painters "work for the Central

FIGURE 25
The institute's garden. Photograph by
Jo Q. Hill, Suzhou Embroidery Research
Institute, 1997.

Institute of Crafts and Fine Arts in Beijing and know something about Chinese art and handicrafts, so their paintings are suitable for making embroideries.... Since they are fairly famous modern Chinese painters, ... they know something about the developments and styles in international art. They are aware of a lot of new things." [24] These two artists represent the new creativity in Chinese art. While in subject matter their paintings can be understood as flower and bird paintings, the spiky cactus, wildly colored crabapple leaves, and inky black of the lotus pond, which contrasts with the finely embroidered lotus blossom, all challenge canonical expectations for this genre. Zhang Meifang explained: "Chang Shana's painting is much more natural, much more like the real thing, and this appeals to modern tastes."

Both of the artists came to the institute and lectured on their style and artistic ideas so that the embroiderers would better understand how to treat their works. In another institute collaborative project, Zhang Meifang invited an artist who had spent years studying cranes in the wild to come and lecture on his observations and painting style. In each of these cases, the visiting artists learned how to paint in styles appropriate for embroidery, and the embroiderers learned about the artists' concerns and methods. These kinds of exchanges are very important to Zhang Meifang and the institute and constitute a fundamental aspect of their creative practice.

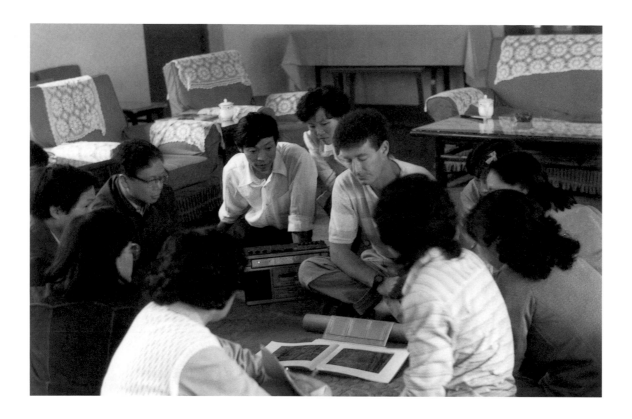

FIGURE 26
Ketchum gives a presentation on Western
art to SERI workers on one of his earliest
visits. Dr. He Shanan listens at left (in blue
coat). Photograph courtesy Suzhou
Embroidery Research Institute.

Robert Ketchum's first visit to SERI was in 1986, a time when curiosity about Western painting vastly outstripped the information available. Some prints and books on modern Western art were available, but a combination of China's low economic level and poor distribution left an enormous gap between interest and actual knowledge. When Ketchum came to the institute, he explained Western aesthetics to the embroiderers, filling in the theory behind the images they had seen (see fig. 26). He recalled giving a talk on Claude Monet, which greatly interested Zhang Meifang. In January of 1998 she showed me an embroidery based on a Monet, which was startling for the lack of anything but diffuse, nonobjective color through almost two-thirds of the image — this in embroidery. In 1986 so daring a work was not yet possible, but Ketchum's yearly visits became the occasions for deeper and deeper forays into Western aesthetics. Zhang Meifang told me: "The features of Western oil painting are its focus on color and motion and the use of light and colors. Oil painting can grasp the instinctual happening in nature."

In Ketchum's essay in this volume he writes of the concerns he addressed in discussions with Zhang Meifang and the embroiderers about his own works. As the Chinese grew more accustomed to the themes and aims of his work, the American learned the embroiderers' visual vocabulary and, more importantly, their grammar. One of the most basic aspects of photography is editing, and Ketchum was able to suggest increasingly appropriate works for embroidery as he learned more about the art and about China. For their part, Zhang Meifang and the embroiderers learned to see photographs more critically. The institute had carried on these types of exchanges for many years, and Ketchum was used to collaborative projects from his own experiences in photographic printmaking, publishing, and exhibitions. Each side had participated in sophisticated artistic exchanges, and this provided a basis for their collaboration.

### Talent, Theory, and Skill: The Practice of Embroidery

Many of the thoughts Zhang Meifang shared with me reflected on the training and artistic growth of the institute's embroiderers. At SERI embroiderers receive their artistic education under the direction of institute leaders. The curriculum has changed over the years but is still practically oriented. During the 1960s and 1970s education was pitched to inculcation of the highest-level embroidery skills. Today the theory of embroidery is taught as well, so that embroiderers can make the creative decisions that will help them attain individuality in their art. One could say that education at the institute is never really complete since there is an emphasis on continued growth and transmission of knowledge from one generation to the next.

In order to work at the institute, women take a rigorous examination, which tests not only their skill at needlework but also their general academic and artistic ability. The tests are administered only when the institute needs workers. Zhang Meifang came to the institute after passing one of the first tests in 1964 and was unusual among the students admitted that year in that she had finished high school. Nowadays prospective students are required to have twelve years of education before they can take the test, which includes sketching and writing a short essay as well as making a small embroidery. The institute's use of its own application process and its ability to recruit students outside normal channels reflects its special administrative position. Most Chinese are still assigned to work

FIGURE 27

The Random Stitch Embroidery Research Studio at SERI. The workroom leader, Huang Chunya, sits at the front right of the picture with her back to the camera. Photograph by Patrick Dowdey, Suzhou Embroidery Research Institute, 1998.

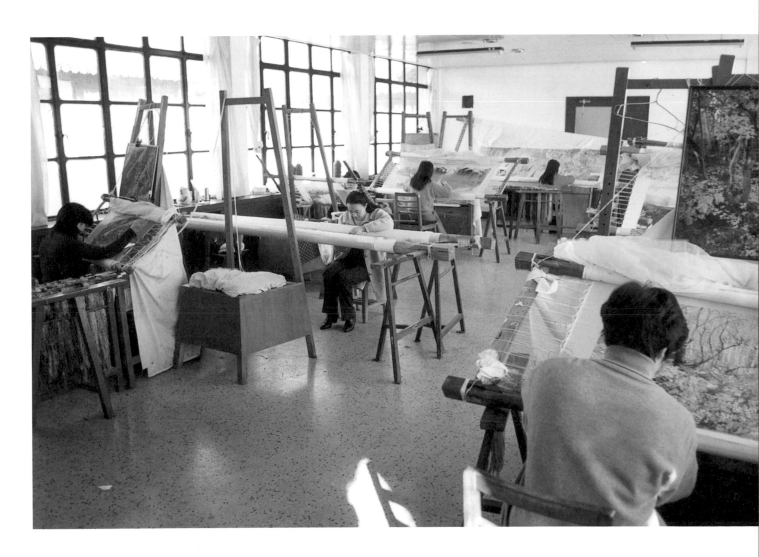

units by the government after graduation from either high school or college, although there are now alternatives to this system. The higher educational level of today's students makes the theoretical training that Zhang Meifang has introduced possible.

Fundamental training is two-pronged: first, the students are taught embroidery and especially what the leaders call the theory of embroidery. They have to know the name of approximately forty stitches and the effect of each one, as well as how to do it. As Shen Guoqing explained: "In this way they will know a specific stitching technique on a theoretical level so they can draw inferences from other cases (*ju yi fan san*) [and] learn by analogy. It has broadened their thinking."[25] Stitches are learned at the rate of one every two weeks. Second, the new workers are also given classes in painting—oils, Chinese painting, watercolors, and sketching from life. These classes also include visits to museum exhibitions and lectures by visiting artists.

The students' progress is closely watched to gauge their special abilities or any proclivity for certain types of work. According to Shen Guoqing: "Since the topics and the field are so broad, after a few years' work we can see what kinds of things [a student] is good at, doing embroidery or expression, and then she will focus on those things."[26] Huang Chunya, who is now the head embroiderer in the workshop where most of Ketchum's pieces were made, was sent to the Nanjing Academy of Fine Arts, where she earned a degree in oil painting. Other students specialize in cats, flower and bird painting, or random stitch embroidery. The best workers continue in embroidery, while others move on to other areas, such as dyeing or office work. Zhang Meifang told me: "The levels of the different embroiderers form a pyramid. For instance, among ten only

FIGURE 28

The embroider Zhao Liya works on one of Ketchum's pieces. Her right hand waits to take the needle she is about to push through the almost transparent base fabric with her left. Photograph by Patrick Dowdey, Suzhou Embroidery Research Institute, 1998.

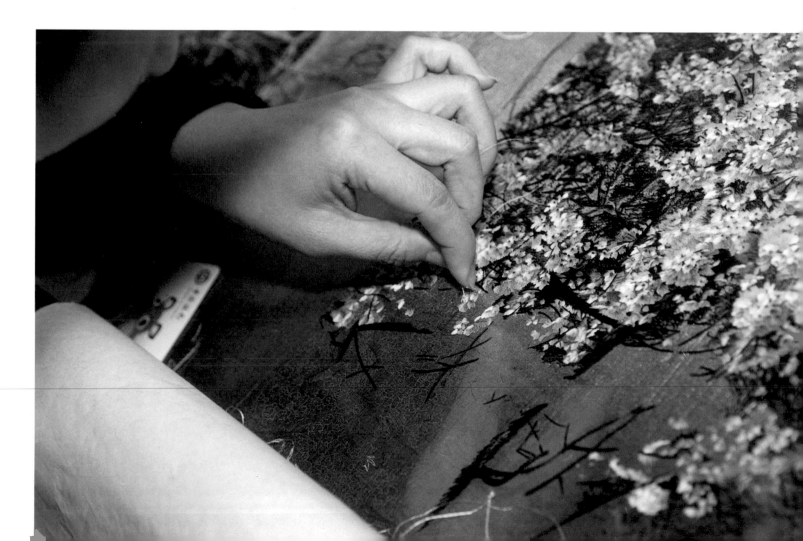

three to five are excellent embroiderers, and they are much better than the others."[27] Almost everyone at the institute, even workers in the office and the gift shop, has had some experience with embroidery.

The education of a talented embroiderer takes a long time: "To be a good embroiderer, three to five years is not enough. It takes at least eight to ten years.... In three to five years you can learn something on the surface, like the skin of an animal. After that three to five years, development really depends on the talent of the person."[28] Zhang Meifang's point is that embroiderers today have skills that extend beyond technique and add an important creative dimension to the artist's work. After the first period of education, embroiderers begin to develop their individual style and approach.[29] "If you don't have any idea what embroidery is ... you can't try something new, you cannot think of anything that's creative."[30] It's almost impossible to succeed at creative work in this difficult medium without devoting a lot of time to acquiring basic skills. After this basic education, the embroiderers begin to work on more complicated pieces, but even then they continue to visit exhibitions and to engage in discussions with visiting artists and among themselves. Easy exchanges among the embroiderers are particularly encouraged, and new students learn how to participate in group discussions of embroidery. As Shen Guoqing put it, "We try to cultivate their artistic group."[31]

Most of the embroiderers who worked on the Ketchum pieces were in their late twenties or early thirties. They were all married, all had children, and all had been at SERI for more than ten years. The Fowler Museum researchers saw no older embroiderers at work, probably because they are given their privacy. We were told that older embroiderers are recognized for their contributions, many of them by the state, and work on development of new techniques and solutions to embroidery problems. Older embroiderers work more slowly than the women in their early thirties but have more experience and skill and make important contributions to discussions of the handling of a new design: which colors and stitches to use, how to treat especially difficult passages. Ketchum told me he had seen an older embroiderer who sat with Huang Chunya as she worked, discussing the progress of her piece and making suggestions.

Collegiality is very much in evidence at the institute in every aspect of its work. The embroiderers learn a great deal from one another, first in the formal classes given by the institute, in day-to-day interactions in the workrooms, and finally in the decision-making and design process that precedes a new work. Zhang Meifang noted: "Our group is composed of different kinds of people, and different people should have different ideas. The intelligence of different people is also different, so each creative

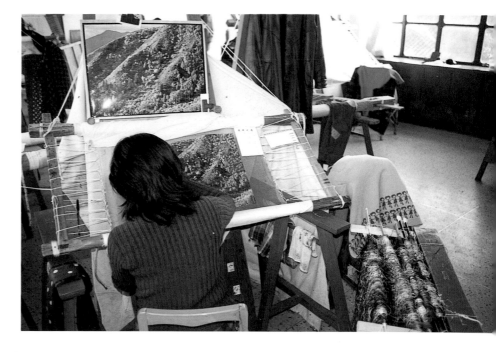

FIGURE 29
Embroiderer Xu Jianhua's work area, showing placement of the embroidery frame on trestles. Photograph by Patrick Dowdey, Suzhou Embroidery Research Institute, 1998.

person definitely has her own special characteristics."[32] Each embroiderer has her own artistic strengths, which the others recognize. Embroiderers often walk over to another artist's frame and make comments on a certain section or on the progress of the piece. Rolling out a new section on one of the large frames requires the help of several people, and everyone pitches in. When the piece is finally set up, all of the embroiderers gather around and discuss its progress.

The selection of new works to be embroidered also depends on comments from many of the embroiderers. Older embroiderers have a strong influence at this stage. The embroiderers discuss the practical aspects of the new project, colors, stitches, its difficulty, and whether it is appropriate for embroidery. As Ketchum makes plain in his essay, these discussions are quite detailed and can take a long time. The institute must be very selective in choosing its projects since a large embroidery can take several embroiderers two or three years to complete. Zhang Meifang feels that every piece the institute produces needs to be excellent and delivered on time. Her emphasis on creative challenge and the skill and creativity of the younger embroiderers cannot overcome all of the doubts raised by

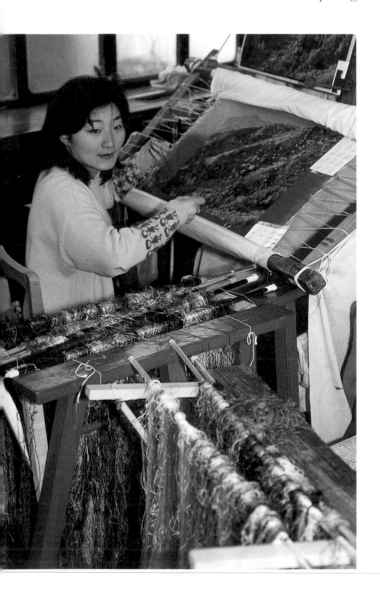

some projects. The selection process becomes a forum for exchange of ideas and experiences and as such represents an arena for continued creative growth at the institute.

Zhang Meifang puts great emphasis on personal and artistic growth. In one of our discussions of aesthetics she told me, "I am not satisfied with my ability to appreciate artistic work."[33] On another occasion she told me that on a recent trip to New York she had spent the entire time visiting galleries to get a better understanding of Western art. "The world of art is so big that most of the arts are beyond our knowledge. Our world is just a microcosm."[34] In her own view Zhang has seen very little of the world and knows little about art. She referred often to her sense of the enormity of the unknown, not just in art but in knowledge generally. She'd say, "Like looking through a hole" (*yi kong zhi jian*), while she squinted through her fingers held in a tight little circle. This intrigues her: "It might have something to do with my own personality. I myself like change; you cannot stick to the same way forever."[35]

New things inspire Zhang Meifang to greater accomplishments, and she believes that development of creative ability springs from meeting challenges and grappling with difficult problems. She conveys this sense of the opportunity in challenges to the embroiderers. She told me that an embroiderer wept when she was assigned one of Ketchum's pieces, complaining that it was too difficult. Zhang comforted her and told her to try it anyway. When the artist had made a good start, the director praised her accomplishment and asked her if it made her feel good to have overcome the obstacles.

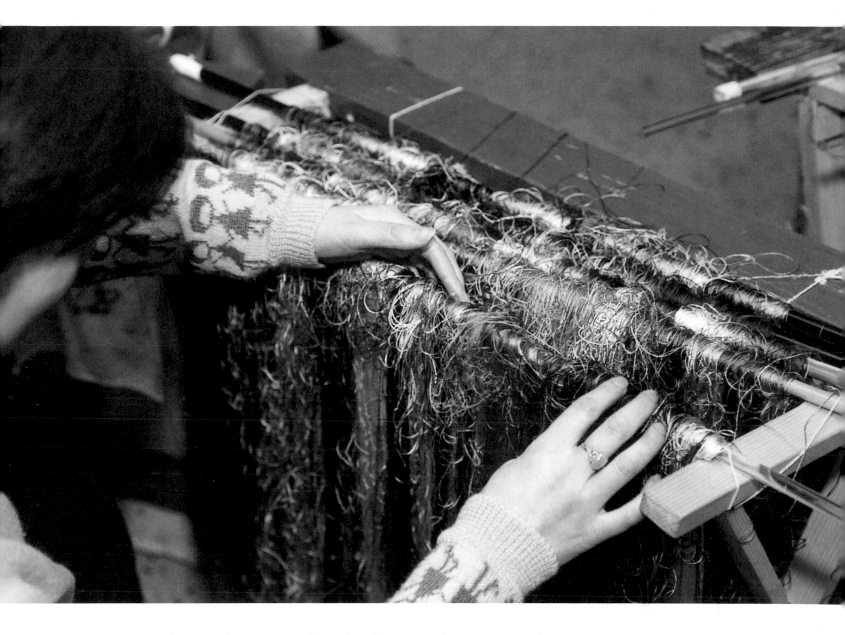

FIGURE 31
Xu Jianhua picks a new strand of floss from
the selection prepared for her by the dye
room for her current piece. Photograph by
Patrick Dowdey, Suzhou Embroidery
Research Institute, 1998.

Zhang Meifang requires the embroiderers to make summaries of
pieces when they complete them so that they will later be able to review
the problems they met and their solutions, and they are also asked to make
a smaller version of each piece either before or after they do the work.[36]
The Institute leaders are very conscious of the value of Shen Shou's dic-
tated reflections on embroidery from the early 1920s. Older embroiderers
have a wealth of experience, which they pass on to younger embroiderers,
but lack a systematic theoretical background that would allow them to
record this accumulated knowledge. The whole process of creative life at
SERI—daily work, decision making, visits to museums, class work, lec-
tures from visiting artists, looking at books together—all of it adds up over
time. The challenges and accomplishments add up. The combination of
theoretical, artistic, and technical education that the younger embroider-
ers have received was designed to allow them to take a greater part in the
development of the embroidery tradition and its transmission to succeed-
ing generations. The institute today is larger, able to handle more sophisti-
cated work, and more confident than it was even five years ago.

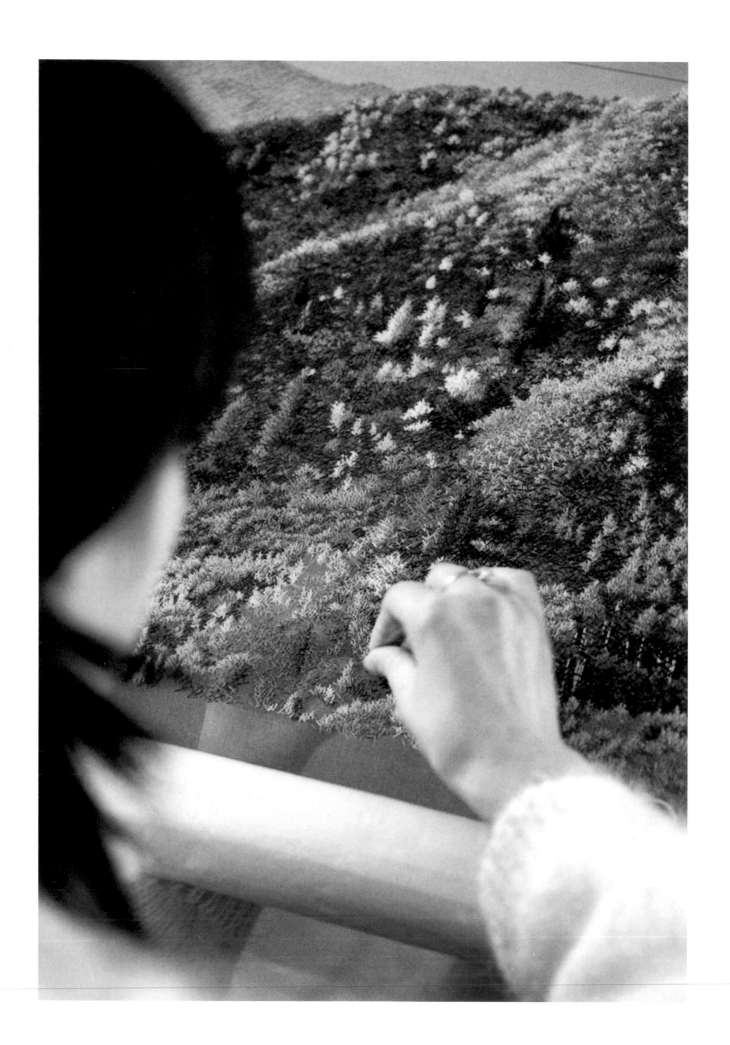

## Climbing Mountains: Challenge and Artistic Growth

When the Fowler research team first arrived in Suzhou, one of our main focuses was embroidery stitches: their names, what they were used for, and how they looked. One evening at dinner Zhang Meifang told us that we should recognize that individual stitches were only one aspect of embroidery and weren't as important as expression and creativity. She said that we should try to understand the process as a whole, rather than focusing on one part: "In process we pursue our goal."[37] What makes embroidery remarkable for Zhang Meifang is the indescribable effect that great pieces have on viewers, the visible manifestation of creative process. "The process of pursuing something is painful—just as it was with Robert's photos. In the beginning we weren't willing to do them, it was just like climbing a mountain. But when you climb to the top of a mountain, you have a kind of feeling that you've never had before."[38] This unique feeling is what all of the SERI embroiderers strive to attain.

Stitches and needlework are the bases of the process of embroidery, and because they are named and categorized, they have become the focus of connoisseurship. But what makes an embroidery successful is something harder to name, harder to categorize. What is expressed in embroideries like *One Hundred Butterflies* or *The Beginning of Time* (cat. nos. 4, 26) transcends stitchwork. "Artworks should have a spirit inside—that is, something living inside—so that's why we have to continue to explore."[39] What makes a work of art expressive, communicative, and evocative arises from the exploratory character of its creation. This is just as true for an embroidery as it is for a painting or, for that matter, a photograph. Creation is a process of discovery.

The conservative nature of traditional embroidery left only a narrow scope for creative exploration. Shen Shou and Yang Shouyu enjoyed a broad social experience and opportunities for travel, which helped them discover new possibilities for embroidery. Random stitch embroidery epitomized these; it allowed for greater freedom of technique and heightened expression, showing the way to embroidery's modernization. Like earlier advances, it was derived from painting, in this case, Western oil painting. Technical advancement was accompanied by a theoretical development that privileged realism and increased creativity. The balance between tradition and creativity began to shift with the work of these two embroiderers. Changes after Liberation led to a social environment in which these new developments could be explored methodically. Since the beginning of the reform and opening up in the late 1970s, social and economic improvements have allowed many artists to enjoy the freedom to pursue the creative explorations that only the most privileged could before.

While the process of embroidery is opening up, the past is not being abandoned. As Zhang Meifang remarked: "We cannot give up our traditional habits or traditional advantages, [but] we shouldn't simply copy what we did before; we need to create new things.... But when we do that, we really feel the difficulties because it is difficult for embroidery artists who are used to the usual way of doing things to easily change styles.... In order to change our style, we have to learn a lot of new things."[40]

FIGURE 32
Xu Jianhua at work on a piece based on Ketchum's photograph **THE COAT OF MANY COLORS** (fig. 42). The dimensionality lent by the layering of stitches is apparent. Photograph by Patrick Dowdey, Suzhou Embroidery Research Institute, 1998.

Although the shift to a more creative way of working is not easy, meeting challenges helps the artists grow. "We do this according to our own artistic taste and our own artistic need.... In past times the best works were the ones in which each stitch seemed the most even or smooth, but now that seems rigid and stiff. Now when we work, stitches are sometimes very big and sometimes very small. It looks irregular, but the artistic enjoyment and artistic effect are totally different."[41] What SERI has accomplished is to move Chinese embroidery into the modern world, to reinterpret embroidery's own traditions to make them speak to modern people, to today's society. As Zhang Meifang says: "I think the most important thing for me and also for the institute is to combine creation and tradition. You should walk using two legs."[42]

This sort of work is produced out of a sense of exploration but also with a knowledge that today's audiences will understand it. The success of any art depends on the greater society beyond the art world. In the twenty years since the beginning of Deng Xiaoping's reforms, Chinese society has opened up enormously. New social conditions have created new audiences, new tastes, and thus new possibilities for artists. "Because we consider embroidery as a kind of culture, it should have a close relationship with the development of society."[43] Educational levels have risen, and perspectives have broadened, thanks to an increased knowledge of the world at large. These social changes have created opportunities as well as pitfalls for artists. Opportunities include the acceptability of many styles and ideas and the opening of an international market for art. The pitfalls lie on either side of the road—too much outside influence, and nothing unique remains; too little, and you are left to practice an antique art as it slowly withers away.

Too close an embrace of tradition has been one of the big problems for embroidery, and, surprisingly, it has been reinforced by the foreign market. In the 1950s the anthropologist Jacques Maquet (1961) noted the tendency of Westerners to think of the antique as more authentic than the modern in foreign cultures. This is certainly true of Chinese embroidery, as Zhang Meifang has noted:

> Foreigners have a stereotype of Chinese arts and think that Chinese should always follow tradition. They don't notice the innovations that have happened in Chinese art. I believe that our renewed art will attract more interest and more attention from foreign audiences in the future.... It's my impression that Americans think that ... Chinese art should always be the same ... and they don't think that China should be changing ... but Americans can change every day, can be different from day to day.... Americans ... wanted to appreciate modern art, why can't we Chinese do that?"[44]

The art presented in this exhibition grew out of the new society that arose in China after Deng Xiaoping's reforms, and it represents the mixture of openness to the West and pride in Chinese tradition that is characteristic of this period.

Zhang Meifang told me: "I think that the development of embroidery has a very close relationship to cultural background; it's definitely not just a technique, but a part of culture. It's the result of cultural accumula-

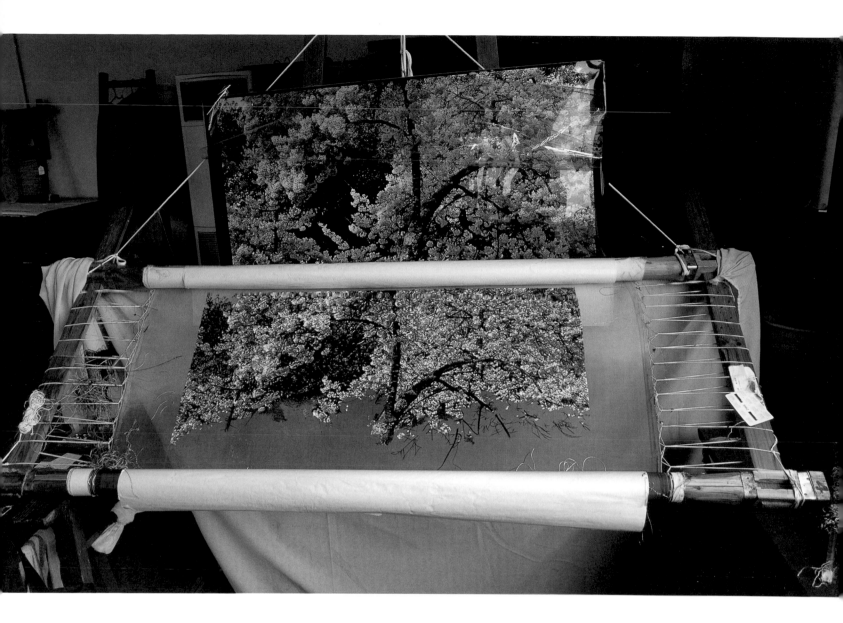

FIGURE 33
Ketchum's **CHERRY TREE BLOSSOMING**
in progress. The master photograph hangs
over the embroidery frame. The piece will
be rolled out a bit in the frame to complete
the bottom section. Note the embroiderer's
notes tucked into the ropes of the frame.
Photograph by Robert Glenn Ketchum,
Suzhou Embroidery Research Institute, 1998.

tion."[45] The institute's collaboration with Robert Glenn Ketchum has produced a body of work that represents the accomplishments of thousands of years but in a language unique to the present, one that can move modern people. Its subject is, in fact, one of the most ancient in Chinese art—our environment, what Chinese call "great nature." Photographic realism is new to Chinese art but not entirely foreign to a realistic tradition that goes back millennia and that emphasizes expression. The selection of photographs to be embroidered was an example of that most photographic of activities, editing, but now colored as much by the eye of a Chinese painter as by that of the photographer.

What the embroiderers have found and expressed in the works of their collaborators, including Ketchum, is an image of nature that catches the feeling the artist had at the moment of conception, at the moment of creation, distilling and intensifying it with the embroiderer's own creative power. And while I think that Ketchum and Zhang Meifang will continue to have to sort things out in long negotiations, they will never again have to ask whether the resulting works will be beautiful.

●

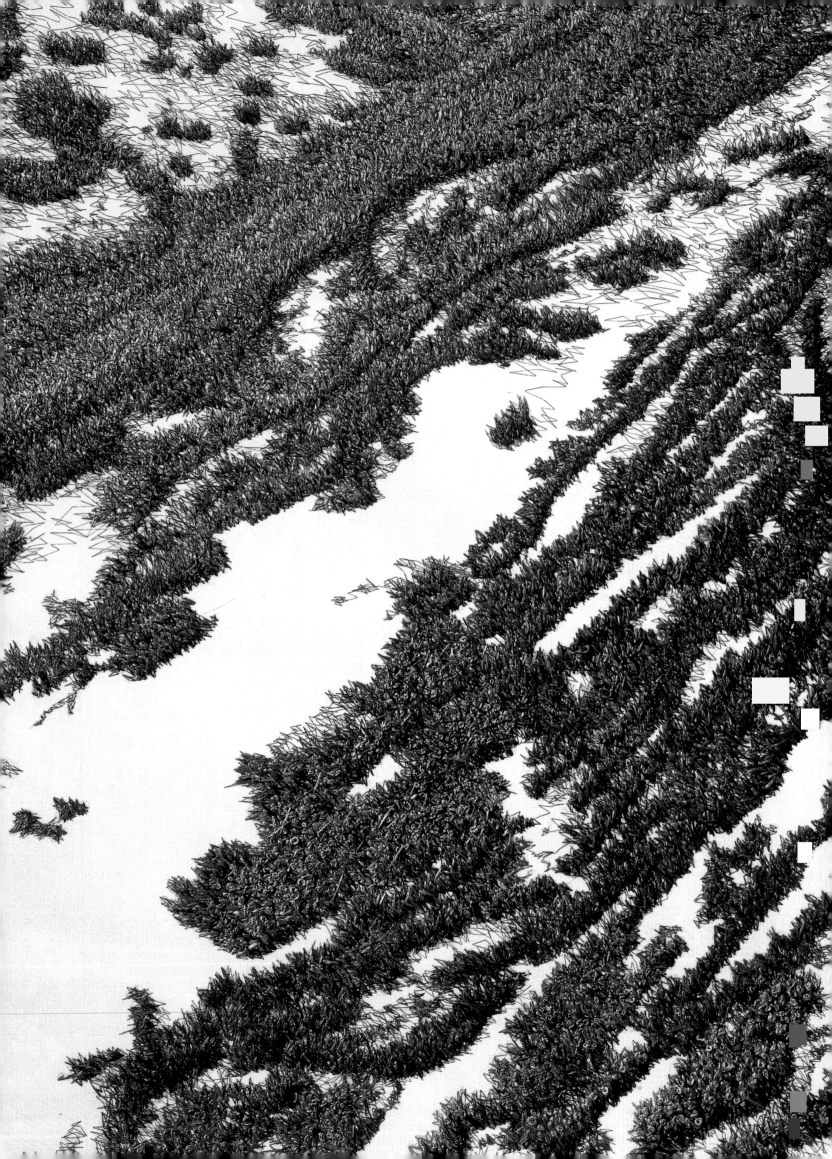

# In Pursuit of Texture

## A Collaboration with the
## Suzhou Embroidery Research Institute

### ROBERT GLENN KETCHUM

For nearly three decades the color photograph and the fine color print have been my most visible forms of expression, but I have also been pursuing other directions. One of those investigations has been the integration of textural surface into my photography. My photographs utilize texture compositionally, often layering one atop another in profusion, and although photographic paper renders my imagery with great fidelity, it does so on a smooth, glossy surface, completely devoid of relief. The large wall tapestries of medieval Europe have always appealed to me because they so successfully addressed my visual interests in representation, scale, and texture. They were also laborious works

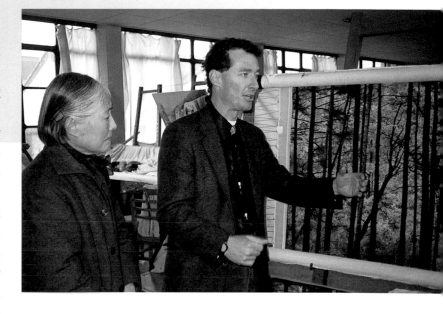

FIGURE 34
Ketchum discusses **OCTOBER 24, 1983/2:10 P.M.** (cat. no. 22) as Ren Huixian, a master embroiderer from the Central Institute of Crafts and Fine Arts in Beijing looks on. Photograph courtesy Suzhou Embroidery Research Institute.

FIGURE 35 (OPPOSITE)
Detail of **FALL DREAM IN THE HIGH DESERT**, cat. no. 28.

that demanded great skill and years of devotion to complete. I found myself increasingly drawn to the idea of translating my complex and highly organic images into a similar textile form.

The sheer intensity of detail that the camera brings to the recording of landscape, however, complicates that task in ways that medieval craftsmen never considered. The right-angled grid of the loom is ill suited to reproducing the curvilinear world recorded in a photograph of nature. To accommodate the limitations of the technology, one must simplify and stylize the imagery, greatly reducing the photographic illusion. My first attempts at textile reproduction were interesting but unsatisfactory because they lacked the detail and color nuance of my prints. The rectilinearity of the loom asserted itself, making many of the smooth, curved edges appear ragged.

Weaving was also far more expensive to pursue than photography, so, frustratingly, I was able to produce only a few small pieces, over what seemed to be an excruciatingly long period of time. Eventually new technologies appeared, and in the late 1970s a crude (by today's standards) digital scanning printer was introduced to the United States by a Japanese manufacturer. This machine had the capability to translate photographic information directly from film to virtually any flexible surface that would receive ink. The material selected to be printed upon was wrapped around a drum, which spun rapidly as airbrushes sprayed minute dot patterns onto its surface. This technology allowed me to work with textured fabrics and to convert imagery to extremely large scale without too much loss of detail,

65

but the downside was that the material upon which the print was made generally had a uniform texture, lacking the variations inherent in my photographic subjects. Moreover, the color nuance and clarity of detail of these digital reproductions did not approach that of my photographic prints.

Serendipity often provides unexpected answers in both life and art, however, opening doors to the unimagined. In the late 1970s a report appeared in the *Journal of the Society for Photographic Education* about photography in modern China. Most of the article dealt with photographers working in fairly traditional directions, but there was one curious and brief remark about the author's having seen Chinese hand embroidery that looked so realistic that it might have been photographically derived. Shortly thereafter the *Los Angeles Times* published a photograph of a political rally in Beijing in which the podium and surrounding architectural elements were decorated by a gigantic banner featuring the face of Mao Zedong. The subtlety of the rendering left no doubt in my mind that it was derived from a photograph. Perhaps most oddly of all, the news story contained a credit line identifying the textile as a silk hand embroidery executed by the Suzhou Embroidery Research Institute (SERI). The precise photographic rendering of the image suggested that this institute might be the resource for which I had been searching.

At the time, China was only beginning to welcome foreign visitors. Travel was often limited to organized tour groups, and individuals with independent itineraries were rarely admitted. Unsure as to how I might approach SERI, I turned to UCLA, which had just initiated one of the premier China exchange programs in the United States. Supportive of my idea, the program welcomed me as its first visual artist. For nearly two years contacts were explored throughout the Chinese bureaucracy, and finally a curious but cautious SERI extended a formal invitation to me to visit and discuss the seminal ideas put forth in my first letters. The process had begun.

The experience of entering China at that particular point in history is another story entirely, but in 1986 I finally arrived at the institute's doorstep or, perhaps more accurately, its moon gate. Once the formalities of introductions were achieved, Zhang Meifang, the institute's director, and Chen Caixian, a vice director, offered up my ideas for general discussion, often in the presence of large groups that included not only master embroiderers but designers as well. Part of the institute's large staff, designers develop new imagery for embroideries, mostly through prolific painting and drawing, and I am sure that my proposed project seemed an intrusion upon their realm. Typically their designs reflect traditional Chinese subject matter, stylized and simplified renderings of natural subjects, but the embroiderers also copied historic Chinese and European paintings.

Our group discussions were lively, with everyone showing interest and participating, but it was clear that there was skepticism about the actual possibility of creating an embroidery from one of my photographs, quite simply because the embroiderers feared that they were too complex. It was also generally felt that, because I knew virtually nothing about embroidery technique, I could not appreciate the amount of time and work necessary to complete an image. I persisted nonetheless in pressing my ideas. I also noted that the embroiderers were especially attracted to work in one of my

earliest black-and-white portfolios, *Winters, 1970–1980* (1981), because they felt that the simplicity of the photographs made them more approachable than my more recent, highly detailed, full-color landscapes.

Although they appreciated the winter images, the embroiderers still expressed doubt that they could justly represent my photographs through stitchery. As they viewed the problem, my images most often depicted complexly layered, three-dimensional subjects, and embroideries were flat, two-dimensional objects that could never render such a subject with enough verisimilitude to be satisfactory. They were also concerned that a viewer would respond to images in a particular way knowing that they were photographs, but that the same information might not translate as an embroidery and the subject would lose its meaning.

This debate consumed the better part of a week but was pleasantly punctuated by side trips to the numerous gardens of Suzhou and to the countryside, greatly increasing my appreciation of the landscapes and forms rendered in traditional Chinese paintings and standing screens. Finally, in the closing hours of the last day of the visit, the institute agreed to attempt an embroidery of one image — not surprisingly, from the *Winters* portfolio. The photograph in question appealed to everyone, but it had clearly been selected because it exemplified some of the very problems we had been discussing with regard to the ability of the embroiderers to translate my photography with any fidelity.

Entitled *Snowfall* (cat. no. 15), the image depicts a single barren tree in front of a line of distant evergreens, all engulfed by a snowstorm. The shutter speed of the camera was such that the falling snowflakes are suspended in the air, and because some of the flakes are quite close to the lens and considerably out of focus, they break up the darker tones of the background trees significantly. The embroiderers loved the image as a photograph but believed that viewers understood it because they knew a camera could suspend the falling motion of the snowflakes and that a lens could cause parts of an image to be out of focus. They argued that, out of the context of the photograph, the knots of white thread used to represent the snowflakes would seem unreadably abstract and fail as a representation of the subject. I was just thankful to have a starting point.

In comparison to our current work, *Snowfall* (cat. no. 16) was relatively simple. Translated into a small, 12-by-18 inch table screen, it demanded minimal detail, displayed a limited palette, and required only a few of the embroiderers' more than forty stitches. Nonetheless, it proved to be a very important, and very beautiful, embroidery. Most SERI embroideries are stitched on a background of pure silk or mixed silk and synthetic fiber, which is sheer and featureless. This support fabric is stretched tightly on a wooden frame, and the image to be embroidered is then traced onto it from the original artwork. For *Snowfall*, however, the embroiderers created a special loom-woven background in which irregularities were incorporated into the weaving to appear as subtle vertical streaks. Later in the embroidery process, when knotted clusters of white thread were applied to represent the snowflakes, the streaked background quite successfully suggested downward motion, furthering the illusion that the "snowflakes" were falling.

In less than six months *Snowfall* was completed. Sewn in SERI's unique double-sided style, the more detailed foreground tree is set against a background of loose random stitching that suggests the distant forest. The hazy effect of viewing the forest through falling snow has been accomplished by the use of single stitches, each subtly hand-dyed in dozens of shades of gray and black. Snowflakes were created using combinations of knotted and looplike stitches, which were untraditionally employed in widely varying sizes and degrees of stitch tightness, leaving some flakes defined by loops so loose that they actually drape from the surface of the embroidery. Most importantly, the image was not unreadable; the design decisions successfully captured the visual essence of the photograph.

The doors were open. Everyone was excited by the small, elegant table screen, and now both the embroiderers and I could see the possibilities of furthering our mutual exploration, so we began to discuss other photographs that might become the basis for embroideries. I wanted to attempt something more complicated and in full color, which would address the unanswered concerns that all of them had as to whether the intricate detail of my more complex photographs could be stitched "verbatim" or not. SERI was still cautious about engaging in anything too time-consuming or expensive, however, as our partnership was still quite new, and the embroiderers were as yet unsure as to whether I could be patient enough, or afford, to commission a monumental piece that might take several years.

Nonetheless, following some discussion, we agreed to attempt *Upper Lake Cohasset*, an image from my first Aperture book, *The Hudson River and the Highlands* (1985). Referring to the photograph as "red maple with black trunk" (which would become the title of the embroidery), the embroiderers were attracted to the multihued red leaves of the foreground tree, set off strikingly against its jet black, rain-saturated trunk. There were other trees of varying colors in the background, and a lake, all of which presented them with the opportunity to explore a much greater variety of textures and to employ more of their numerous stitch styles. They proposed rendering the image as a one-sided, full-color 20-by-24-inch embroidery and projected that it would take about one year to complete.

When I returned to Suzhou in late 1987, I was greeted by a stunning accomplishment and a remarkable step forward in our collaboration. Incorporating more than twenty stitches, *Red Maple with Black Trunk* (figs. 36, 37) displays a profusion of textural surfaces with an incredible variety of knots, bundles, and loops. The embroiderers had also changed the technical application of some of their stitches, varying their length rather than keeping them uniform. This embroidery marks a significant departure from their more traditional stylized landscapes, rendering directly from nature with a different and significantly more complex "realism." It is particularly startling, however, because it is indistinguishable from the original photograph unless inspected quite closely.

The embroiderers were obviously excited about the success of the piece, and my enthusiastic response made it clear how much I appreciated the intricate detail and complex application of stitchery. It probably also

confirmed their worst fear, that I would like to incorporate that level of work into everything we might attempt, especially larger pieces. That fear was soon realized, as in our ensuing discussions I proposed that we explore something equally complex and in a considerably larger size. From my book *Overlooked in America: The Success and Failure of Federal Land Management* (1991), I selected the three-panel photograph *CVNRA #177* (cat. no. 17) and suggested translating it as a six-panel standing screen by dividing each of the three panels of the photograph in half. This proposal, a bit overreaching to say the least, was met with both skepticism and serious resistance, and I feared that I might come away from the trip having initiated nothing new and likely impairing the momentum that we had gained. Willing to compromise just to assure that something would be produced, I agreed to pursue a small, 15-by-18-inch full-color, one-sided study of the left panel of the photograph. The embroiderers felt that this study would provide an acceptable way to investigate the larger embroidery and determine how we might proceed if we chose to go forward with it.

    *Wild Meadow* (cat. no. 18) was completed in late 1988, and although it was quite beautiful, I found it disappointing. It employs stunning stitchwork, using more than eight different stitch variations, and features an especially successful rendering of the tangled meadow in the foreground of the photograph, but other areas, such as the tree trunks and

FIGURE 36
**RED MAPLE WITH BLACK TRUNK** (1987), the second work in the exchange between SERI and Ketchum. Photograph by Robert Glenn Ketchum, Suzhou Embroidery Research Institute, 1987.

FIGURES 37A–F (OVER)
Details of **RED MAPLE WITH BLACK TRUNK** (1987). Photographs by Robert Glenn Ketchum, Suzhou Embroidery Research Institute, 1987.

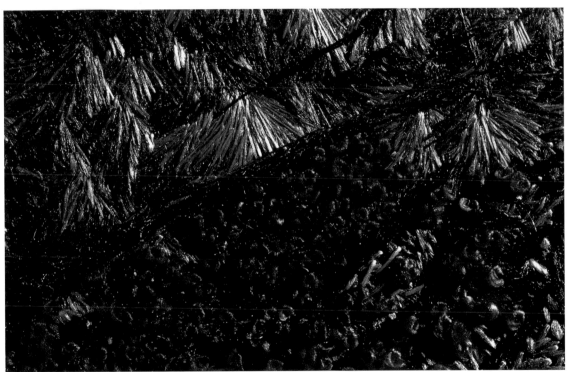

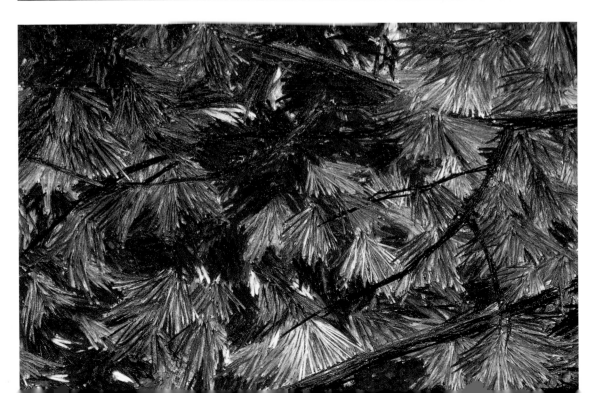

branches, are too loosely sewn. Lacking the kind of detail found in *Red Maple with Black Trunk* compromises the photographic qualities of the final embroidery, and I specifically do not like the treatment of the sky, which was accomplished by a linear filling in of the entire area with thread. This rather traditional approach to defining sky (and water) has always struck me as the least visually successful of all of the embroiderers' technical applications. This was the first time my response to the finished piece was less than enthusiastic, but it defined my expectations more clearly for the embroiderers, and they were probably relieved when I chose not to press forward with my proposal for a larger version of the same image and instead presented several new ideas.

The unexpected benefit of our exchange over *Wild Meadow* was that, in the wake of such an epic proposal, almost everything else I suggested for consideration seemed manageable. Also, mindful of my responses to the work, the embroiderers were rededicated to the intricacy and complexity that helped to define the illusion of photographic likeness. In our many discussions they had frequently implored me to consider ways to simplify my imagery, an idea that I was willing to ponder on their behalf. I was certain, however, that this had to be accomplished without reducing the essential detail or simplifying the subject matter by stylizing it. One solution would be to incorporate more of the support fabric into the final design of the embroidery, as we had done in *Snowfall*. This would also allow us to utilize the transparency of the fabric, an approach that would lend itself particularly well to the depiction of sky and water, which I preferred to leave unembroidered anyway.

The first new image I proposed was entitled *October 24, 1983/2:10 p.m.* (cat. no. 21), from *The Hudson River and the Highlands*. The photograph features a pastel-colored fall meadow behind a line of very dark trees. I suggested that we utilize a sheer black support fabric onto which only the pastel background meadow would be embroidered. The dark foreground trunks would be treated as negative space and be left entirely without stitching. The image had tremendous textural possibilities as well, so I encouraged the embroiderers to use as great a variety of stitches as possible and to exaggerate those textural features. Anticipating the transparency created by the unembroidered vertical trunks, I hoped that they would consider making this piece double-sided.

Interestingly, before any dialogue about technical approach could begin, the embroiderers repeatedly asked why the dark tree trunks had been placed in front of the colorful meadow, in effect interfering with the view (as they saw it) and interrupting what they all felt would have otherwise been an excellent design. I countered that having the dark and relatively colorless trees in the foreground provided a foil for the subtle colors in the background and that the contrast made those colors more pronounced. The foreground trunks also heightened the dimensional aspects of the image and gave the viewer the sensation of looking through one space into another in the distance. It was clear, however, that they continued to see the trees as intrusive, and they kept returning to that point, avoiding any dialogue about technical execution.

Gazing around the room in frustration, I realized another bit of serendipity. The institute is housed in a complex of historic buildings and gardens that were once the private home of an affluent administrator. Suzhou is famous for such homes and gardens, and they are some of the area's most important tourist attractions. Windows in these buildings are often large and incorporate elaborate wooden frames that divide the glass into small panes (see fig. 38). Often these windows overlook a garden, which may be completely enclosed by walls and intended as viewable only through the design of the window. This architectural device was precisely comparable to my use of the dark tree trunks against the pastel background in the photograph under discussion. Groping for an argument to sustain my idea, I pointed this out. After some brief, untranslated comments among themselves, the embroiderers conceded that I had made my point and began in earnest to consider the image for embroidery.

Traditionally the embroiderers prefer to use only a few stitch styles in any one piece, focusing the viewer's attention on the skill of work in the individual stitches. Too much variety is perceived as overwhelming. The beauty of our exchange, however, is that different cultures see things in different ways, and I embrace the use of diverse stitch styles as a way of expressing textural richness. Importantly, they realized that I was willing to accept this piece entirely as a textural experiment, so it was a chance for them to explore applications and techniques outside their usual approach. They agreed to apply as many stitch varieties as they felt could be incorporated into the design plan of the piece and offered to embroider the image at 30 by 40 inches, the size of my largest prints, making this the largest embroidery we had attempted to date. They declined to embroider the image on a black background, though, because of its minute detail, which, they felt, would not be easily readable when traced on the fabric. The idea of leaving the tree trunks as negative space, without any embroidery at all, was just too abstract as well, and they insisted on rendering them as part of the final design. They also preferred to keep such a complex embroidery one-sided, but, even so, they projected that it would take several years to complete.

I was elated at having concluded such a momentous negotiation, but I was also concerned that much time would elapse while *October 24, 1983/2:10 p.m.* was being executed, so I asked that we might consider beginning additional, less involved embroideries that would likely be finished in the interim. They seemed willing, so I continued to pursue the idea of simplifying my imagery by eliminating embroidery in some areas and using the support fabric as a design element. I asked them to consider a photograph titled *C73* that featured a line of fall sumac trees against a dark and slightly out-of-focus background of forest. The formal design was simple, and the sumac were brightly lit by an overcast sky, so the palette of reds offered the embroiderers a chance to display their spectacular command of that color. By using a black support fabric, we could greatly simplify the image by dropping out the background details entirely, which I suggested that we do, while at the same time delineating the sumac leaves with their most detailed needlework, referred to as "Suzhou fine style."

Red is the national color of China, and the embroiderers take great pride in their ability to render it in a spectrum of shades that is almost uncountable. Strands of embroidery floss are hand-dyed in individual lots, and two lots may vary in color by only a single additional drop of dye, a difference in hue that is subtle to say the least. The way silk thread reflects light is based on the direction in which it is sewn, a property the embroiderers frequently exploit. *C73* (cat. no. 19) offered exactly the right subject in which to incorporate all of these effects.

Although the embroiderers recognized that I was trying to simplify their task by using the black background to eliminate a portion of the stitching, they nevertheless felt that some limited embroidery of the distant forest should still be included to maintain a sense of realism. The final technical obstacle reflected their earlier concern that it would be too difficult to follow tracework on black support fabric. It was clear from our discussions, however, that they did like the image, so finally I persuaded them

to consider using fine-tipped white pencils to trace the design, which they agreed to attempt in a 24-by-30-inch format, one-sided and in full color.

Completed in 1990, the embroidered version, *Sumac along the Chattahoochee* (cat. no. 20), took more than four hundred days. Eight stitch styles and more than fifty shades of red delineate the sumac leaves and stalks with precise detail. At the same time, the loose, minimal background stitchwork conveys the effect of part of the image being slightly out of focus, greatly exaggerating the illusionary distance between background and foreground. The sumac stalks are embroidered one atop another, starting with the most distant ones and building toward the foreground, which results in a thick layering of stitches and establishes considerable relief. The effect of this is significant. With no embroidery in the darker spaces in between the stalks, the relief is enhanced, and with proper lighting, very slight cast shadows further the remarkably dimensional reading of the image. That these results were extraordinary was clear to us all, and *Sumac along the Chattahoochee* marks an important moment in our collaboration because we discovered a method of application that significantly increases the photographic illusion, one that we have since employed in numerous other ways.

A year later, in 1991, after more than six hundred days of effort, *October 24, 1983/2:10 p.m.* (cat. no. 22) was completed, the largest and most complex piece we had yet attempted. A virtuosic display of more than twenty stitch variations and hundreds of hand-dyed thread colors, each section of the elaborate textile is stitched in the fashion of a Renaissance painting, starting from the background of the image and building toward the foreground. The embroiderers and designers spent long hours planning the layering so that in the end each tree and individual bush would be correctly placed in the dimensional space. A verbatim reproduction, the final result reflects the more traditional method of filling all of the space with stitching, but this has been accomplished through an unparalleled display of texture and color palette. Perhaps as importantly, we had addressed a piece of considerable size and difficulty, resolving it to everyone's satisfaction.

During a visit to see *2:10 p.m.* in a developmental stage, and because *Sumac along the Chattahoochee* was nearly completed, I proposed another embroidery during a round of discussions. I had recently been working in a three-year artist-in-residence program at Robert Redford's Sundance Institute in the Wasatch Mountains of Utah, and I had produced some very striking photographs of the colorful fall foliage. I had two photographs in particular that were completely unrelated, but when one was flopped and placed next to the other, they seemed continuous (cat. nos. 23a–b). Only at the seam that joined them could you see that they were separate. I thought that we might attempt to merge the images, allowing the embroiderers to "invent" a common border by replicating similar details from other parts of both pictures. The idea proved of interest, and so they agreed to produce *Double-Wide Wasatch* (cat. no. 24) as a one-sided, full-color embroidery. Each panel measured 16 by 20 inches horizontally, creating a final size of 16 by 40 inches.

Finished in 1993, *Double-Wide Wasatch* marks the first time the embroiderers would work without an exact subject and actually create nonexistent visual information. The invented seam is undetectable, so we were successful in synthesizing a landscape while still maintaining a completely believable photographic likeness. Another unique feature of this embroidery, which employs a relatively modest variety of stitches, is the complex layering of colors. The intertwined threads and gaps—designed to simulate the leaves of one tree flickering out from behind the leaves of another, different-colored tree—allow fleeting glimpses of contrasting colors to be revealed across the entire surface of the image. The red of maples glows between tiny openings in the branches and leaves of greener trees that obscure them, and the pale tones of spring in the lush understory of the forest peek through the bright oranges and yellows of the aspens above. Again, a striking visual result was achieved by attempting a completely new style of stitch application.

FIGURE 39
Detail of **DOUBLE-WIDE WASATCH,**
cat. no. 24.

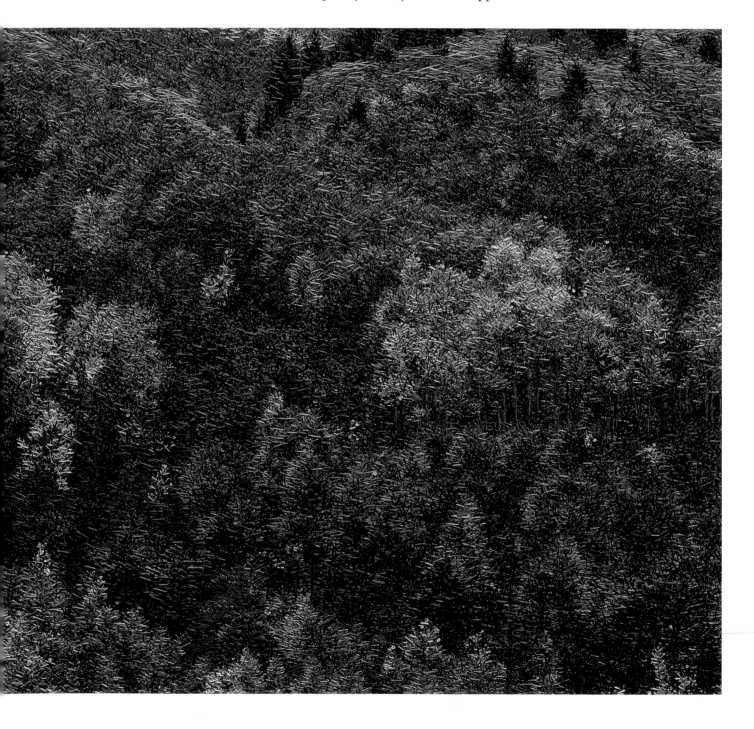

Projects were starting to overlap, and during the execution of *Double-Wide Wasatch*, I had proposed two new pieces, which had been accepted. Both evolved from my thoughts about the technique of dropping out the background of the photograph and utilizing the resulting transparent space as part of the design. This transparency could easily represent anything from sky to water to fog, depending on the color of the support fabric. Ideally we could simplify future embroideries significantly by choosing to translate images that included some of those elements. *CVNRA #412* (cat. no. 25), from *Overlooked in America*, included *all* of those elements, so I proposed it, envisioning that only the dark trees and shrubs and the subtle hint of spring green in the foliage would be embroidered. The sky and water would remain unembroidered, creating a piece that was mostly transparent space and, therefore, potentially two-sided. I also asked if we could once again consider a multipanel standing screen, this time splitting one photograph twice to create three panels.

The transparency of the suggested design struck a chord of interest. The embroiderers embraced the image and the concept, immediately seeing the possibilities, but expressed concern that the water and sky were different colors, so that one or the other had to be embroidered. As an alternative I suggested using a white silk background that was selectively painted or hand-dyed with a blue cast to represent areas of water. I insisted that the embroidery remain limited and that the transparent spaces be essential parts of the design. After some debate the consensus was that this could be accomplished, and a lengthy discussion regarding design considerations ensued. We were about to embark on our most adventurous piece, one that would likely take three years or more to finish.

Over the course of several visits I watched *The Beginning of Time* (cat. no. 26) slowly emerging, but until it was completed, in 1994, framed and standing in its three continuous panels, the full impact of its achievements could not be appreciated. The overall design and the application of stitchwork transcended anything we had anticipated or previously accomplished. The hand-dyed background is flawless, flowing smoothly and seamlessly between the suggestion of water, sky, and morning fog. The transition from solid objects to vapor is completely convincing, and the exact reproduction of the subtle reflections on the surface of the water imparts a sense of movement that is uncanny. Displayed in a room that changes as the natural light crosses it in the course of a day, *The Beginning of Time* alternates between perspectives of shimmering color and silhouette. Different at every adjustment and angle of light, the surface of the embroidery is transformed hour by hour in a cycle that seldom repeats.

Amazingly, the most important discovery of the process was an element none of us had anticipated. Chinese screens are traditionally four or six panels, and their symmetry gives them stability when standing. A three-panel screen demands a different framing construction. *The Beginning of Time* therefore had to be designed with its outermost legs slightly shortened, allowing it to tilt forward slightly, and more safely, when displayed. This presentation further enhances the photographic illusion of dimension established by the embroidery of the water. When a viewer stands in front of the screen, centered on the middle panel, the other two panels seem to

reach out, engaging the peripheral vision and engulfing the viewer in the image. The sensation is that the water actually extends forward into the viewer's visual space, resulting in a true three-dimensional experience. To this day, *The Beginning of Time* remains the most significant of our embroideries. Not only is it the largest of our efforts, but it represents that moment of perfect synthesis when all the random elements of the artwork coalesce. Each design decision was irreversible once taken but turned out to be the ideal choice in view of the results. No legion of embroiderers, designers, and photographers could have planned the outcome as well, and yet the outcome was never exactly planned or anticipated.

Remarkably, during the trip in which *The Beginning of Time* was finally framed and delivered, I also received a much smaller piece that I had commissioned simultaneously. It was based on another image selected from my work done during the Sundance residency (cat. no. 27), and it too featured the multihued fall landscape of the Wasatch Mountains. In contrast to the more exuberant displays of fall in my other pictures, this photograph was taken late in the evening, after the sun had gone down and the colors in the brush were subdued and influenced by the blueness of shade. The desert hillside in the picture is rocky and barren of vegetation, with sparse clusters of sage and chaparral scattered in patterns over the steep slopes. Formally composed with a very tight frame, the rendering of the landscape is quite abstract, consisting only of some lines of brush clinging to the vertical ridges and the slightest suggestion of a valley receding in the distance.

Initially the embroiderers argued that the image was too abstract to be readable and that the colors of the flora seemed to merge and flow with no delineation between the individual plants, making it impossible to render them with any specific definition. In fact, the detail of the plants was so minute that the embroiderers were concerned that they could not render them at all, and certainly they could not define them leaf by leaf. I agreed and proposed that we approach the image entirely differently, by using a kind of visual metaphor to represent the brush. If the basic shapes of the overall brush forms were precisely and accurately embroidered, those shapes would define the landscape and its contours, and it would not be necessary to render every detail of either the landscape or the vegetation. Carrying that idea to the extreme, I further proposed that we drop out all the rocky background, leaving it completely unembroidered and making the screen significantly transparent. Agreeing that the colors seemed without definition as they flowed across the bushes, I suggested that they emphasize texture and work to blend one color into another in the actual stitching, creating a seamless merger between differing hues, a technique I had seen used in other pieces.

In many of the conversations I have had with the embroiderers, something said by one of us stimulates an idea in someone else, and that input adds significantly to the design plan. Expanding on my suggestion to embroider areas of color and blend their transitional edges in *Fall Dream in the High Desert* (cat. no. 28), the embroiderers opted to carry the technique of blending even further, while at the same time addressing my request for texture. They proposed rendering the brush forms with the

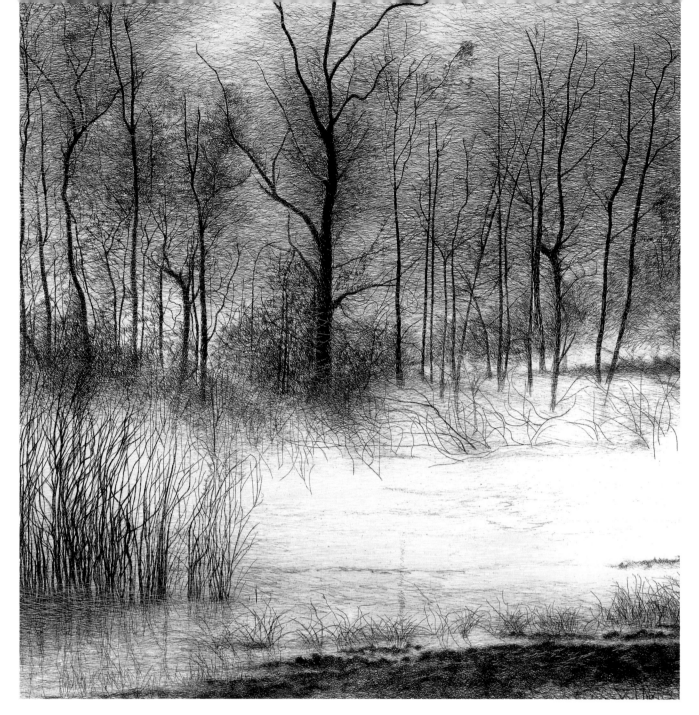

FIGURE 40
Detail of **THE BEGINNING OF TIME**,
cat. no. 26.

"bundle" stitch, a technique in which a piece of silk embroidery floss is separated into its individual strands of silk. Strands of one color can then be mixed with strands of other colors and rewound to form a multicolored floss. The embroiderer can control the mix of colors by varying the number of strands of any one color incorporated into the floss.

 *Fall Dream* is a two-sided standing table screen with an image size of approximately 16 by 20 inches. Completed in 1995, it took about one year of work. The landscape is haiku-like, defined only by the gestural shapes of the shrubbery, which nevertheless clearly delineate the steep incline of the hill and the recession of the valley. The exterior edges of the brush forms are perfectly detailed, so that the overall image, although abstract, still contains enough information to make the subject understandable. The multicolored bundle stitches are a brilliant addition. Combining the colors in this way blends the transitional edges between the bushes but allows small splashes of color to shine through, creating a more realistic look by implying that the colors of the individual leaves may differ from that of the overall bush.

There is another interesting facet of the development of this embroidery, which occurred in my studio and not at the institute. Concerned that the overall blue tone of the photograph suppressed the vibrancy of the fall colors, I enhanced the final print from which the embroiderers were to work with hand-applied dyes. It was important to paint in enough dye to bring up the color richness and counteract the blue tones, but not so much that the coloration lost its subtlety or believability, and it took several prints to achieve the desired result. Because the embroiderers work directly from the original art, making these corrections for them, rather than asking them to interpret, seemed a more appropriate choice. It also unexpectedly opened a door to the possibility of employing further studio manipulations, a direction that we are presently pursuing.

By 1995 almost ten years of working together had matured our collaboration, and our discussions of ideas were increasingly more comfortable and open. Embroideries we had attempted rewarded us with discoveries that changed the way we collectively approached a subject. My career and cash flow grew, allowing me to commission ever larger projects. At the same time China was changing in significant ways, and at a speed that seemed inconceivable, with the result that the workshop was more willing than ever to take on new projects. Seizing the opportunity, for the first time we initiated five new embroideries during a single visit. Two were derived from early black-and-white photographs found in the portfolio *Winters, 1970–1980*, and the other three were full color, but all were selected because they offered the opportunity to further explore transparency as a design element.

Completed a little more than a year later, the black-and-white images are especially minimal. The identifiable details are stitched into white background screens, and the snow has been treated as negative space and left unembroidered. In the one-sided piece *Tree and Branch in Deep Snow* (cat. no. 34), derived from the photograph *Visual Haiku* (cat. no. 33), the dark trunk and single branch are embroidered in great detail. More than ten different stitches are employed in the overall design. The texture of the snow was rendered by using "knotting" or "looping" stitches, which were arranged in such a way that the widely varying size and looseness of the individual stitches help to define subtle contours in the snow. Since this is a one-sided embroidery, and the "body" of the snow is transparent, the color and texture of anything placed behind the embroidered image as part of the framing had to be carefully considered.

The other black-and-white embroidery, *Three Trees* (cat. no. 32), is even more diaphanous. This double-sided image is framed as a small standing table screen with a swiveling mount. The original photograph (cat. no. 31) depicts a steep, snow-covered hillside upon which three large trees and a few small outcroppings of stone are visible; all else is white. Employing their finest thread and tiniest needles in some of the most delicate work yet accomplished, the embroiderers painstakingly rendered the trees and rocks, which seem to float on the transparent background. Subtle white stitches of varying lengths have been used to describe snow highlights and contours, but their application is quite spare and gestural, and they are often revealed only by a shift in lighting.

This was also my first piece incorporating an embroidered edge, a technique called *chuo sha*. In this technique the transparent support fabric is bordered on all sides by hand embroidery in an entirely different style, which utilizes a repetitive pattern. Taking as long to complete as the embroidery itself (six months), these narrow borders are intended to enhance the overall impact of the design, rather than distract from it, so they are almost always done in white thread. Patterns are infinitely variable, but generally extremely subtle.

Reproducing these two photographs for the Chinese also required some new technical steps for me. Both of these photographic prints were made more than fifteen years ago, and in a small, 5-by-8-inch size. The embroideries were designed at a substantially larger size, and using traditional darkroom techniques to enlarge the original film would have caused a noticeable loss of quality. In the years since these images were created, however, digital technology has improved significantly, especially with regard to the output of the final print. So, working with an original black-and-white print from the *Winters* portfolio, a digital scan was made. An enlargement was then generated from the new digital file after adjustments were made to assure its likeness to the original photograph. Nash Editions of Manhattan Beach, California, provided output on an Iris Scanning Printer, publishing the pieces at 20 by 24 inches as ink on paper, rather than as traditional gelatin silver prints. The embroiderers worked from these larger scan-printed images.

Two of the three colored images in this group were also completed in 1996, and each of them explored territory quite similar to that of the black-and-whites. *Pale Leaves in Blue Fog* (cat. no. 30), a 24-by-30-inch semitransparent embroidery, is based on the photograph *November 11, 1983/9:15 a.m.* (cat. no. 29) and took one and a half years to complete. A birch tree dominates the immediate foreground, its silvery leaves the only ones remaining in an entire forest of dark, barren trunks. The bluish fog of the photograph is implied by a transparent pale blue background, onto which the birch and leaves have been stitched using the most highly detailed Suzhou fine style embroidery. The forest behind the birch is carefully rendered, but as the trees recede, the stitching becomes looser and the details less readable. The leaves of the birch utilize the reflective qualities of the silk thread, which is sewn in opposite directions on either side of each leaf. This not only greatly enhances the sense of the three-dimensional space the birch occupies, but it imparts a sense of volume to the foliage, rather than a stylized flatness.

In the original photograph raindrops are clearly visible on many of the branches and birch leaves. The embroiderers used looping stitches to render the largest ones, which appear randomly on the trees throughout the forest, but without a needle small enough, there seemed no appropriate way to detail the tiny droplets on the tightly stitched leaves. According to Zhang Meifang, it was while considering this problem that it occurred to her that it might be possible to make very small stitches with the aid of an acupuncture needle.[1] The next day she purchased some for the embroiderers to experiment with, and a beautiful and very tiny new stitch style was born. Close examination of the embroidery reveals hundreds of

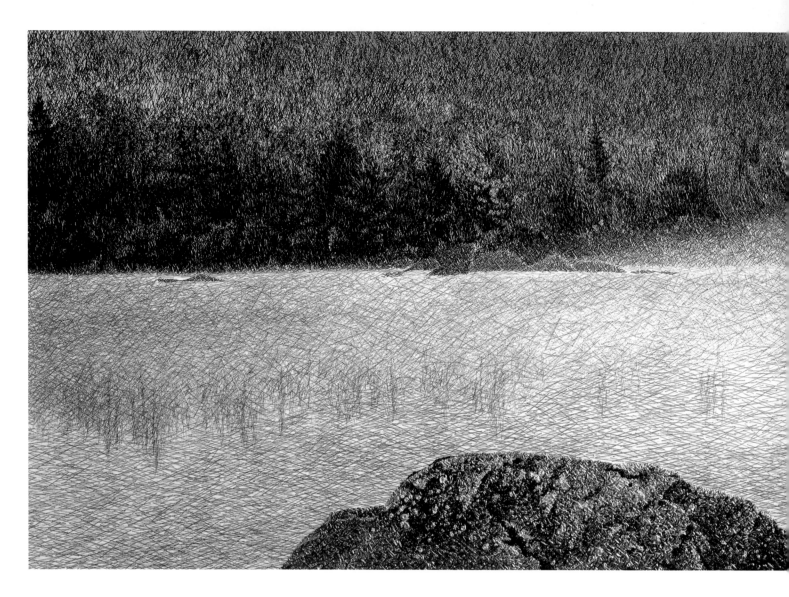

these minute stitches sitting at the edge of the leaves, their silk threads irregularly reflecting the light in the same way that an actual raindrop does. Much like *Tree and Branch in Deep Snow*, this is an extremely transparent one-sided piece, requiring that the framing incorporate a background that complements the tones in the "blue fog" without discoloring it or patterning its seamless negative space.

*Rock in Lake with Fog* (cat. no. 36) was translated from the photograph *Mendenhall Lake* (cat. no. 35), taken in the Tongass rainforest of southeast Alaska. In this embroidery transparency is once again utilized to represent water. The image features a prominent lichen-covered rock, reflected in a pale blue lake, from the surface of which a light fog is rising. In the distance are dark conifers and a few fall-colored deciduous trees. The color of the support fabric matches the lake, and only highlights and superficial surface patterns are embroidered where water is implied. Much attention has been devoted to the rock and its reflection, with the embroiderers using very fine stitches to represent the many nuances of its shape and the growth it supports. The distant trees, though also quite detailed, are stitched more loosely, employing the design technique we had previously developed to enhance the illusion of dimensional space by suggesting that the forest in the background is slightly less "in focus" than the foreground.

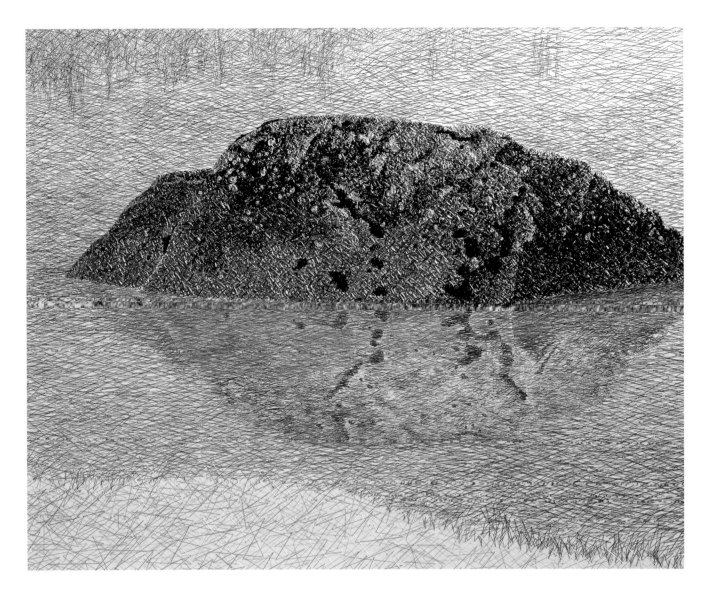

Embroidered in the double-sided style, the 20-by-24-inch image incorporates nearly twenty different stitches and is displayed as a standing table screen in a swivel mount constructed of a wood that is much lighter in color than the dark mahogany most often used. The spectacular random stitchwork used for highlights employs the technique of reversing the reflective direction of the silk thread, so that as the viewer moves around the piece, the features of the water surface change with the angle of the light. In the past the embroiderers have also used a very traditional stylized design to represent rocks. Seeing the realistic and subtly dimensional result of rendering this one so carefully, and from nature, was once again positive reinforcement for putting the extra work into the precise detailing that accomplishes striking photographic realism.

Slightly later, in early 1997, the fifth and final piece of this group was completed. Derived from a recent photograph, *Wet & Wind Driven* (cat. no. 37), which was produced in the Lake Tahoe area, the image features a large and very prominent tree in the right foreground, whose trunk and massive lower branches have been covered by a heavy snowfall. Beyond the tree there is only a neutral, formless sky, and sticking up randomly in the lower left-hand corner of the image are just the topmost branches of a few other equally snow-laden trees. The embroidered version, *Trees and Branches with Heavy Snow* (cat. no. 38), is a one-sided,

24-by-30-inch piece that took one and a half years to complete. In it the sky is the transparent element; the support fabric simulates the sky tones, and only the trees have been embroidered. All the works in this group of five embroideries incorporate transparency, but in the other four the style and application of stitches were chosen specifically to complement the delicacy of the pieces. None of the other embroideries employs the rather weighty textural stitching used in early pieces, so we decided to explore that direction in this image.

The sky is completely devoid of stitching, without even a suggestion of tonal change or the addition of highlight stitches that were used to enhance parts of the other embroideries. Instead, all the labor in *Trees and Branches with Heavy Snow* has been dedicated to capturing the significant textures of the trunk and bark (another first in rendering directly from nature), the pine-needled branches, and the heavy, wet snow that covers everything. In the foreground, in particular, stitches defining the tree and branches are overlaid upon one another and built up, just as the snow appears built up in the photograph, thus giving the embroidery a palpable, visible weight. These parts of the piece incorporate more than ten stitches, applied in widely varying sizes. Because of its transparency, when this piece was framed, the selection of a background cloth behind the support fabric was carefully considered, as it shows through, affecting the viewer's perception of the sky.

FIGURE 42
**THE COAT OF MANY COLORS,**
photograph by Robert Glenn Ketchum, 1989.

During the 1997 visit to conclude the framing of these five embroideries, new images were proposed, and additional work is presently going forward. Excited by the possibility of having a few of these embroideries included in the present exhibition, the workers attempted to finish the two pieces described below, and one of these pieces is included in the exhibition. Two other projects are monumental with several years of work yet to be done before they will be complete. Although they will not appear in the show, they are important enough to note here, and on-site shots of them in process provide an understanding of how they are developing.

The first of the two embroideries—which unfortunately was not completed in time to be included in the exhibition—is derived from the photograph *The Coat of Many Colors* (see fig. 42), done during the Sundance residency. Aptly and simply named *Colorful Hillside* (see fig. 43), this 16-by-20-inch, one-sided embroidery features a steep-sloped summit, completely covered by trees and vegetation at the peak of fall foliage. Color and textural variations abound, as the many types of plants offer contrasting shapes and wildly vibrant hues. The image was selected to pursue further issues of textural detailing, but a small upper corner of the image, which features a distant peak and a cloud-filled sky, has been left transparent. The background peak is in shadow and has little detail, so the embroiderers have rendered it quite loosely, delineating its outline and

FIGURE 43

**COLORFUL HILLSIDE.**

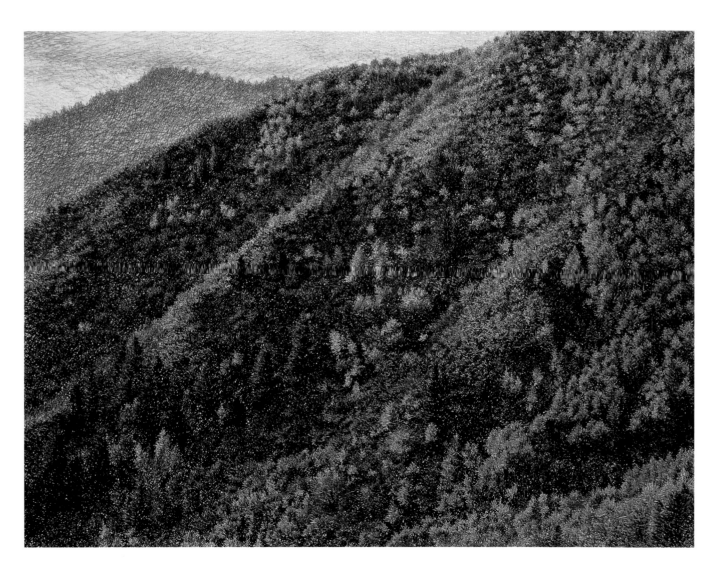

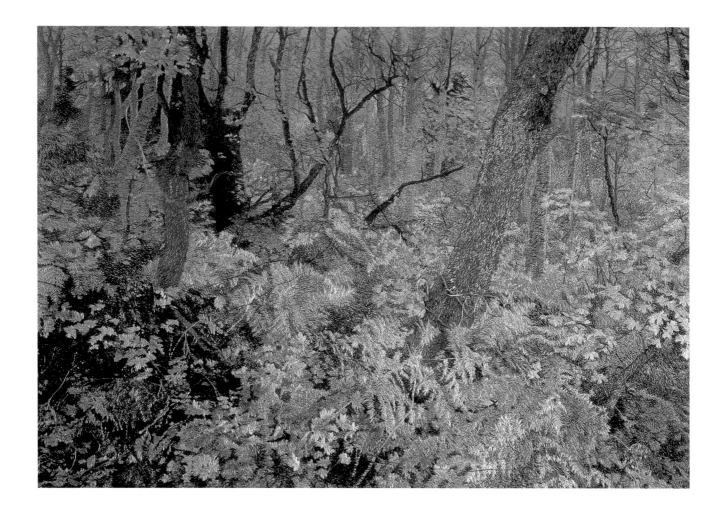

FIGURE 44
**COSMIC TREES** in process.
Photograph by Robert Glenn Ketchum,
Suzhou Embroidery Research
Institute, 1998.

FIGURE 45
**COSMIC TREES** in process.
The large windows shed light on the
embroidery, which is stretched on the
frame, with the original photograph
propped above. Photograph by Robert
Glenn Ketchum, Suzhou Embroidery
Research Institute, 1998.

physical presence with only a few "suggestive" stitches. In framing, consideration must again be given to selecting a background that, when placed behind the transparent section, will enhance the realistic representation of the sky.

The second embroidery is 16 by 20 inches, two-sided, and also from the series done at Sundance, but its design is devoted more to transparency than to texture. Translated from the photograph *Early Morning, Provo River* (cat. no. 39), the embroidery *River Scene in Winter* (cat. no. 40) takes advantage of both the blue water and the deep blue shadowed areas of the picture to employ transparency, leaving most of the image without extensive embroidery. The frosted trees surrounding the banks of the river have been attentively stitched, and the water has been rendered particularly successfully, seeming to actually be in motion as it flows over the rapids and rocks. Random stitching, utilizing the reflective qualities of the silk thread, has once again been used to create transitional highlight details. The swiveling frame and the transparent areas of water and blue shade offset the brilliant whites of the directionally sewn threads and cause the embroidery to noticeably shimmer as light plays across its surface.

The two remaining pieces that will not be included in the show are works of significantly greater complexity, and although some transparency has been designed into them, they are primarily exercises in rich texture and color. *Cosmic Trees* (see figs. 44, 45) is another Sundance image, set deep in a fall forest filled with a tremendous variety of vegetation. The plants display a profusion of color, and the wet, saturated trunks of the trees glow in an impossible shade of blue, reflecting the color of the clearing sky above them. In this embroidery the most prominent plants in the foreground will be rendered in the Suzhou fine style, with some of the reflective stitching techniques likely employed in the larger leaves. The dense and busy forest background will be sewn in loose stitches that will become even looser as the trunks and flora they are defining retreat to the background of the picture.

Huang Chunya, one of the institute's most accomplished embroiderers and the master embroiderer of several of our most important and difficult pieces, is working on this one. Even in its partially finished state, the craft of her design and development is already apparent, and I am eagerly awaiting completion of this 24 by 30-inch, one-sided embroidery. As an artist, Huang seems particularly challenged by the most difficult works I propose and has always preferred to work on them. I am very excited to have her attention once again, as I know it means that *Cosmic Trees* will reflect her intuitive interpretation of the subject and her inventive application of stitches.

The final image shown in process here, *Cherry Tree Blossoming* (see fig. 46), is based on *The Exuberance of Spring*, a recent photograph in which a profusely blooming cherry tree is framed in such a way that it fills most of the picture. Early light is beginning to strike a few of the flowers and illuminate some of the darker trees behind. The blooms are a symphony of pastel hues, and the camera has precisely defined hundreds of them, each of which has dozens of shades in the petals of its leaves. The

astoundingly laborious design plan is to detail *every single* blossom using Suzhou fine style embroidery, capturing the nuances of each flower and giving them a dimensional, volumetric presence on the surface of the embroidery.

The foliage behind the cherry tree is quite dark, so I originally suggested that it be left out entirely. The embroiderers, however, wanted to use the dark background shapes and textures to offset the brilliant colors of the cherry blossoms, so they preferred to include the background details, rendering them more loosely. They were also very attracted to a subtle background detail: numerous small yellow blossoms from a vine that had woven itself through the distant undergrowth. Inspired by our previous experiments in textural excess, they wanted to include the additional bright color in their design. To simulate the yellow trailing flowers, they invented a new stitch derived from our previous experiments with extremely fine acupuncture needles. Wrapping the silk thread around the shaft of the needle before closing the stitch creates a coil of loops when the needle is withdrawn. These hang from the surface of the embroidery, suggesting the look of the vine's flowers remarkably well.

FIGURE 46
**CHERRY TREE BLOSSOMING** in process. Photograph by Robert Glenn Ketchum, Suzhou Embroidery Research Institute, 1998.

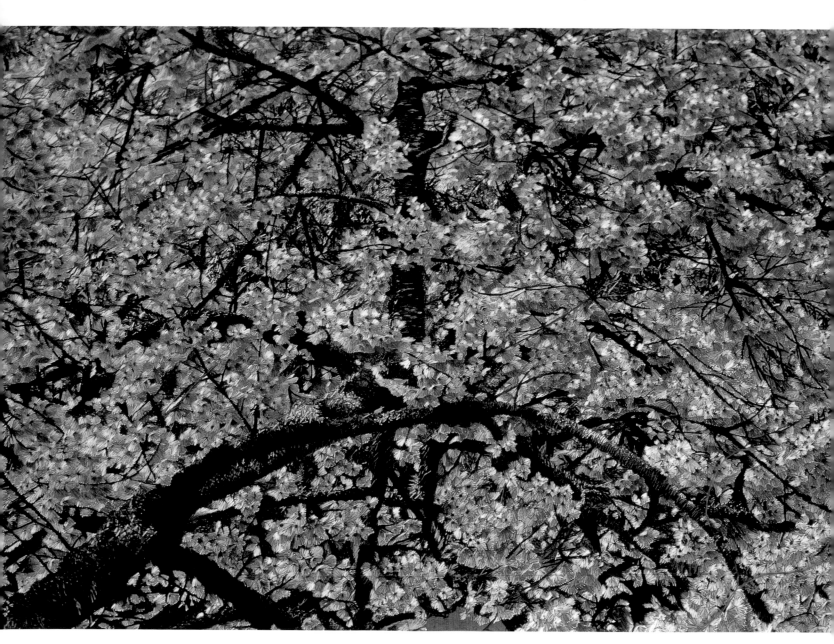

88

Neither of these last two embroideries is as yet at its halfway point of completion, and inevitably they will change as they evolve. Regardless of what direction any one image takes, however, or whether every detail is executed as planned, it is clear from our collective work of more than a decade that we have not only resolved some interesting problems while creating beautiful objects but that we are growing exponentially in the process as well. Every finished piece teaches us something new and opens doors of opportunity. We are just beginning to explore the use of transparency, and my mind is reeling with the possibilities suggested by other images since the completion of *The Beginning of Time*. By using transparency and negative space as a design element, we may be able to simplify some of my images significantly enough that perhaps we can even attempt larger projects such as six-panel standing screens. I am also considering some boxlike framing designs for especially elaborate textural pieces, so that their relief will not be crushed flat when they are mounted between the glass and Plexiglas surfaces.

I am always struck by the unfinished pieces that I view when I visit the institute and by the way the photographic likeness looks as it emerges from the traced background. When you can see both the finished elements of the image and the basic raw outline, the viewer's awareness of the magic of the process is enhanced considerably, as a dimensional object appears to rise from the flat, featureless cloth screen. I would very much like to produce a large piece that has a mix of finished parts with other sections that are completely unfinished.

I also think that computers will play an increasingly important role in my collaboration with the embroiderers as they will allow me to deliver to SERI finished designs derived from my photographs without having to ask the embroiderers to interpret changes I have made. Many of the issues that we have debated at length because we have lacked actual examples can be resolved with digital models. It is a very exciting time.

I am often asked how long will I continue to be interested in pursuing my collaboration with the institute. As an artist, my response would be that I will continue to do this until the objects we create become redundant and the sense of exploration is lost. That does not seem likely to happen in the immediate future. As someone who must also deal with the realities of living in this world, I would add that I will continue to do this as long as the Chinese welcome me. This exchange has opened other worlds to all of the participants, and we seem to enjoy one another's company as we proceed along our journey. I hope that it will continue to remain rewarding and provide each of us with insights into the other's culture and appreciation for its traditions and skills.

●

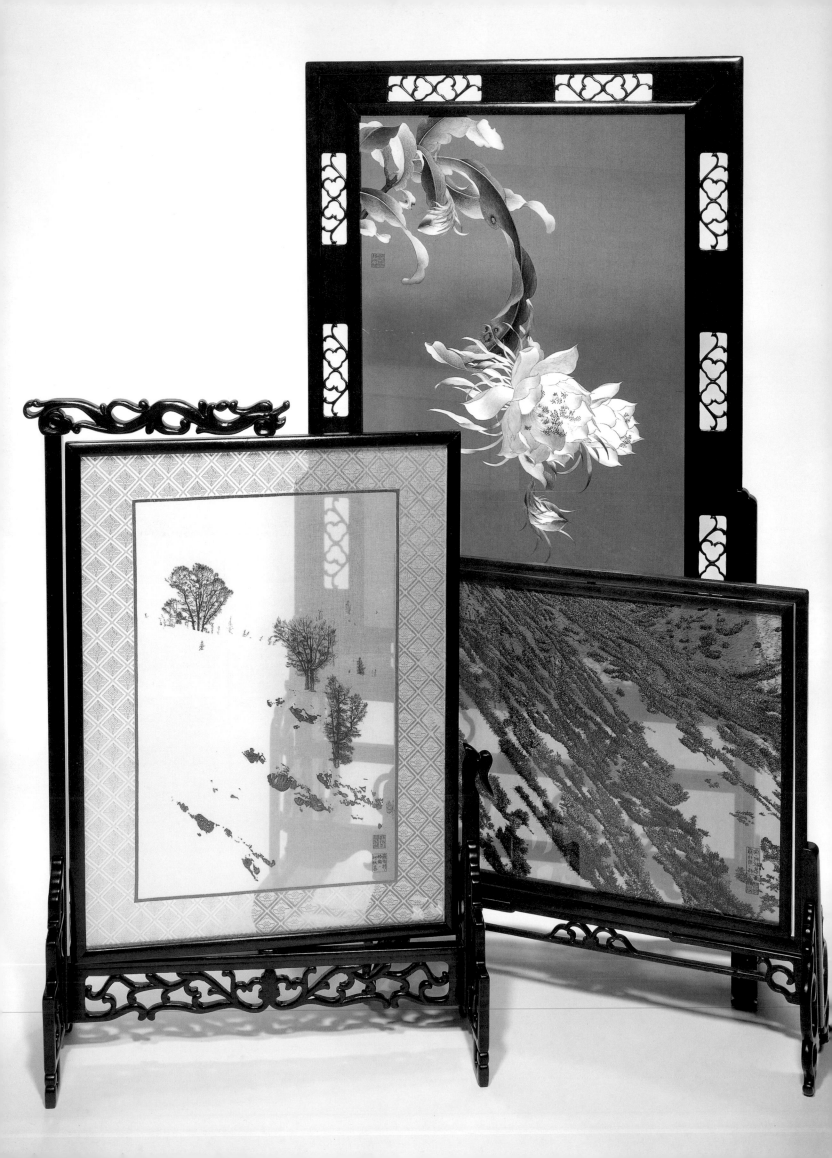

# Technical Aspects
# of Suzhou Embroidery

## JO Q. HILL

Each of the several stages of production of the embroidered works made at the Suzhou Embroidery Research Institute (SERI) requires the expertise of a variety of embroidery specialists. Although many of the institute's 260 employees are familiar with each stage of embroidery production, most specialize in a single craft. Twenty designers research potential projects, refine design conceptions, and apply the outline of the design on the support fabric; ten dyers tint silk fabric and embroidery floss with chemical dyes (see fig. 47); approximately eighty embroiderers devote long hours to intricate stitchery on works that may require several years to complete. While it is certainly a mark of status to be a specialist, it is also valuable to have mastered several skills, and a few SERI employees "do everything," including the stretching of the fabric onto fabrication frames, mounting the completed artwork onto the glass support, and framing the glass-mounted textile in a custom-carved mahogany frame. The workers at SERI routinely employ both traditional and modern materials, tools, techniques, and stitch types (Zhang 1989; Suzhou City Embroidery Research Institute 1976; Wang 1987, 130–51; Saint-Aubin 1983, 64–78; Brown 1994, 6–79; Brittain 1990, 12–55; Gasc 1977, 87–91; Birrell 1973, 344–76).

FIGURE 47
Dyeing of silk floss, with drying loops of silk arranged by hue and shade. Photograph by Shen Guoqing, Suzhou Embroidery Research Institute, 1998.

FIGURE 48 (OPPOSITE)
The arrangement of these three embroideries reveals their transparency. The work in the middle is shown here viewed from the back. Front to back: cat. nos. 32, 28, 11.

### Embroidery Materials

Silk floss is always used for SERI artwork embroideries; the support fabric for the embroideries is also generally silk. A lustrous and supple natural fiber, silk has a long history of use in China as a textile material, dating to sometime before the middle of the third millennium B.C.E. Sericulture, the method of raising silkworms, was a strictly guarded secret in China until the fourth century C.E. (Vollmer et al. 1983, 196). By the first millennium B.C.E., however, the Chinese had begun to export silk cloth, and the ancient trade route that linked China with the West became known as the Silk Road. Silk continues to be recognized and valued internationally as a textile fiber for such properties as its high resilience and tensile strength (Hutt 1987, 179–82; Suzhou City Embroidery Research Institute 1976).

91

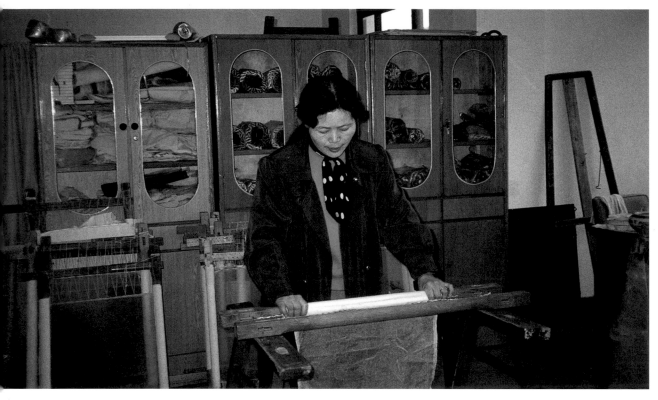

FIGURE 49
Huang Chunya prepares to embroider by splitting blue silk floss into eight strands; she will then retwist three of these strands to intertwine them with a single strand of gray to create a subtle blue-gray color as she continues to work on **COSMIC TREES**. Photograph by Jo Q. Hill, Suzhou Embroidery Research Institute, 1998.

FIGURE 50
In the room where workers stretch and roll support fabric onto embroidery fabrication frames, hundreds of bundles of dyed silk embroidery floss await in glass-fronted cabinets. Photograph by Shen Guoqing, Suzhou Embroidery Research Institute, 1998.

The silk thread used by SERI is reeled to suit the purpose of embroidery stitching. For example, six individual strands of silk are combined to make the finest silk floss, while twenty-five strands yield a coarser floss. The colors and other qualities of the floss will be enhanced if this is essential to achieving the desired result. For instance, the dyed floss is routinely split, either to yield a thinner floss for more delicate stitches or to retwist with fine strands of other colors for special effects (see fig. 49).

The institute does all the dyeing of the silk floss for embroidery, as the color range available in the local marketplace is considered far too limited for use in Suzhou artwork embroideries. Color schemes in Chinese textiles in general (Wang 1987, 19–20), and at SERI in particular, reflect the movement away from traditional natural plant dyes toward modern synthetic organic dyes.[1] Silk floss in more than one thousand hues is arranged by color and gradation of tone in glass-fronted cupboards at the institute, allowing for an extraordinary color range (see fig. 50). To supplement the stock, colors are sometimes "invented" to achieve a specific effect; for example, the silk threads in the stitched trees in *Cosmic Trees* (fig. 51), which are an indescribable tone of blue, were dyed in a special dye batch. The appearance of the same silk thread will also differ in different settings; for example, silver-colored silk thread has a certain desirable transparency on some fabric types (e.g., pale silks or silk and synthetic blend), communicating a hazy appearance, but is brilliantly reflective on dark silk fabrics (see fig. 52).

Many varieties of silk textiles, classified according to texture and weaving technique, are housed at the institute for use as support fabrics. Thin, light, transparent silk fabrics such as *sha*, *luo sha*, and *qi* (see fig. 53) are gauzes; *jin si* (brocades) are rich and sumptuous, with colorful patterns; and *duan si* (silk satins) are smooth and shiny (Tsang 1995, 1). The Chinese names for the three basic fabrics used at SERI as a support for fine embroideries are *duan si* (silk satin), *juan sha* (silk gauze), and *yi xing si*. The latter fabric is polyacryl, a blend of natural silk fiber and a synthetic fiber that has a triangular cross section; this special fabric has been extensively used for the Ketchum textiles because of its reflective properties.

The weave type of the support fabric affects the appearance of the final work, and occasionally fabric is woven at SERI, rather than purchased from outside vendors, for use in special embroideries (see fig. 54). For instance, the diaphanous background fabric for *Snowfall* (1986; cat. no. 16) is thin and translucent; it was deliberately woven unevenly to enhance the illusory downward-falling movement of the embroidered

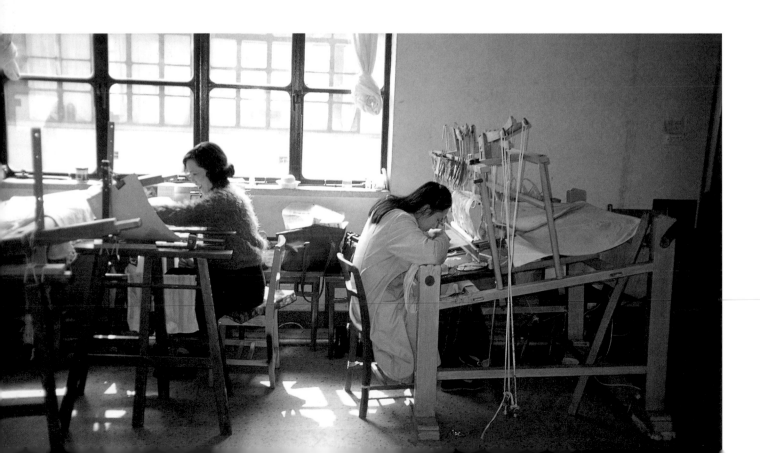

snow. The organdy-type weave used for *The Beginning of Time* (1994; cat. no. 26) has a special construction: as the weaving progresses, once every four or five picks the weft yarn is given a single twist. In the finished piece the warps are aligned vertically to the design plane (Shore 1997, 1). As the patterns of sunlight passing through a room shift over the course of a day, this three-part standing screen reflects light in subtly different ways, mimicking the movement of fog and steam on swamp waters.

Some fabrics are dyed or painted, depending on the design for the embroidery and the desired final effect. The black-dyed support fabric for *Sumac along the Chattahoochee* (1990; cat. no. 20) allows for the recession of the dark background and the progression of stitches to achieve a heightened sense of depth, and the blue-gray–dyed support fabric for Ketchum's *River Scene in Winter* (1998; cat. no. 40) lends an atmospheric wintry chill to the snowy scene. Painted details in SERI embroideries include the yellow-gold sky of *Spectacular Spring* (1997; cat. no. 14) and the fields of color in one fabric layer of the two-layer *Magnolia* (1993; cat. no. 8).

### Preparation of Fabric for Embroidery

Historically many different types of embroidery frames have been used to hold fabric under tension for stitching (Chung 1979, 16–17; Hutt 1987, 195; Brown 1994, 11; Brittain 1990, 13; Dillmont, 1972, 53, 77, 153, 155; Wang 1987, 131). The Suzhou embroidery frame is made of carpentered wood and is unusual in that it provides even tension on all four sides of the fabric, rather than on only two sides (Brown 1994, 11; Saint Aubin 1983, 23–25; Brittain 1990, 8, 12; Dillmont 1972, 53, 164). Propped at an angle appropriate for the worker's height when seated and for the work's stage of progression, the stretched embroidery fabrication frame is lashed to a trestle or onto an artist's easel (Zhang 1989, 17–18). Smaller works are commonly executed with the fabrication frame in a horizontal orientation, and larger works, with the frame propped on a diagonal or nearly vertical (see figs. 55, 56).[2]

The embroidery support fabric is prepared for stretching in the following manner. After muslin strips are sewn to the top and bottom edges of the fabric, the muslin-silk seam is pressed into a groove present on each horizontal member of the fabrication frame and then secured with a length of cordage pressed into the groove. The fabric is then rolled onto the horizontal bars an appropriate distance to access the desired area for current embroidery work. To achieve the desired degree of vertical tautness, the horizontal bars are braced by the insertion of pins into the holes drilled into the vertical bars of the fabrication frame; the staggered, carefully calculated placement of holes allows for the fine-tuning of vertical tension. Suzhou artwork embroiderers maintain that light reflectance is most effective when silk stitches are executed on a very taut support fabric; for the fabrication of textile articles for everyday

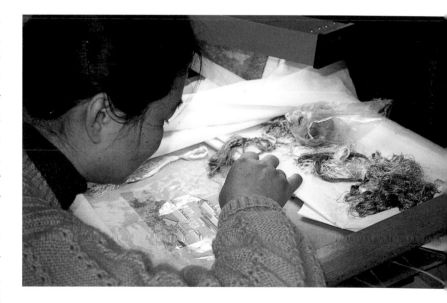

FIGURE 55
This small embroidery is oriented horizontally during the fine, close work of SERI embroidery. Fluorescent light supplements the natural light from a nearby window. Photograph by Jo Q. Hill, Suzhou Embroidery Research Institute, 1998.

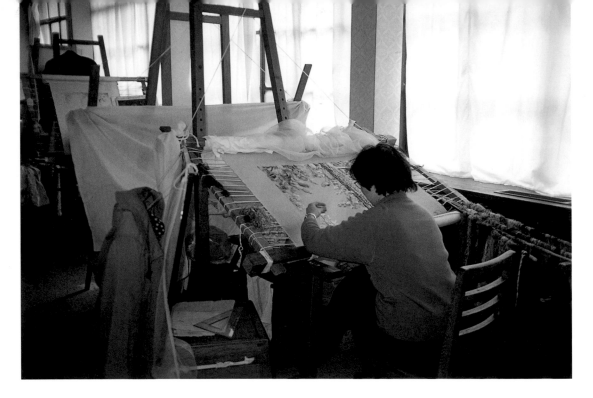

use, however, looser tension on the frame is deemed sufficient. To achieve the appropriate degree of horizontal tautness, cotton twine is threaded through the vertical frame members and progressively tightened through loops sewn to the parallel reinforced edges of the embroidery fabric.

The next step is the transfer of a design to the stretched support fabric (Brown 1994, 10; Saint-Aubin 1983, 21, 65; Dillmont 1972, 44, 65, 66, 773, 774). Typically the design is traced with a black lead pencil (2H or HB), following the lines of the design placed below the stretched fabric (see fig. 57). Colored pencils, particularly white, are helpful in drawing legible designs on dark-colored fabric; water-based paints applied with writing brushes may also be used to trace the design (see fig. 58).

Other methods of design transfer include basting through a piece of tissue paper on which the design has been outlined (Brittain 1990, 16; Brown 1994, 10; Chung 1979, 19; Saint-Aubin 1983, 21). In some cases, as a final step before the actual stitching begins but after the major design elements have been drawn on the embroidery fabric in pencil or paint, fields of brush-applied paint may be added as part of the design (as in the gold-colored sky of *Spectacular Spring*, cat. no. 14).

### Planning the Embroidery

The eighty embroiderers at the institute work in fourteen separate rooms, some of which are named after the stitch in which they specialize (e.g., fourteen workers in the Random Stitch Embroidery Research Studio, others in the Fine Stitch Embroidery Studio, where traditional stitches are researched). The stitching frames are set along windows to exploit the color balance and freshness of natural light (see fig. 59).[3]

The stitching at the institute is a combination of structure and artistry, and the process of developing a solution to achieve unique results can be extremely time-consuming. Embroidery is by far the longest of a complex sequence of production steps; an individual worker in the Random Stitch Embroidery Research Studio may devote anywhere from six months to four years to a single embroidery.

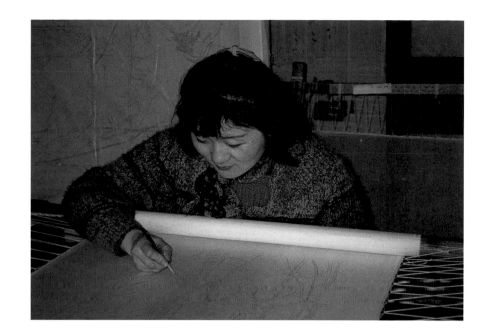

**FIGURE 57**
The designer is tracing an outline for embroidery onto stretched embroidery fabric, using a sharp lead pencil. Photograph by Shen Guoqing, Suzhou Embroidery Research Institute, 1998.

**FIGURE 58**
The design has been outlined in both pencil (bamboo) and white paint (crane). Photograph by Jo Q. Hill, Suzhou Embroidery Research Institute, 1998.

**FIGURE 59**
Individual embroidery workers at their stations aligned along the windows in the Fine Stitch Embroidery Studio. Photograph by Jo Q. Hill, Suzhou Embroidery Research Institute, 1997.

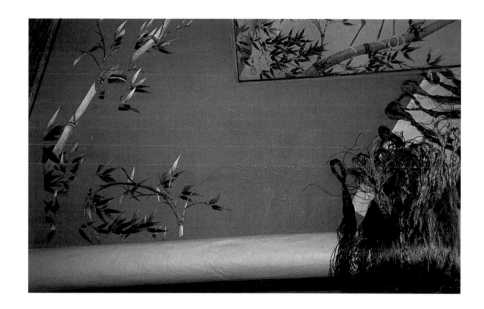

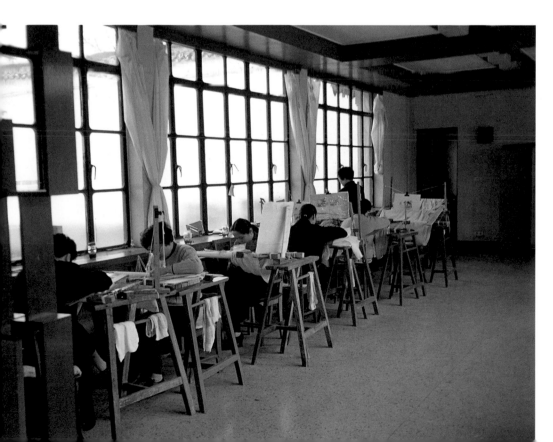

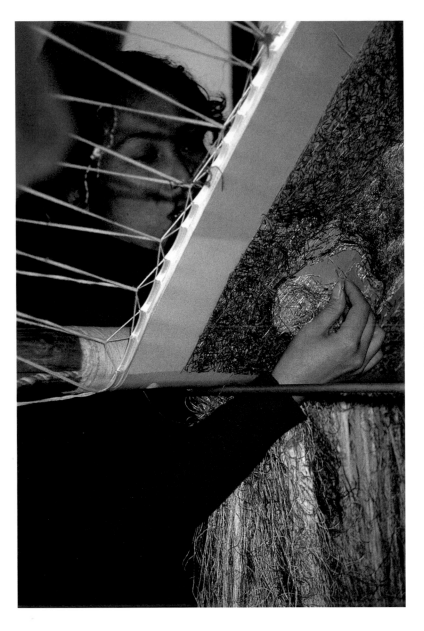

After the embroiderer is given a new project (embroidery fabric stretched onto the fabrication frame with the design already outlined in pencil or, less frequently, a gouache-like paint), she generally considers various working methods in solitude.[4] This period of study—during which the original work to be translated is scrutinized with careful attention to color, form, mood, and texture—may last several hours or a couple of days. Then the leader of the embroidery studio listens to the initial proposals for stitch type and color choice. Eventually the entire roomful of embroidery workers enter into a spirited discussion, each worker offering opinions based on long years of experience. Such discussions continue throughout the process of making the piece.

After consultation with embroidery masters such as Zhang Meifang (director of the institute), Huang Chunya (head of the Random Stitch Embroidery Research Studio), or Chen Caixian (retired senior crafts master), the best method of achieving the desired final effect of the embroidery is determined. Several trials may be needed in order to select the most effective stitches for a particular project. Either near the beginning of the project or when the piece is finished, the embroiderer makes a small sampler showing the thread colors and stitch types used in the embroidery. This is retained for use as a guide while embroidering or, if made after the fact, as a record, along with the written notes on each embroidery.

This careful planning is manifested in *Sumac along the Chattahoochee* (cat. no. 20). Although the embroidered textile is only millimeters deep, a heightened sense of depth has been achieved visually through the progression of color and stitch, from the black fabric to the rearmost layers of foliage, and from the middle ground to the red sumac details in the foreground.

Despite the long initial decision-making process at SERI, the embroiderers feel that a large part of their creativity and skill is employed while stitching, in their constant attention to achieving the final desired effect. This is the "R" portion of the name SERI for the embroidery workers; they feel that they are not just working, but are actively interpreting in a dynamic act of creation. They are conducting constant research.

FIGURE 60
Mei Guiying, like all the SERI embroiderers, works her stitches by passing the needle quickly from one hand (on the obverse) to the other hand (on the reverse). Photograph by Jo Q. Hill, Suzhou Embroidery Research Institute, 1998.

## Embroidery Tools

Remarkable as the embroideries are in terms of their execution, the tools employed to produce them are relatively simple. The needles used by SERI embroiderers are typically long and thin with a sharp tip and tapered eye. After tying a thin strand of silk embroidery floss to the eye of the needle, the first stitches are quickly laid onto the support fabric without visible knots or ties; all the embroiderers sew with both hands (see fig. 60). Traditionally only straight needles have been used at the institute, but curved needles are now increasingly employed for specific purposes in the Random Stitch Embroidery Reseach Studio since the author's introduction of surgical needles in early 1997.[5]

Other simple embroidery tools include fine scissors for cutting silk embroidery floss, clear plastic sheets with holes cut in them to protect the support fabric and silk embroidery stitches from dust and skin oils while the work is in progress, maulsticks used as armrests during stitching, and cloth drapes to protect the textiles from the ultraviolet and infrared radiation of the otherwise desirable natural light from the windows adjacent to the workers' embroidery stations (see fig. 61).

FIGURE 61

An overhead view of an embroidery in progress on a small trestle. This photograph shows the original work being translated, a maulstick for supporting the embroiderer's left arm, braided strands of silk floss sorted by color, and a variety of small tools. Photograph by Jo Q. Hill, Suzhou Embroidery Research Institute, 1998.

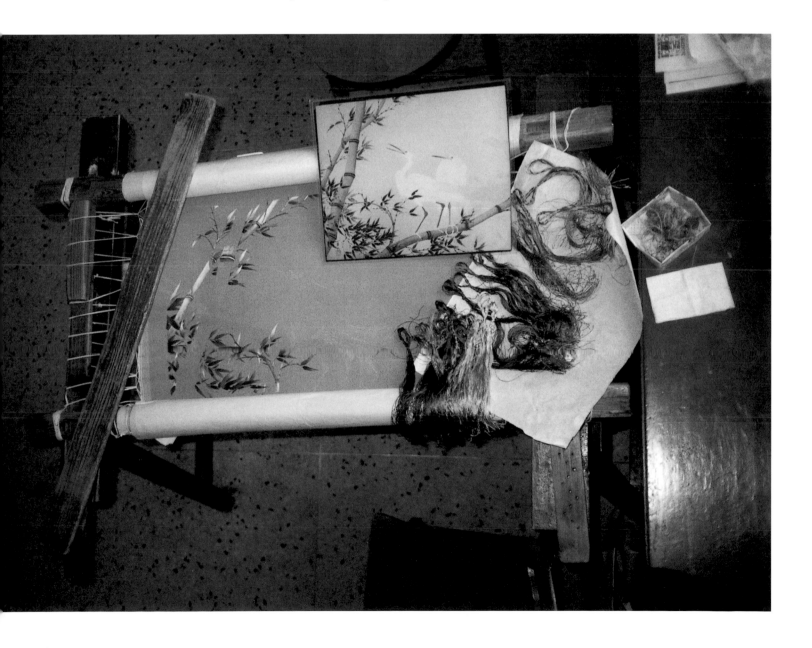

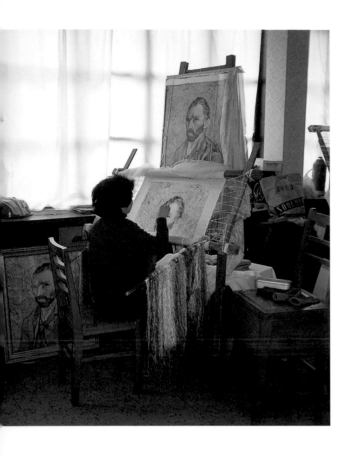

FIGURE 62
Mei Guiying works from a print (top image)
in swirling stitch patterns. A completed
embroidered version of this van Gogh
self-portrait is propped against the wall at
her side. Photograph by Jo Q. Hill, Suzhou
Embroidery Research Institute, 1997.

FIGURE 63
The embroiderer refers to the original
image every few stitches to continue
the complex creative process of interpre-
tation. Photograph by Jo Q. Hill, Suzhou
Embroidery Research Institute, 1998.

FIGURE 64
Mei Guiying selects a particular shade
for the hat area of this van Gogh image.
Photograph by Jo Q. Hill, Suzhou
Embroidery Research Institute, 1998.

FIGURE 65
Mei Guiying pierces the embroidery
fabric with her long, thin needle threaded
with very fine silk floss. The small print
propped on the embroidery fabrication
frame is a reminder of her last project,
a van Gogh self-portrait. Photograph
by Jo Q. Hill, Suzhou Embroidery Research
Institute, 1998.

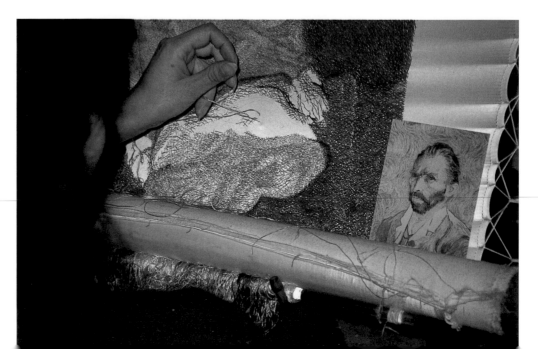

## Embroidery Stitches

Planned well in advance, the progression of stitches in the execution of an embroidery reflects careful thought by the original artist and individual embroiderer, supported by their coworkers, leaders, and master embroidery consultants. The original artwork is kept in close proximity for reference, and the embroidery workers glance at it frequently as they verify stitch placement, juxtaposition of color, and the overall progress of the work (see figs. 62–64). Working from the top of the design to the bottom, the workers unroll and reroll the embroidery in progress every time it needs to be repositioned on the fabrication frame (see figs. 64, 65).

Culled from a centuries-long tradition of textile adornment, more than forty different embroidery stitches are currently in routine use at the institute.[6] Various special stitches employed in functional Chinese embroidered textiles have been adopted by fine arts embroidery groups such as SERI, including stitches executed with plied twist silk floss to create an interesting rough texture, human hair embroidery (see *Emperor Kangxi's Inspection Tour of South China* [1990; cat. no. 6]). As a research institute, SERI prides itself on both drawing from tradition (Wang 1987, 10–23, 148–51; Mailey 1978, 9–16) and on the innovative experimentation that characterizes its recent work.

Both in their daily work and in the training of embroiderers, the institute's administrators consider knowledge of basic stitches to be of primary importance;[7] only then can these stitches be creatively applied to attain particular effects: for example, to create variations in the reflectivity of the silk floss in order to translate a photographic image into a complex, multilayered, colorful textile (see fig. 66). The virtuosity in embroidery stitching that all the SERI workers aspire to is considered to have been achieved when stitched silk "strokes" capture the vitality of living beings: the moist eyes of cats, the translucency of fish fins, and the tangible softness of animal fur and bird feathers.

FIGURE 66

SERI embroiderers in the Random Stitch Embroidery Research Studio pore over an American embroidery encyclopedia; these workers provided the Chinese translations of the stitch names found in the glossary, stitches that are used by both Chinese and American embroiderers. Photograph by Jo Q. Hill, Suzhou Embroidery Research Institute, 1998.

Key concepts are embodied in the stitches themselves; these concepts are best understood by studying the "process" embroideries that are used as study pieces for embroidery students. These embroideries are copied from photographs, and the progression of stitches and layering of colors (especially the use of contrast for emphasis) is very clear, even to the novice. Layered progressively in the process embroidery of three hands, the *san tao zhen* (shaping and shading stitch) communicates the sheen and subtle variations of color (fig. 67). The three-dimensionality of form evident in this process embroidery was achieved by skillful application of carefully chosen colors. Contrast of color is one of the methods employed to impart the startlingly lifelike quality to the fur of the three cats (see fig. 68); compare the texture of the soft fur inside the ears with that of the stiff whiskers on the cats' faces.

The importance of mastering the application of basic stitches can clearly be seen in a process embroidery of three apples (see fig. 69) in which *chan zhen* (satin stitch) was used to outline and impart a sense of three-dimensionality to each apple: one with diagonally oriented hatch-like, parallel stitches (*xie zhen*); the second with radiating vertically oriented stitches (*chan zhen*); and the third with curving concentric satin stitches. Each apple is dramatically different in its expression. The most lifelike is the third apple; the embroiderer was successful in her experiment of curving the same stitch that rendered the other apples relatively less lifelike.

Internationally stitches are named and classified according to their structure. For instance, in the United States surface embroidery stitches are classified according to such categories as line stitches, couching stitches, raised stitches, and short or long stitches. This is generally true of Suzhou stitches as well, but in Suzhou embroidery the structure of the stitch is integral to its effect, and this is often reflected in the name. For example, two of the most basic stitches employed in SERI work are related: *xie zhen* and *chan zhen*, diagonal and vertical satin stitches (Brown 1994, 24). In these two satin stitches, directionality has a critical

FIGURE 67
Three-dimensionality, delineation of mass, and illusion of depth are communicated in this process embroidery of three hands. Note the subtle variations in stitch angle and the consequent differences in light reflection from the silk stitches.

effect on the interplay of light and color (Zhang 1989, 41). The literal translation of *san tao zhen* is "scattering stitch," an appropriate description of how light dances across the silk stitches (Brown 1994, 25; Zhang 1989, 46–47).

Suzhou fine style embroidery includes the approximately forty stitches in common use at SERI but excludes random stitch embroidery, a contrasting method. Characterized by even tension; deft execution; and the use of parallel lines, slanting rows, and clever knots, Suzhou fine style embroidery encompasses the stitches known in the United States as chain stitches, satin stitches, and French knots, which are used to create highly reflective fields of color.

Some of the special stitches unique to Suzhou fine style art embroidery were developed by the Suzhou native Shen Shou (1874–1921) in the late Qing dynasty; her knowledge and skill have been transmitted to other embroidery experts through her influential *Xueyi's*

FIGURE 68
Process embroidery of three cats. Note the smooth curving whiskers and the soft, nearly tangible fur on the insides of the ears.

FIGURE 69
Process embroidery of three apples. Note how the satin stitch has been applied in each apple with strikingly different results.

FIGURE 70
Shen Shou's influential **XUEYI'S EMBROI-
DERY HANDBOOK**, next to technical
notes on SERI embroideries that are copies
of famed ancient textiles. Photograph by
Jo Q. Hill, Suzhou Embroidery Research
Institute, 1998.

FIGURE 71
**PALE LEAVES IN BLUE FOG** (cat. no.
30), completed but still on the fabrication
frame. Note the stitch sampler propped
on the far corner of the frame. It shows the
experimental "acupuncture needle stitch"
that was so successful in rendering lifelike
dew drops on the leaves. Photograph by
Jo Q. Hill, Suzhou Embroidery Research
Institute, 1997.

*Embroidery Handbook* (*Xueyi Xiupu*; see fig. 70; Suzhou City Embroidery Research Institute n.d., 8; Hu 1993, 9; Suzhou City Embroidery Research Institute 1976, 3).

Random stitch embroidery (*luanzhen xiu*), considered a variety of cross-stitching, is a classic stitch that was invented by Yang Shouyu (1896–1981) from Jiangsu Province (Suzhou City Embroidery Research Institute n.d., 8). It has been described as "another new vitality infused into traditional Chinese embroidery" (Hu 1993, 9). Random stitch embroidery is often utilized in the background of a design to create a general field of color with diffuse light reflection. The overall effect of the finished embroidery comes from the interplay between this "random needling" and the disciplined parallel stitches of the Suzhou fine style embroidery used for the design elements, which show detail and strong light reflection.

Some of the SERI stitches have long been in use, such as the variation of petit point stitch (*dadian zhenfa*) seen in such works as *Geese among Reeds* (1992; cat. no. 7). Other stitches have been invented to solve difficult challenges in translating image into embroidery. For instance, the dew on the leaves in Ketchum's *Pale Leaves in Blue Fog* (1996; cat. no. 30) has been brilliantly executed in a naturalistic three-dimensional manner with the "acupuncture needle stitch." In this unusual technique a row of special silk knots is sewn over a thin, acupuncture needle (which is subsequently withdrawn; see fig. 71).

## The Mounting and Display of SERI Embroideries

Silk embroidered artworks can be mounted and displayed using a wide variety of methods. At SERI works are typically mounted to a glass support (see fig. 72) by adhering the edges of the support fabric to the edges of a sheet of glass with a paste adhesive made from a mixture of protein and starch (wheat and rice starch are probable inclusions).[8] Two-sided works of assorted sizes include: the small table screen *Snowfall*; single-panel large floor-standing screens such as *Silver Star Crabapple* (1995; cat. no. 13); and multipanel folding screens such as *The Beginning of Time*. Alternatively, the more traditional method of mounting on a paper support (often backed with wood panels) yields a one-sided embroidery such as *Nine Carp* (1989; cat. no. 3). The latter method probably originates from the traditional technique of adhering an embroidery executed on paper or gauze to the fabric of constructed garments (Paine 1990, 20) and can be seen in such examples as the large one-sided human hair embroidery on silk fabric *Emperor Kangxi's Inspection Tour of South China*.

Unique constructions produced at SERI are assembled to achieve particular effects, such as the shadow box appearance of *Magnolia* or the double-layered construction of *Three Trees* (1996; cat. no. 32). Ketchum's works lend themselves particularly well to such unusual mounting methods, as they are translations of color photographic prints. *October 24, 1983/2:10 p.m.* (1991; cat. no. 22) and *Double-Wide Wasatch* (1993; cat. no. 24) are mounted so that the display frame mimics the frame used for execution of embroidery. Both *Wild Meadow* (1988; cat. no. 18) and *Sumac along the Chattahoochee* are mounted as traditional photographs and invariably fool the casual viewer until close inspection reveals that the work is actually a brilliantly colored and expertly stitched textile rather than simply a remarkable photographic image.

FIGURE 72
While still stretched taut on the embroidery fabrication frame, the edges of the support fabric are glued to a sheet of weighted glass with wheat starch paste. Photograph by Shen Guoqing, Suzhou Embroidery Research Institute, 1998.

Blending tradition and innovation, the textiles that have resulted from the collaboration between the Suzhou Embroidery Research Institute and Robert Glenn Ketchum reflect the creativity and technical virtuosity of the institute's world-class embroiderers. In these works the institute has pushed the embroidery medium to its limits. Mastery is evident at every stage of production: the extraordinary coordination between hand and eye as an image unfolds in a series of rapid stitches, the ingenious adaptation of modern materials and tools such as polyacryl fabric and curved needles, and the painstaking maintenance of tension to the fabric as it is adhered to a thin sheet of display glass to create a double-sided presentation. What shines through in these works, as the light plays on the silk threads, is not just the brilliance of the technique but an enlightened wisdom that draws on both ancient tradition and modern ideas.

●

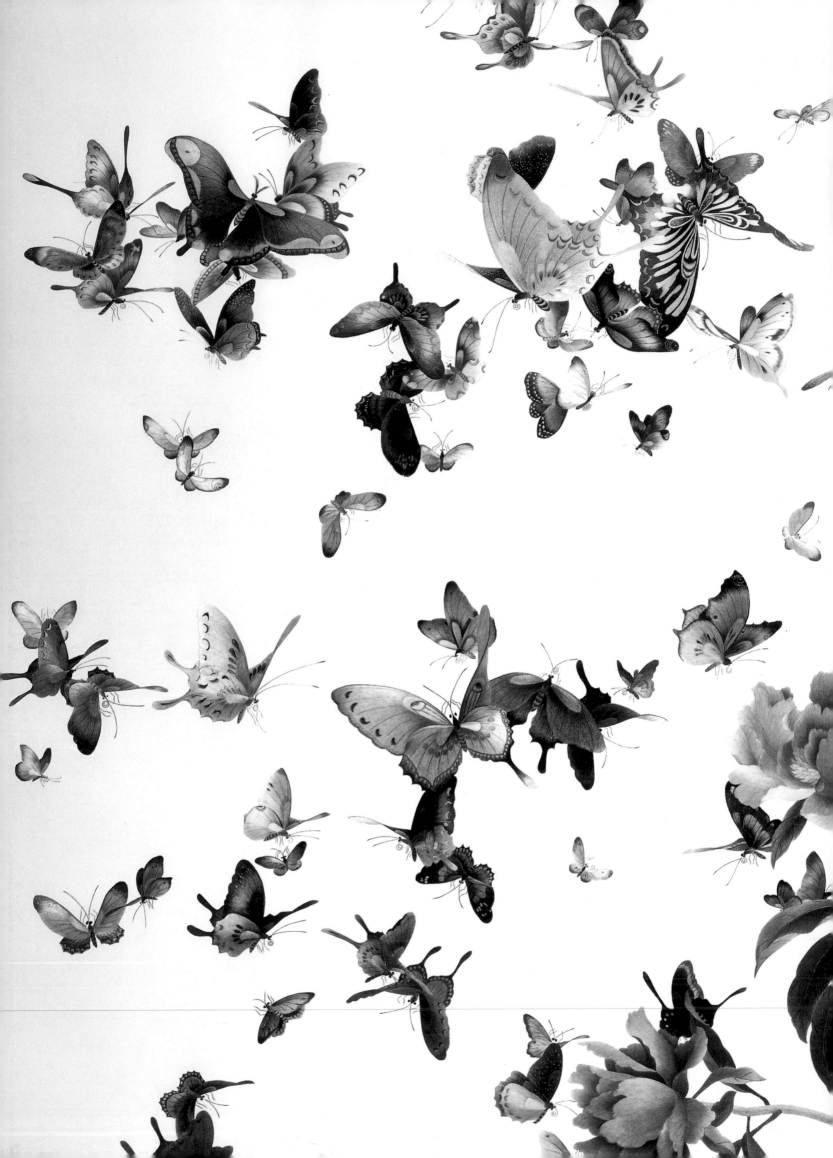

Catalog

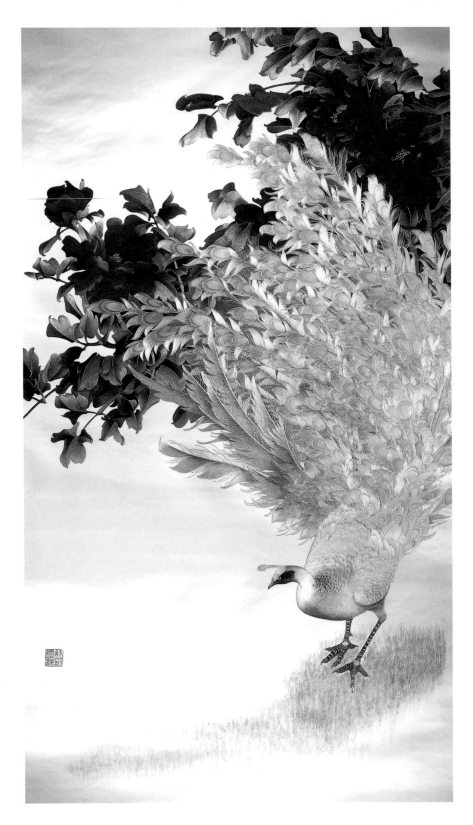

1

**Fluttering**

翩翩

1985
Suzhou fine embroidery
Silk thread on silk satin
175 x 94 cm

Painting by
Zhou Tianmin (周天民)

Embroidered by
Shan Xiaoping (單曉萍)
and others
Lent by the Suzhou Embroidery
Research Institute

Fantastic birds with elaborate tails have been a theme in Chinese art from ancient times. In this case the white peacock's tail serves as the point of departure for a tour de force in the representation of texture and reflection in embroidery. Zhang Meifang calls the viewer's attention to the sound suggested by the work: "The peacock is fluttering very slightly and very beautifully. The character of this embroidery lies in the colors: the white peacock, black leaves, and red flowers. The combination of these three colors has a very beautiful effect." The flowers are peonies.

2
**Spring Returns
to the Great Earth**
春回大地
1986
Suzhou fine embroidery
Silk thread on silk satin
125 x 360 cm

Based on a collaborative
painting by
(1) Cheng Shifa（程十發）
(2) Guan Shanyue（關山月）
(3) Li Kuchan（李苦禪）
(4) Xiao Shufang（蕭淑芳）
(5) Chen Dayu（陳大羽）
(6) Zhang Jiqing（張繼馨）
(7) Tang Yun（唐雲）
(8) Wang Geyi（王個簃）
(9) Xu Shaoqing（徐紹青）
(10) Zhu Qizhan（朱屺瞻）
(11) Zhang Xinjia（張辛稼）
(12) Huang Zhou（黃冑）
Title calligraphy by
(13) Zhao Puchu（趙樸初）

Embroidered by
Wang Linying（王林英）
Xu Meiling（徐美玲）
Gao Hong（高紅）
Zhang Yimin（張毅敏）
Gui Chanjue（歸嬋愨）
Zhou Wenying（周文英）
Lent by the Suzhou Embroidery
Research Institute

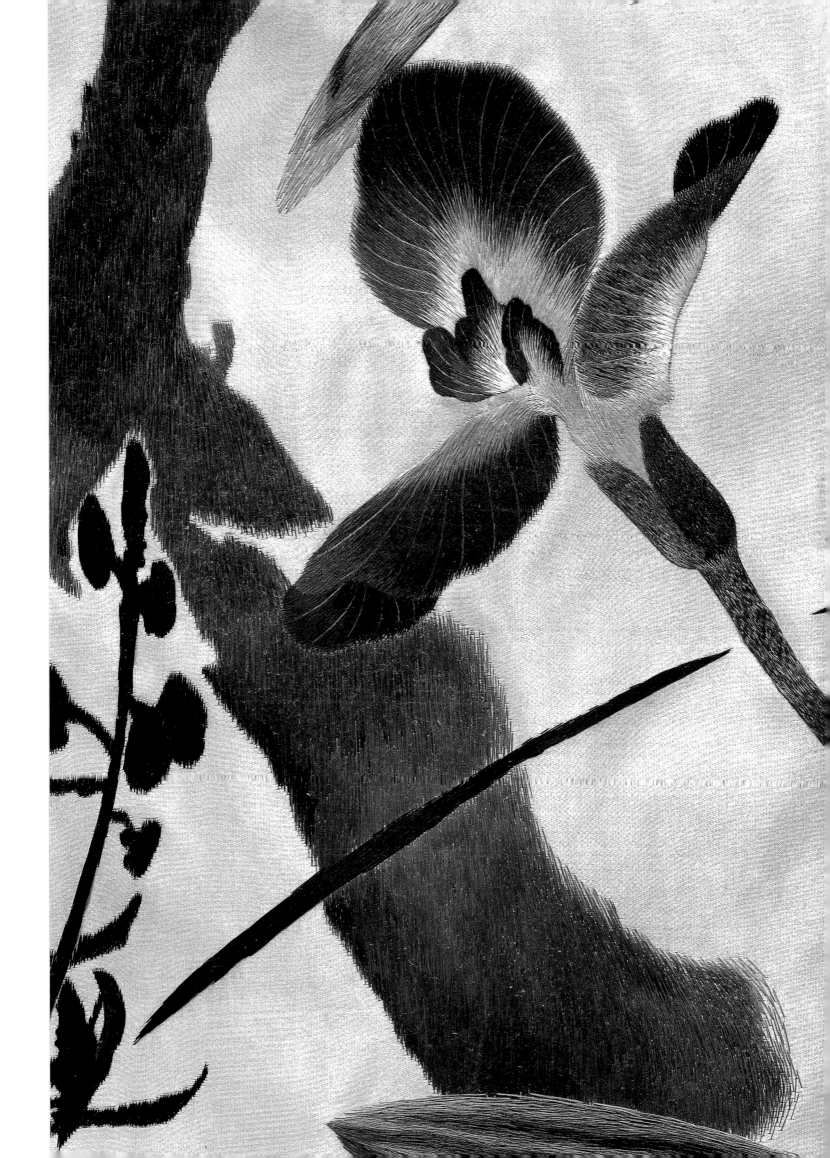

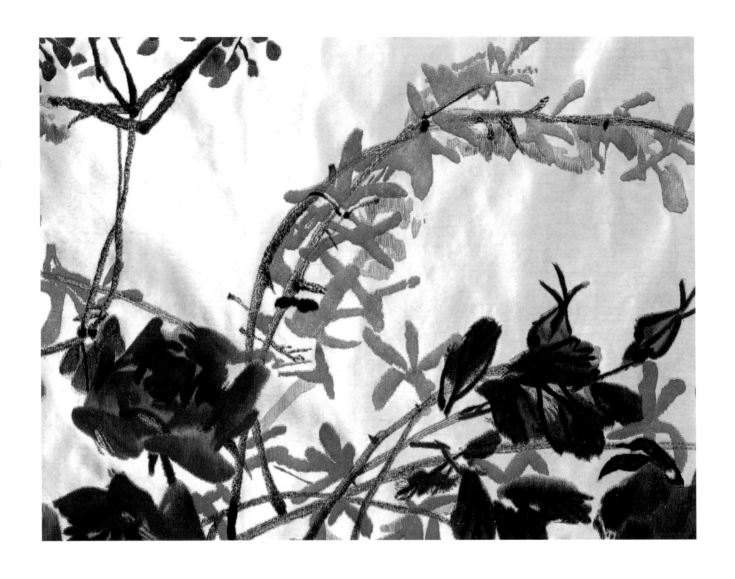

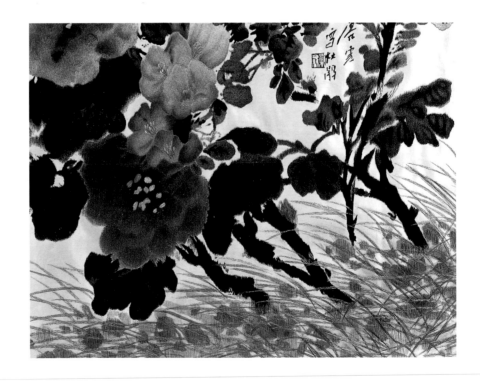

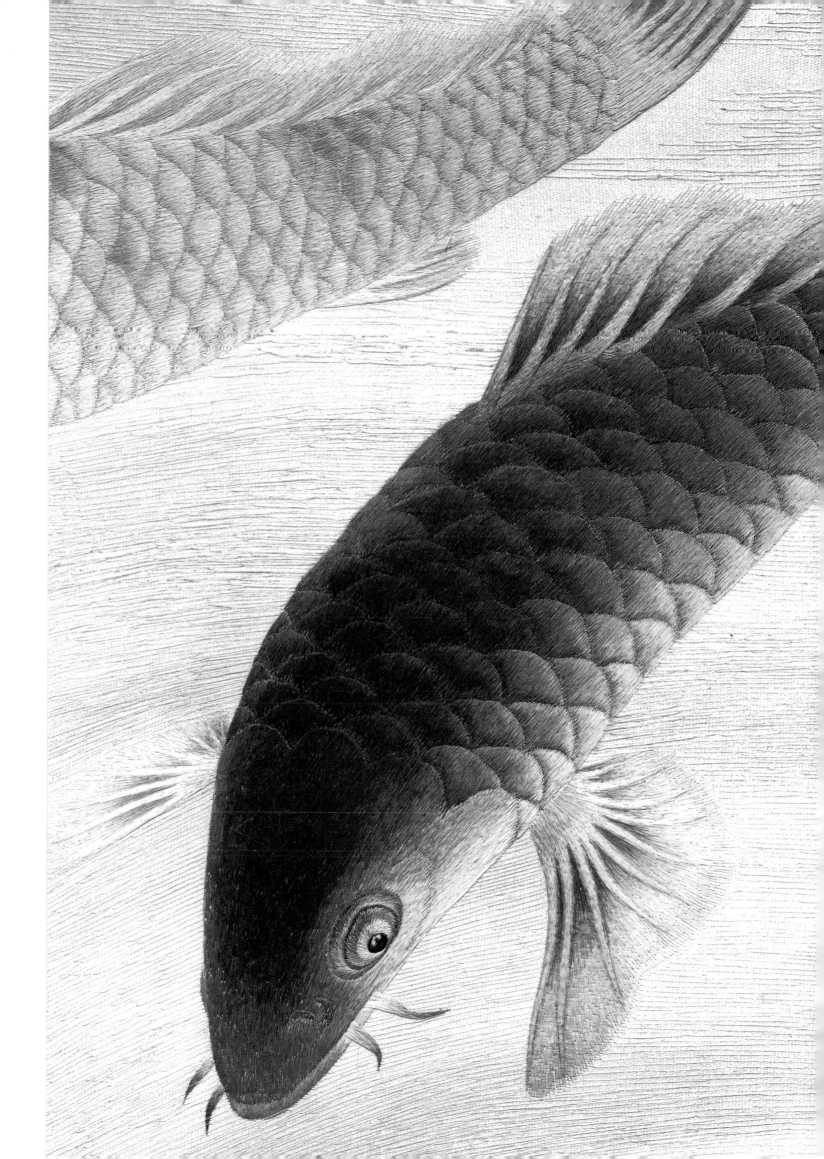

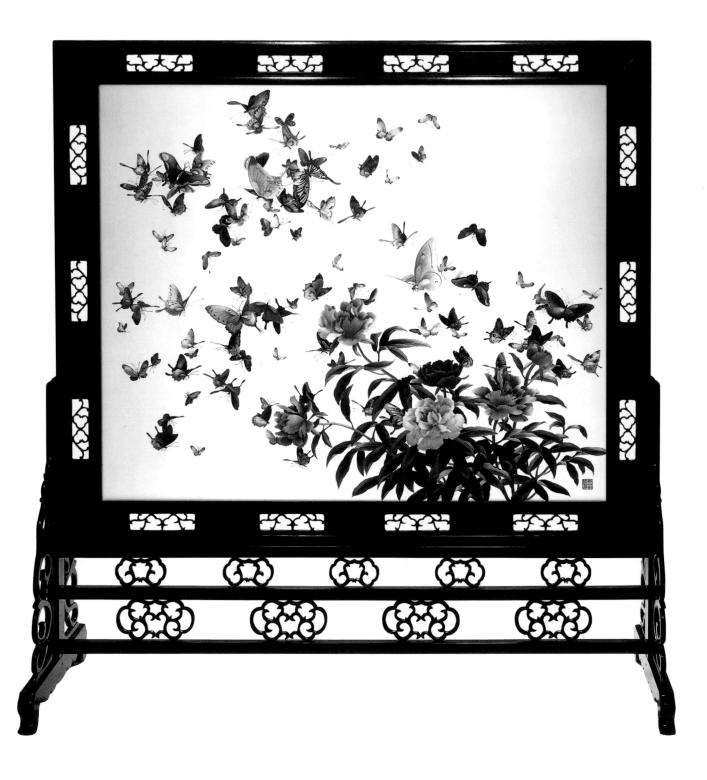

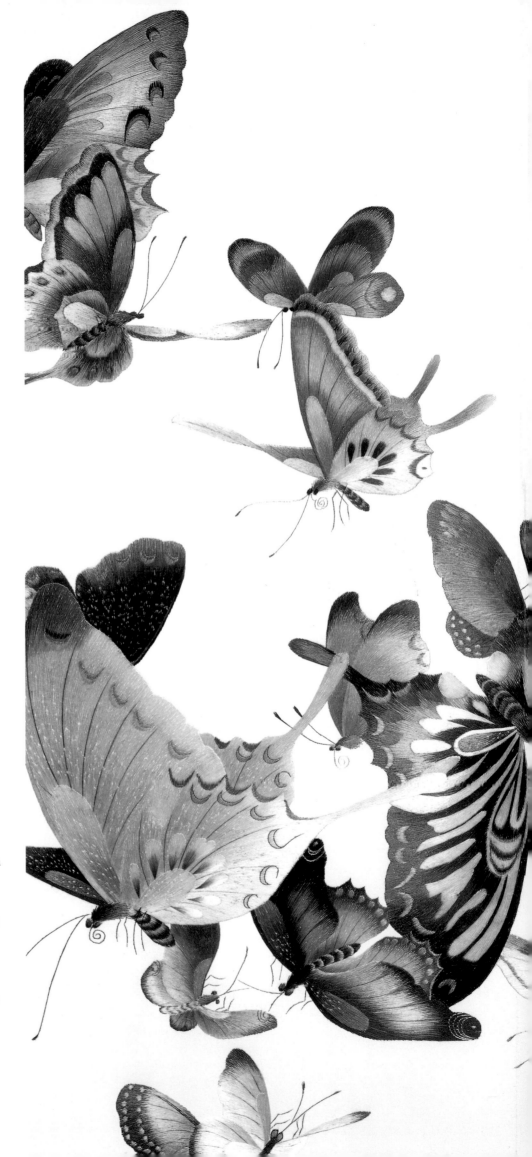

**4**
**One Hundred Butterflies**
百蝶
1989
Suzhou fine embroidery
Silk thread on silk gauze
98.5 x 119 cm

Based on a painting by
Huang Xiang (黄莾)

Embroidered by
Ren Huijuan (任惠娟)
Shi Yi (施怡)
Zhu Huifen (褚惠芬)
Lent by the Suzhou Embroidery
Research Institute

Butterflies — delicate, colorful,
and gay — are another favorite
theme of Chinese painters. Like
fish, they are a subject that is par-
ticularly well suited to double-
sided embroidery because of its
ability to communicate the illusion
of floating. The number one hun-
dred connotes perfection or com-
pleteness. Shen Guoqing remarks:
"Here the colors and the styles of
the hundred butterflies are all
quite different and quite beauti-
ful, and they convey a sense of the
way animals feel in 'the great
nature.'"

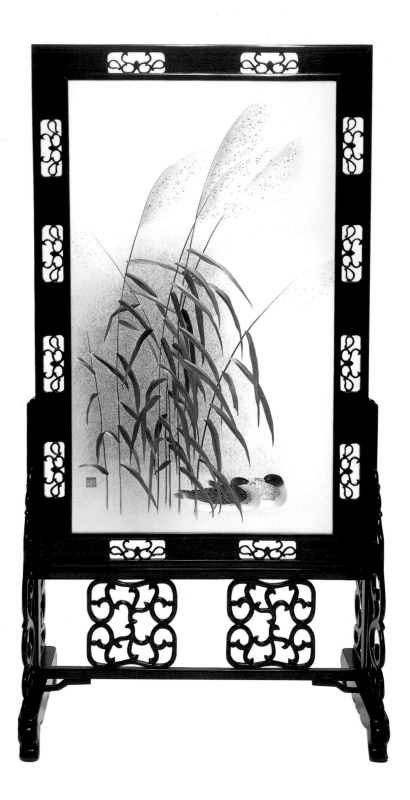

5

**A Pair of Ducks beneath
Reed Catkins**

蘆花雙鴨

1989

Suzhou fine embroidery

Silk thread on silk gauze

100 x 58 cm

Based on a painting by
Wang He (王河)

Embroidered by
Li Wenhua (李文華)
Lent by the Suzhou Embroidery
Research Institute

A pair of ducks represents fidelity,
especially marital fidelity, in Chinese iconography because ducks
are believed to mate for life. "Two
ducks on a small river convey a
sense of silent motion," Zhang
Meifang observes. The reeds are
common in the region around
Suzhou; in this picture they are in
their autumn stage.

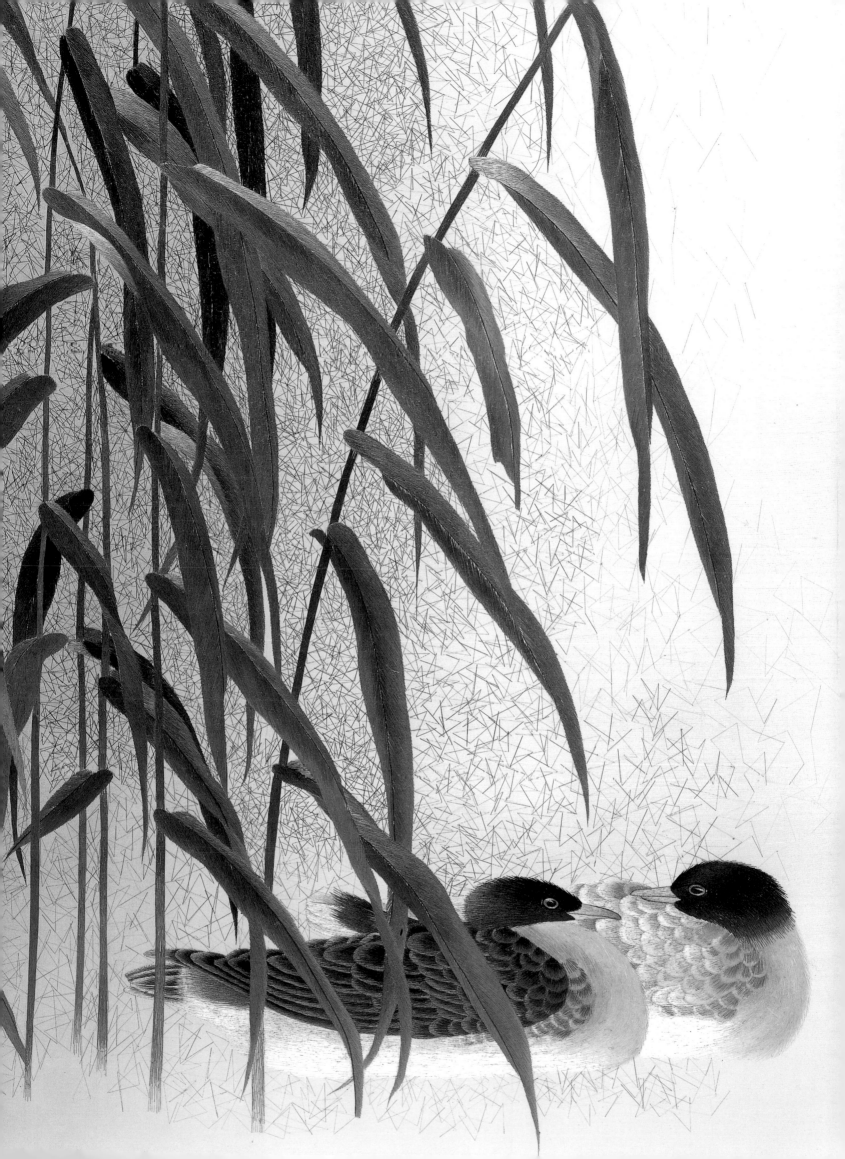

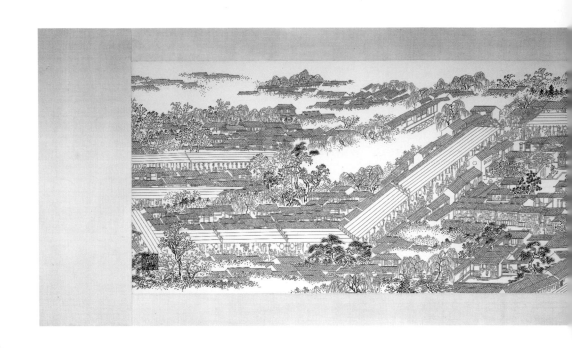

## 6

**Emperor Kangxi's Inspection
Tour of South China**

康熙南巡圖

1990

Suzhou fine embroidery

Human hair and paint on silk

Four panels, 65 x 641 cm overall

Based on a painting by
Wang Hui (王翬), Qing dynasty

Embroidered by
Zhou Chunying (周春英)
Chai Quanyun (柴全雲)
Fang Hui (方卉)
Wu Yudi (吳玉娣)
Luo Xiao (羅曉)
Lent by the Suzhou Embroidery
Research Institute

In 1689 the Kangxi emperor of the Qing dynasty traveled for the second time from the capital in Beijing to south China to inspect water control projects and also to make a political impression in a region where opposition to the Qing had been widespread. He made six trips in all, but the second trip was documented in a series of twelve scroll paintings overseen by the painter Wang Hui (1632–1717). Such a painting was unusual both because it was a court commission and because it depicted an imperial progress. This embroidery is based on the part of the painting that documented the emperor's visit to Suzhou. The streets of Suzhou are filled with people and decorated with awnings and lanterns (a local specialty). The number of people on the street, and their excitement, contrasts with life within

the walls, which is calm and domestic. One can only imagine the smells and tastes emanating from the many small stalls along the streets. In the second panel from the left, the lion dance just to the left of the bridge and the play being performed on a raised platform just to the right of the bridge, in the foreground, have drawn large crowds.

Human hair has traditionally been used in Chinese embroidery. According to Shen Guoqing: "One reason is that the use of hair makes the whole picture look simple and clear.... It is a traditional skill from the Ming dynasty." The imitation of a red seal that appears on this embroidery and the others in this section reads "Suzhou Embroidery Research Institute."

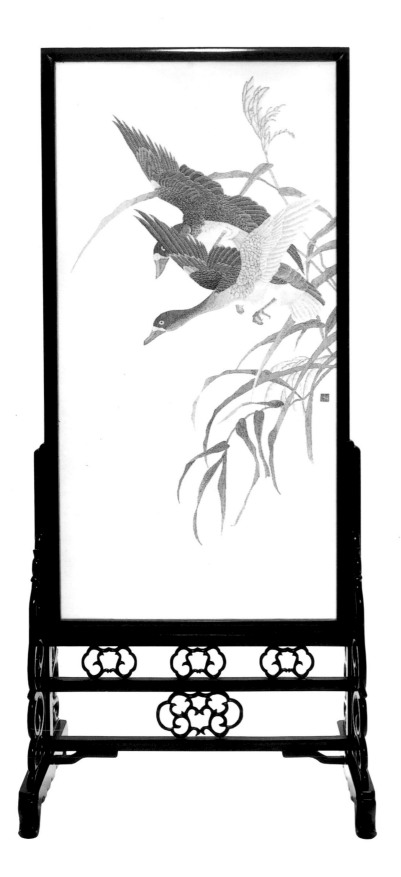

7
**Geese among Reeds**
蘆雁
1992
Petit point embroidery
Silk thread on silk gauze
126 x 60 cm

Based on a painting by
Chen Zifo (陳之佛)

Embroidered by
Chai Quanyun (柴全雲)
Lent by the Suzhou Embroidery
Research Institute

According to Zhang Meifang,
"The importance of this piece of
embroidery is the sense of move-
ment and the behavior of the two
wild geese—it's vivid and real—
very mild and very simple but very
beautiful." The almost obscured
eye of the second goose and the
postures of the geese communi-
cate the energy and suddenness
of a natural scene. This piece
is embroidered in petit point
(*dadian zhenfa*), in which the silk
thread is knotted around each of
the intersections of warp and weft
in the fabric to create detail. As
Zhang Meifang notes: "It conveys
the sense of dimness and haziness
very elegantly. [It is based on
a painting by] the very famous
Jiangsu painter Chen Zifo."

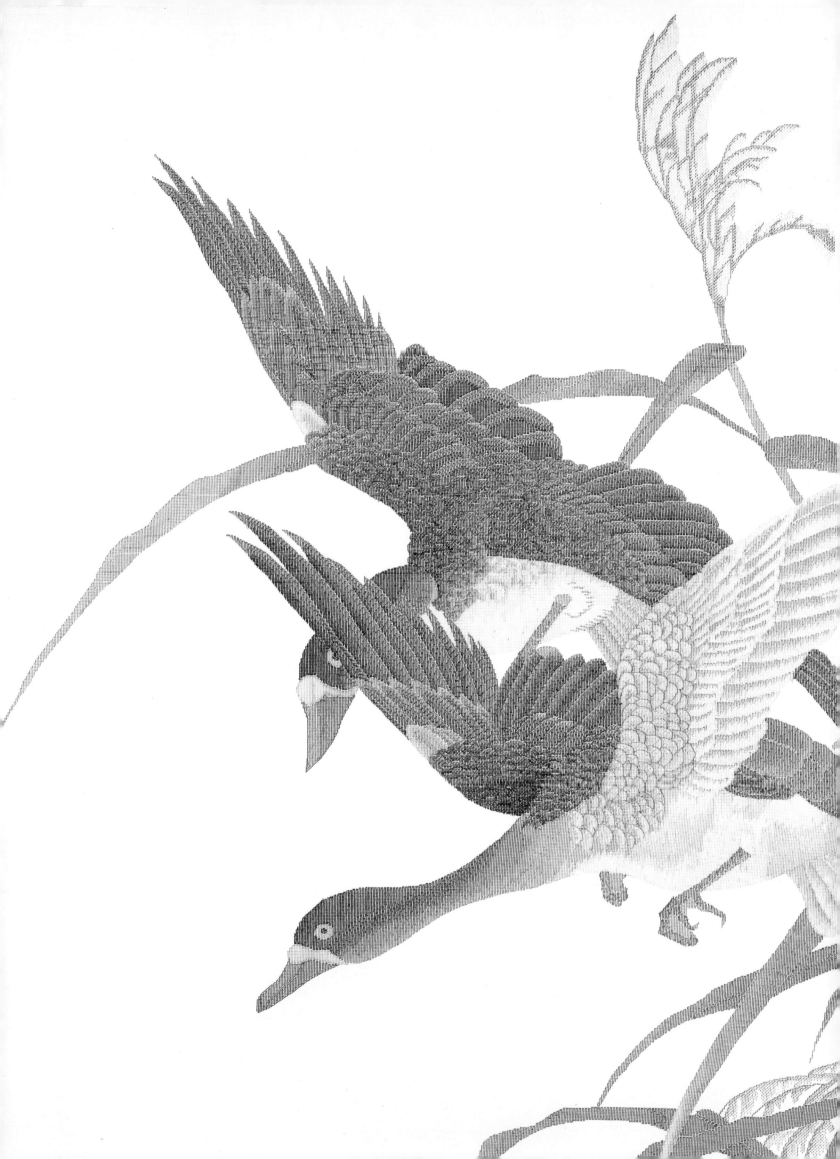

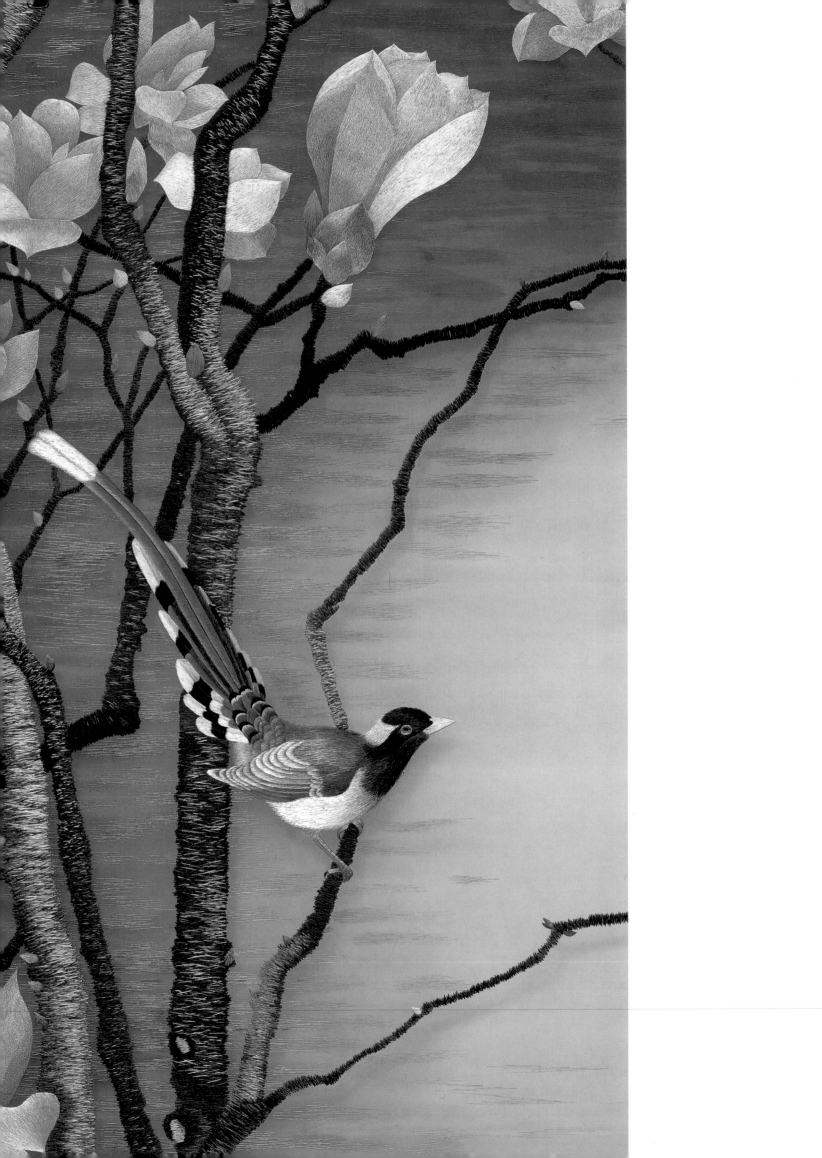

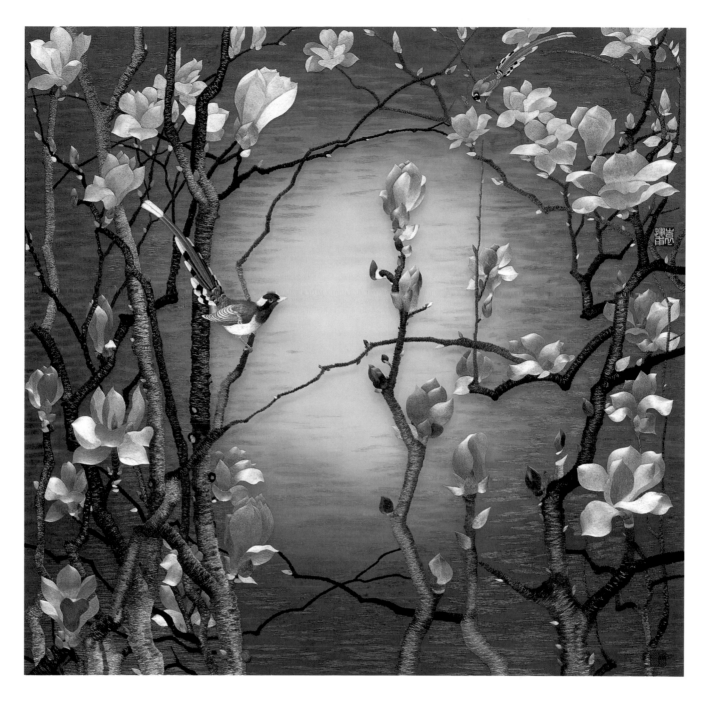

8

**Magnolia**

玉蘭

1993
Suzhou fine embroidery
Silk thread on silk gauze
101.5 x 101.5 cm

Based on a painting by Yuan
Yunfu (袁運甫)

Embroidered by
Zhuge Linmei (諸葛林妹)
Lu Xiuzhen (陸秀珍)
Zhu Huifen (褚惠芬)
Lent by the Suzhou Embroidery
Research Institute

Based on a painting in a modern
style, this work takes traditional
Chinese flower and bird painting
in a new direction. As Zhang
Meifang notes, "The importance
and central idea of this is the
beauty of this flower in the moon-
light." Its dark blue coloring is
intensified by underpainting on
the silk fabric. The tree depicted,
the Yulan magnolia (*Magnolia
denudata*), is native to China.
Because it blooms in the early
spring, it carries its blooms on
almost bare branches. The bird is
a magpie, associated with happi-
ness in China.

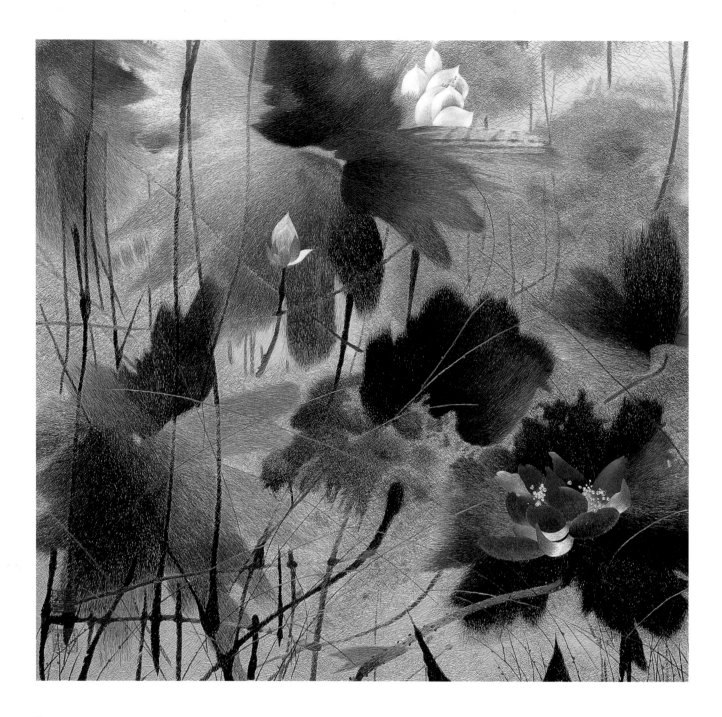

9

**Splashed Ink Lotus**
潑墨荷花
1993
Random stitch embroidery
and Suzhou fine embroidery
Silk thread on silk
101.3 x 101.3 cm

Based on a painting by
Yuan Yunfu (袁運甫)

Embroidered by
Qin Weimin (秦偉敏)
Lent by the Suzhou Embroidery
Research Institute

A fine example of the range of effects possible with random stitch embroidery, this piece expands the expressive quality of Yuan Yunfu's "splashed" brushwork with the addition of the reflective and textural qualities of silk embroidery. The contrast between the freely depicted leaves and stems (executed in random stitch embroidery) and the finely embroidered flowers (in Suzhou fine embroidery) strengthens the impact. Zhang Meifang notes that

this depiction "emphasizes likeness in spirit but not in appearance. You can see that the dark leaves of the lotus are very unrestrained."

124

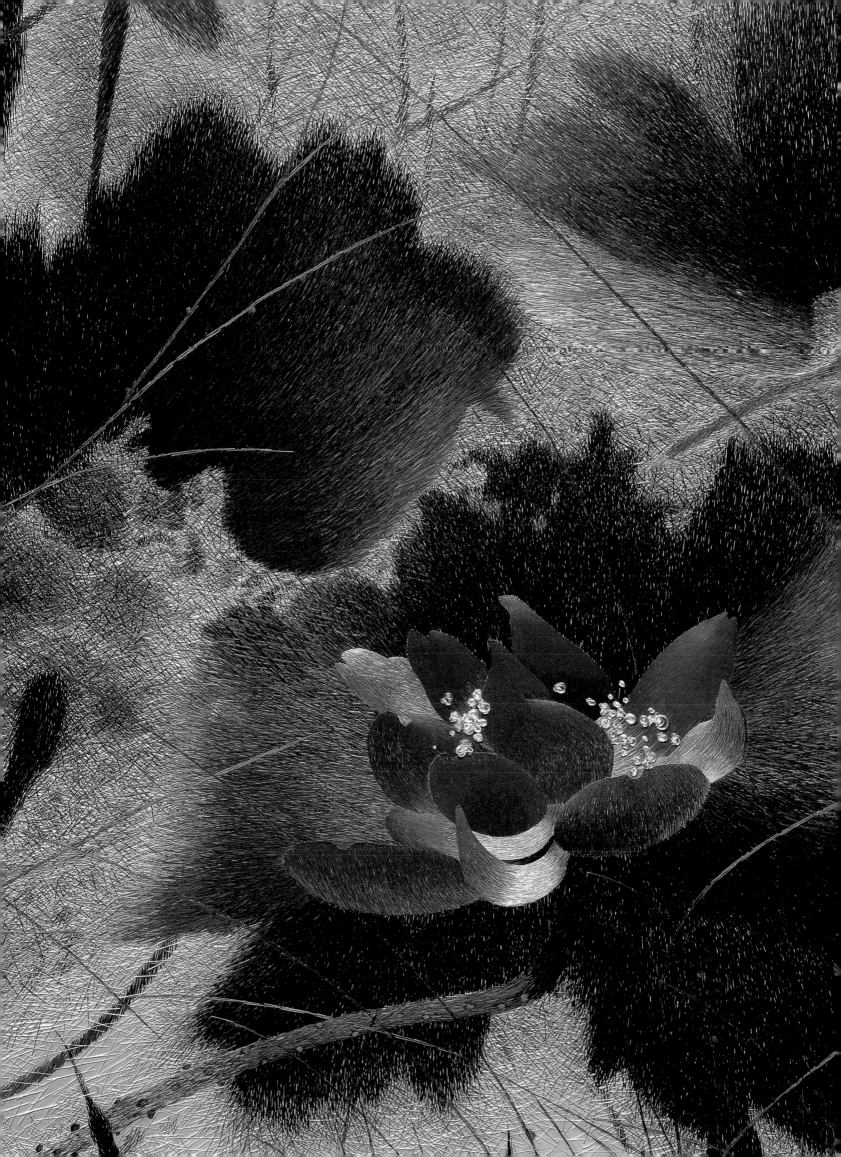

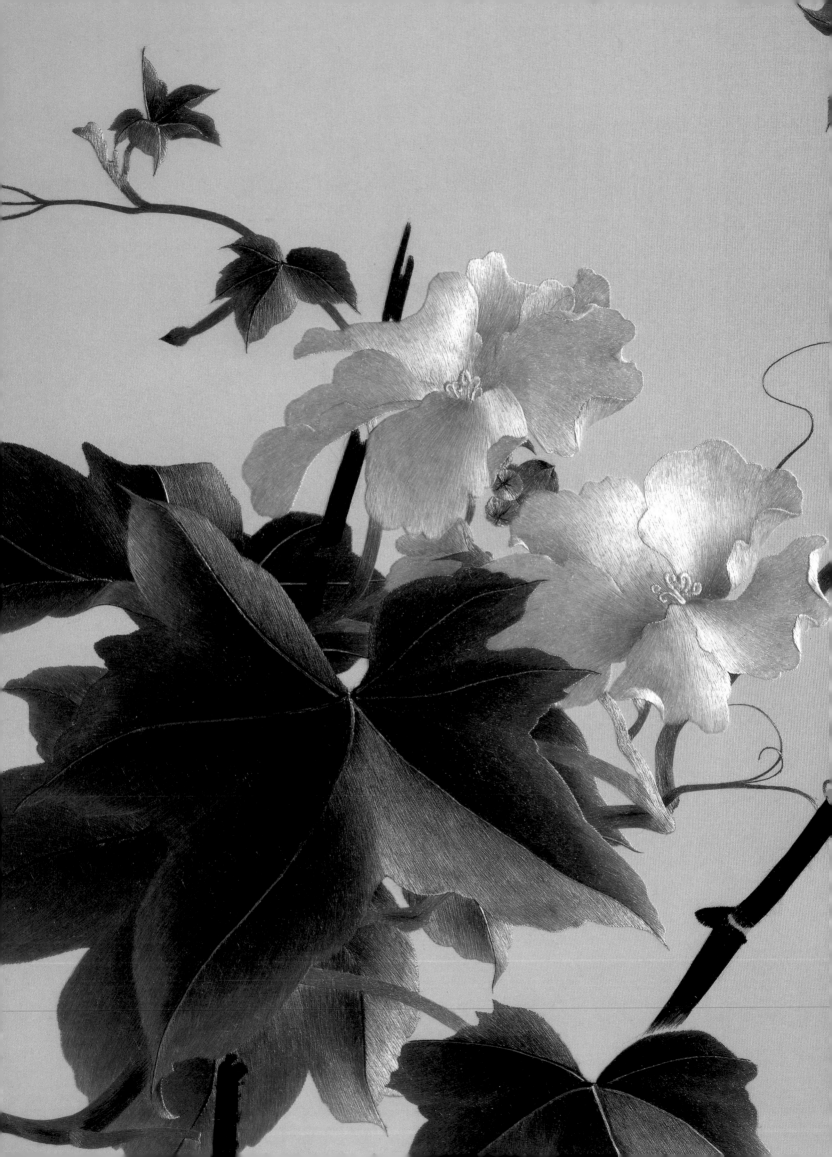

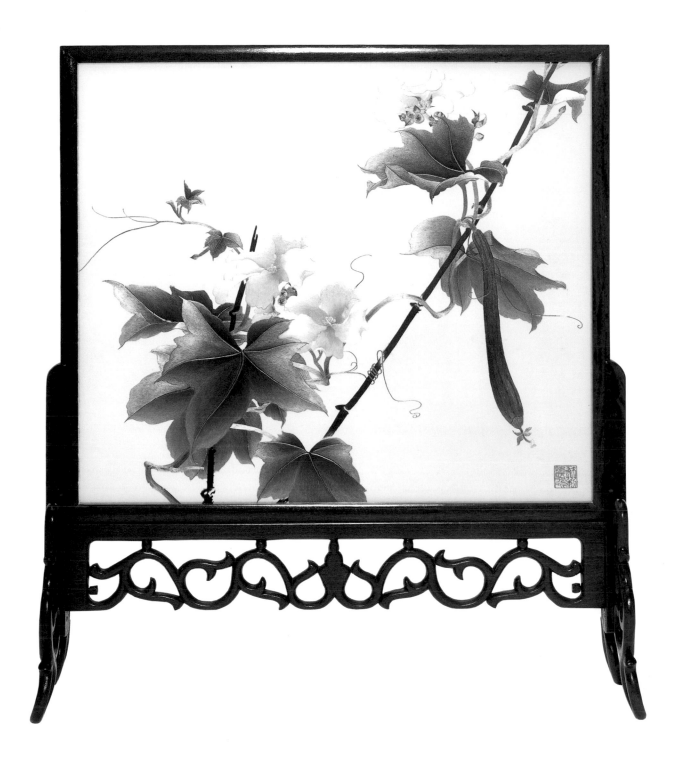

10

**Loofah Gourd Flower**
絲瓜花
1994
Suzhou fine embroidery
Silk thread on silk gauze
40 x 46 cm

Based on a painting by
Yu Zhizhen (俞致貞)

Embroidered by
He Liping (何麗平)
Lent by the Suzhou Embroidery
Research Institute

The painting of a loofah gourd
presented a chance for He Liping
to display her ability to create sub-
tle shading and a sense of depth in
needlework. Zhang Meifang

explains: "Some Chinese painters
draw their paintings simply in
lines, but this piece of embroidery
work shows nature very vividly."
Gourds are frequent subjects of
traditional Chinese flower and
bird paintings. Young loofah
gourds are eaten in a soup, while
the dried insides of mature gourds
are used as scrubbers.

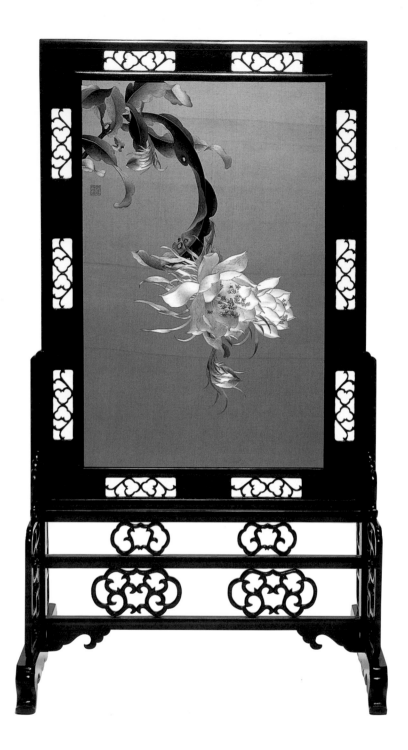

**11**

**Queen of a Night**

曇花

1994

Suzhou fine embroidery

Silk thread on silk gauze

78.5 x 48.5 cm

Based on a painting by
Li Changbai (李長白)

Embroidered by
Fang Hui (方卉)
Lent by the Suzhou Embroidery
Research Institute

The "tan flower" (*Epiphyllum oxypetalum*) blooms for only a few hours on a single night and is therefore referred to in Chinese as "queen of a night." A sense of the transience and fugitive nature of beauty is thus associated with this flower, a native of South and Central American lowland jungles. According to Zhang Meifang, the painter "is very representative of the south China character. The characteristic of his style is that it is very delicate and pretty."

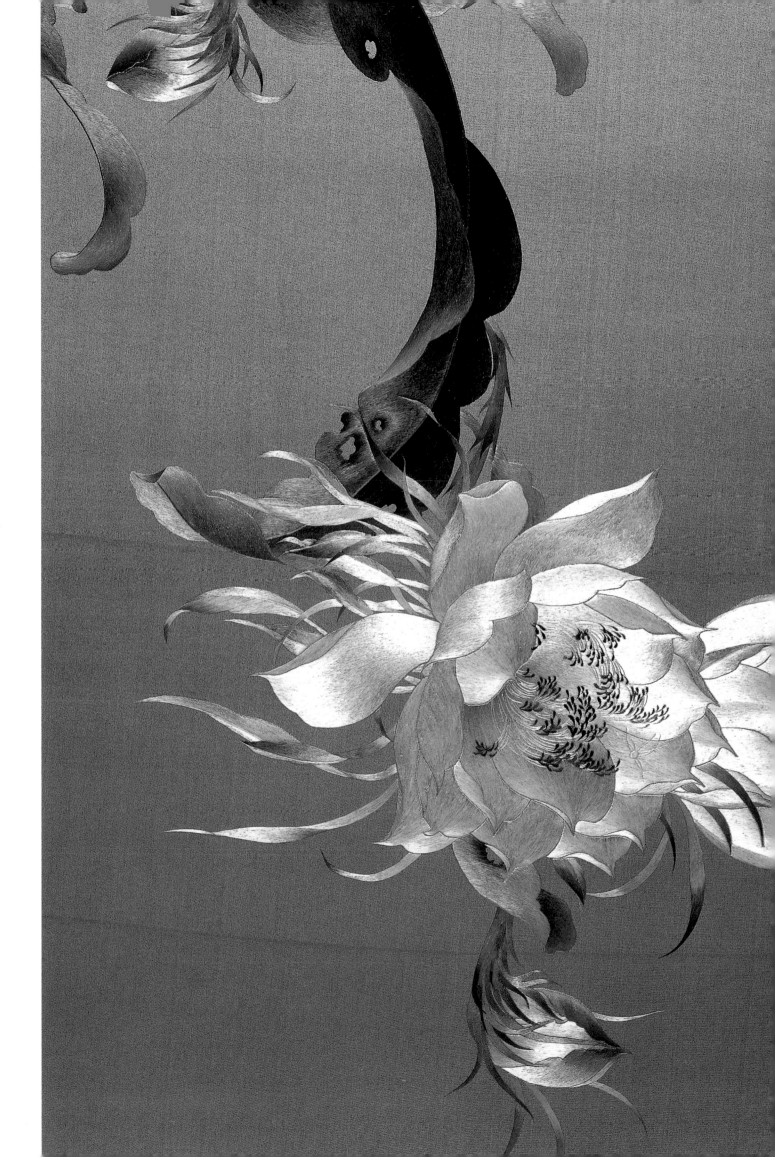

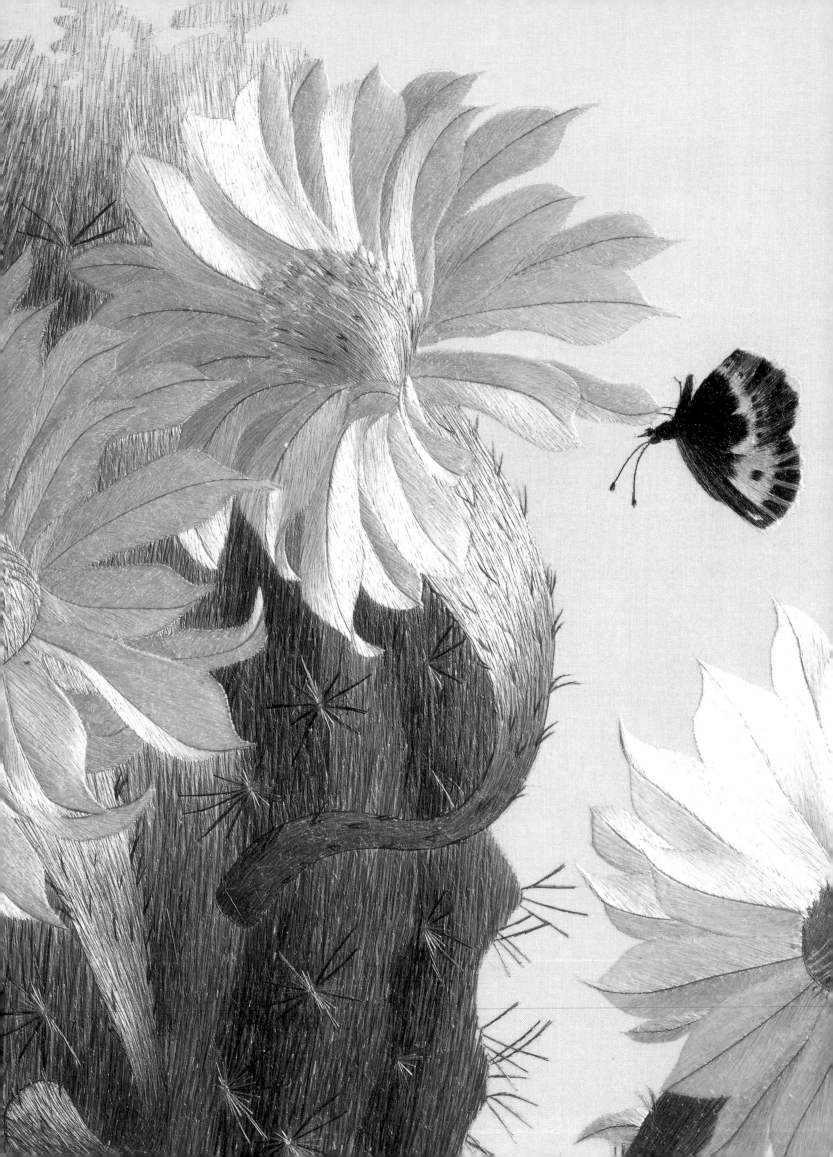

12

**Ball Cactus**

僊人毬

1995
Suzhou fine embroidery
Silk thread on silk gauze
46 x 46 cm

Based on a painting by
Chang Shana (常沙娜)

Embroidered by
Yao Huizhu (姚惠珠)
Lent by the Suzhou Embroidery
Research Institute

This image of a flowering ball cactus extends the genre of flower and bird painting, with its realistic treatment of an unusual subject. The spiky body of the cactus and the brilliant white flowers lend themselves especially well to embroidery. This piece—like *Magnolia*, *Loofah Gourd Flower*, and *Silver Star Crabapple* (cat. nos. 8, 10, 13)—exemplifies a style that is quite popular with the Chinese and that represents a new approach to traditional painting and embroidery.

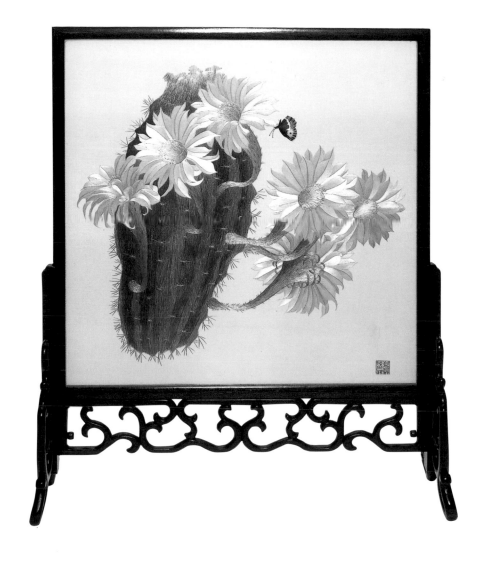

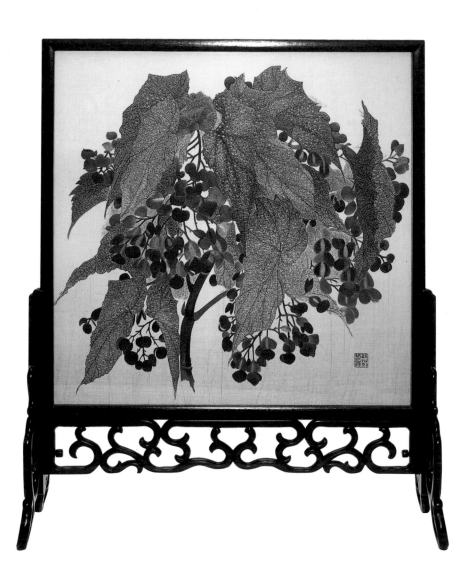

13

**Silver Star Crabapple**

銀星海棠

1995
Suzhou fine embroidery
Silk thread on silk gauze
46 x 46 cm

Based on a painting by
Chang Shana (常沙娜)

Embroidered by
Lu Gendi (陸根娣)
Lent by the Suzhou Embroidery
Research Institute

The flowering crabapple is a traditional decorative tree in Chinese gardens and a frequent subject of Chinese paintings. Usually only its branches or flowers are depicted, often in a highly stylized manner. In this case the artist has instead painted the colorful foliage of the tree realistically. As Zhang Meifang notes: "The flowers we used to embroider were something you could see only onstage; now they're more like the real thing, something you would see in nature."

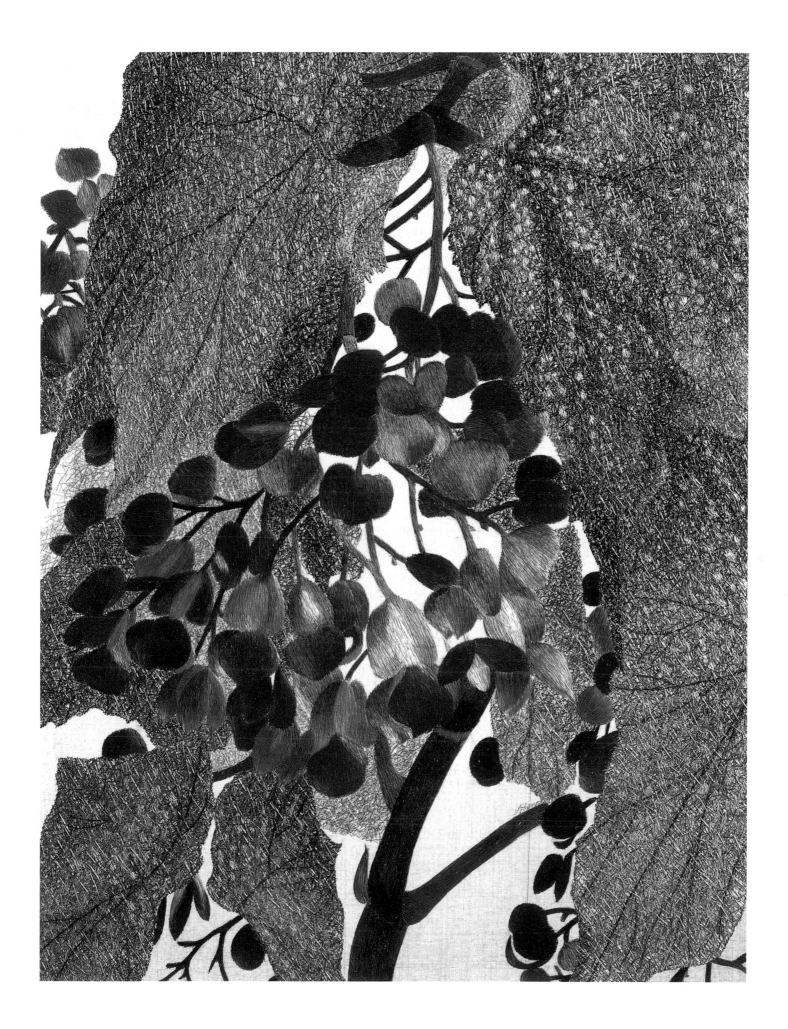

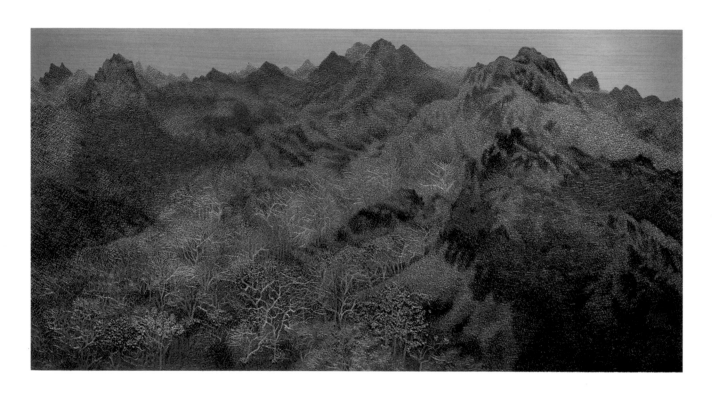

14

**Spectacular Spring**

金碧春曉

1997
Random stitch embroidery
Silk thread and watercolor on silk
and synthetic blend
100 x 190 cm

Based on a painting by
Yuan Yunfu (袁運甫)

Embroidered by
Zhao Chengqiang (趙承強)
Lent by the Suzhou Embroidery
Research Institute

A re-creation of the "green and blue mountain and water" (*qing lu shan shui*) style of Chinese painting, this work exploits the characteristics of random stitch embroidery to capture the sense of immensity and grandeur that is the hallmark of the best examples of this genre. Its coloring echoes the palette of traditional paintings, which were restricted by convention to only a few mineral pigments. The sky is hand-painted.

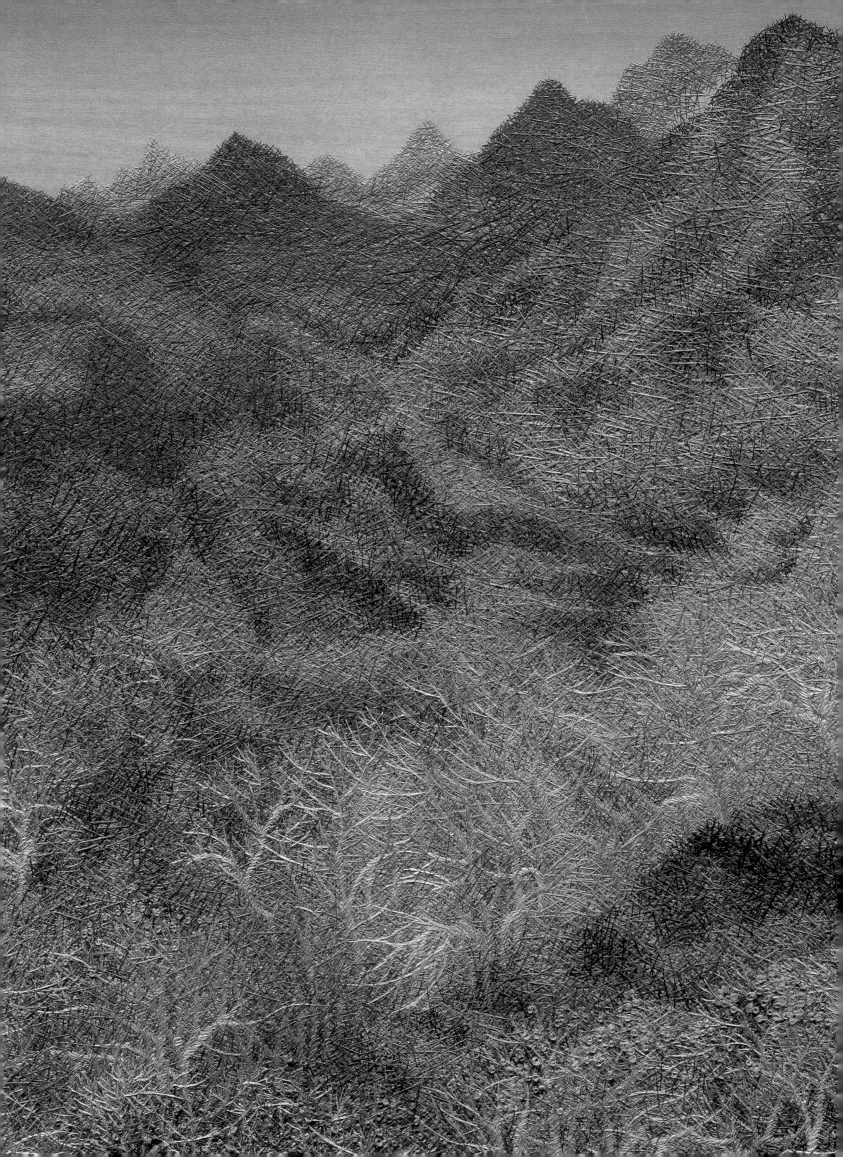

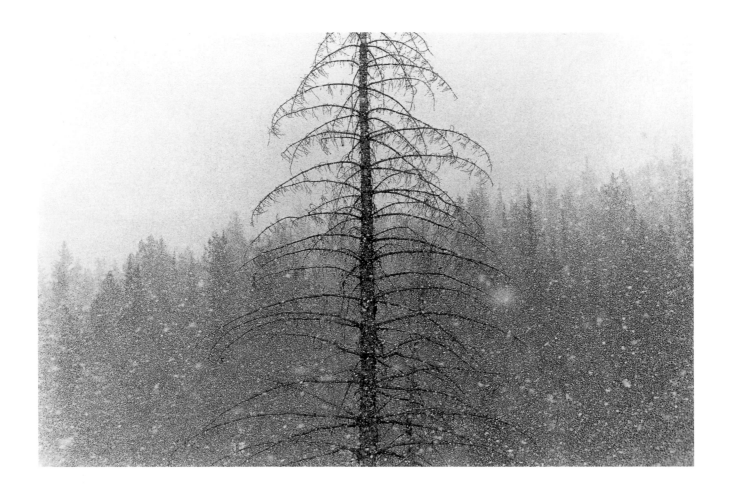

15
**Snowfall**
1979
Gelatin silver print
21.6 x 31.7 cm
Photograph by Robert Glenn Ketchum
Lent by Robert Glenn Ketchum

The photograph is part of *Winters, 1970–1980,* a portfolio of twenty-four small black-and-white prints taken with a thirty-five-millimeter camera. It was published in 1981. This image was selected by the Suzhou Embroidery Research Institute from a group of other, more literal photographs as the basis for an embroidery. The photograph is reminiscent of traditional Chinese brush and ink painting in mood and in effect.

Two other pieces in the exhibition —*Three Trees* and *Tree and Branch in Deep Snow* (cat. nos. 32, 34)— are also based on photographs from this portfolio.

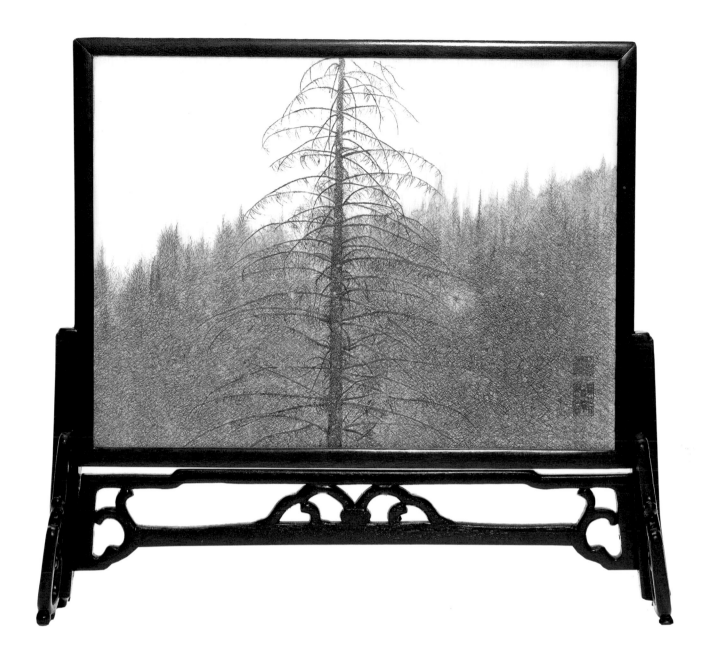

16

**Snowfall**
1986
Random stitch embroidery
Silk thread on handwoven
silk gauze
Standing screen
46 x 76 cm

Based on a gelatin silver print by
Robert Glenn Ketchum

Embroidered by
Ji Shaoping (季紹平)
Lent by Robert Glenn Ketchum

*Snowfall* is the first piece produced as part of the exchange project between Robert Ketchum and the Suzhou Embroidery Research Institute. Ji Shaoping adapted traditional stitches to re-create the mood captured in Ketchum's photograph. Shen Guoqing recalls: "He told us that when he was in Alaska he felt very cold, and he stayed in a big cave and took a photograph of very heavy snow, very dim and hazy."

The embroiderers were concerned that the haze and out-of-focus snowflakes in the photograph would not be understood correctly in an embroidery and specially wove the base fabric for this piece by hand to convey the sense of downward-falling flakes.

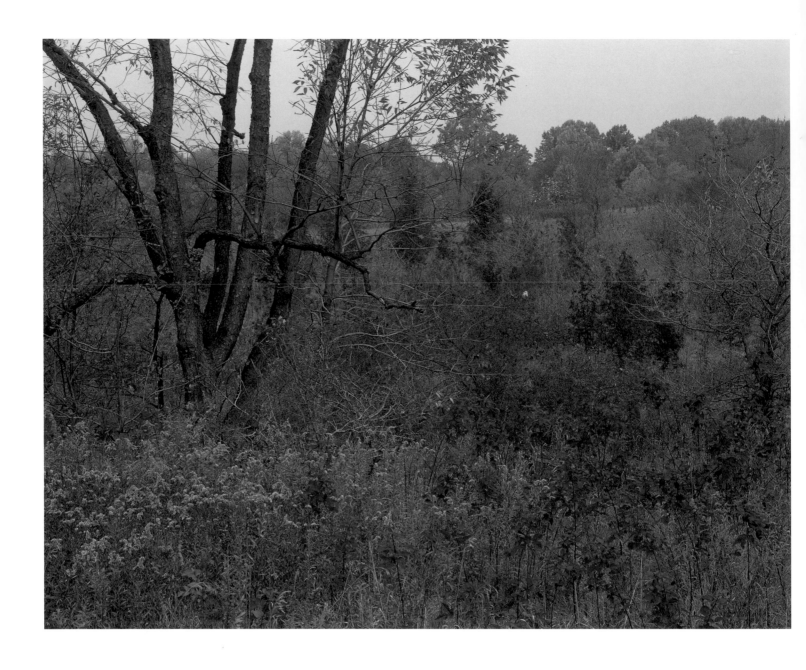

17

**CVNRA #177**

1986

Silver dye-bleach (Cibachrome) print

Three panels: 39.2 x 49.2 cm, 39.5 x 49.5 cm, 39.2 x 49.2 cm

Photograph by Robert Glenn Ketchum

Lent by Robert Glenn Ketchum

This is the far left panel of a three-print panorama taken in the Cuyahoga Valley National Recreation Area in Ohio. Ketchum explains: "I often find monumental beauty in ordinary scenes. I don't go to the Snake River Valley overlook or the floor of the Yosemite Valley and shoot El Capitan. I take pictures of the most ordinary, uninteresting, thickety, brushy, and sometimes dead *stuff*, but it's the sense of wonder at it all that makes the image successful. This photograph is layered, complex, overlapping, and confusing. I was trying to take representational things and make them so cluttered that they became abstract."

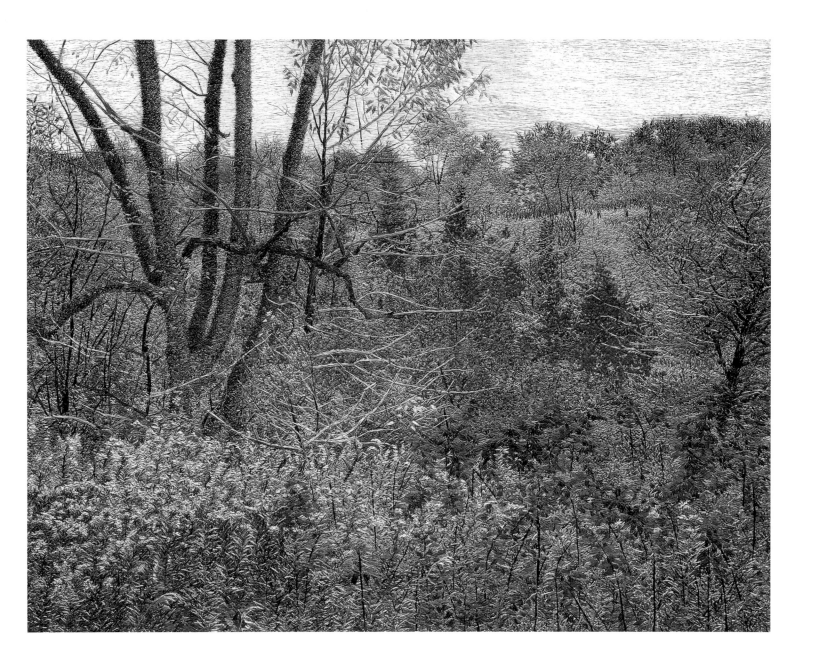

18

**Wild Meadow**

1988
Random stitch embroidery
Silk thread on silk gauze
57.2 x 66 cm

Based on a silver dye-bleach
(Cibachrome) print by Robert
Glenn Ketchum

Embroidered by
Ji Shaoping (季紹平)
Lent by Robert Glenn Ketchum

*Wild Meadow* is the third embroi-
dery produced in this exchange.
It is a trial piece for what would
have been the left two panels of
a six-panel standing screen, a very
ambitious project that was never
carried out.

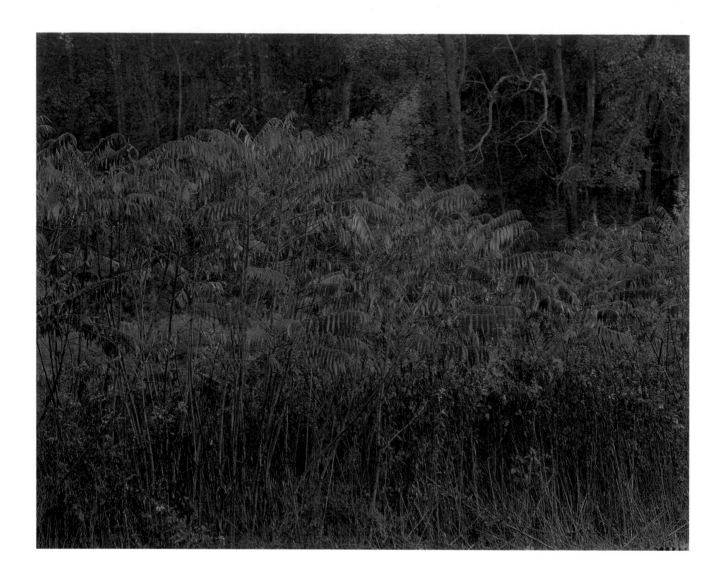

19
**C73**
1987
Silver dye-bleach (Cibachrome) print
59.7 x 75 cm
Photograph by Robert Glenn Ketchum
Lent by Robert Glenn Ketchum

The fall reds of sumac attracted the embroiderers to this piece, and it remains one of their favorites. Huang Chunya has actually intensified the photograph's effect in the embroidery. Ketchum explains: "Rather than contriving and building [a photograph], I just let it be simple like it was. At the time I proposed it for embroidery, I recognized [the institute's] attraction to red and suggested rendering this less-than-complex image against the dark background as a way of simplifying the embroidery process."

The photograph was made for the book *Overlooked in America: The Success and Failure of Federal Land Management* (1991). Ketchum has described the federal land management system as "so manipulated by politicians that, to most people, when it comes down to voting on these issues and to [people] managing lease lots and oil grids and forest clear cuts, they're just spots on a map." The abstract, neutral title reflects Ketchum's belief that government land managers regard the areas they oversee as "spots on a map," rather than as places with individual character. He gave the embroidered version, *Sumac along the Chattahoochee* (cat. no. 20), a more descriptive title, since he regards the embroidery project as nonpolitical.

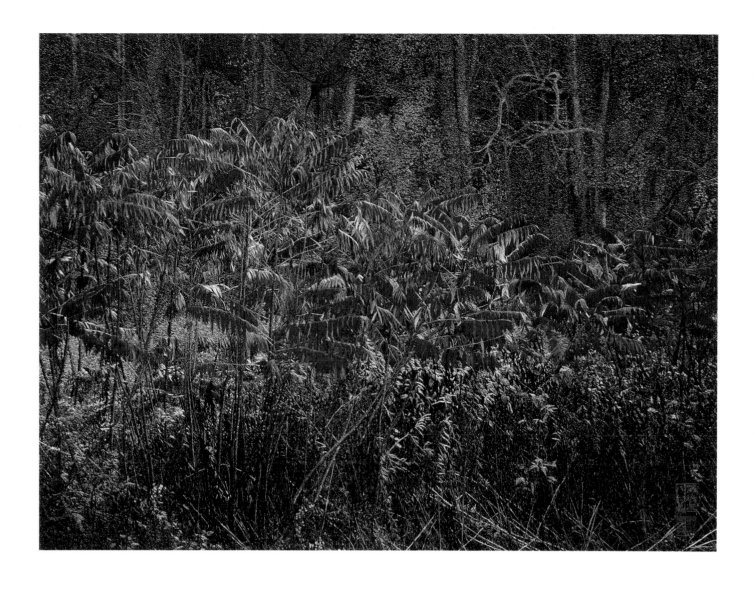

20

**Sumac along
the Chattahoochee**

1990
Random stitch embroidery
Silk thread on silk gauze
57.2 x 69.9 cm

Based on a silver dye-bleach
(Cibachrome) print by Robert
Glenn Ketchum

Embroidered by
Huang Chunya (黃春婭)
Lent by Robert Glenn Ketchum

In this piece and the other
embroidered at the same time,
*October 24, 1983/2:10 p.m.* (cat.
no. 22), Huang Chunya and
Huang Nanping began to embroi-
der from life, to embroider what
the photograph showed rather
than what the conventions of
embroidery suggested. Rather
than simply being two-sided, the
leaves in this piece have real
dimensionality, and the looseness
of the background embroidery
contrasts with the sharpness of the
foreground to create depth. This

is one of the first pieces to be
done on colored silk—in this case,
black—which allowed the
embroiderers to leave areas blank.
Huang Chunya's training in oil
painting helped her work from so
complicated an image.

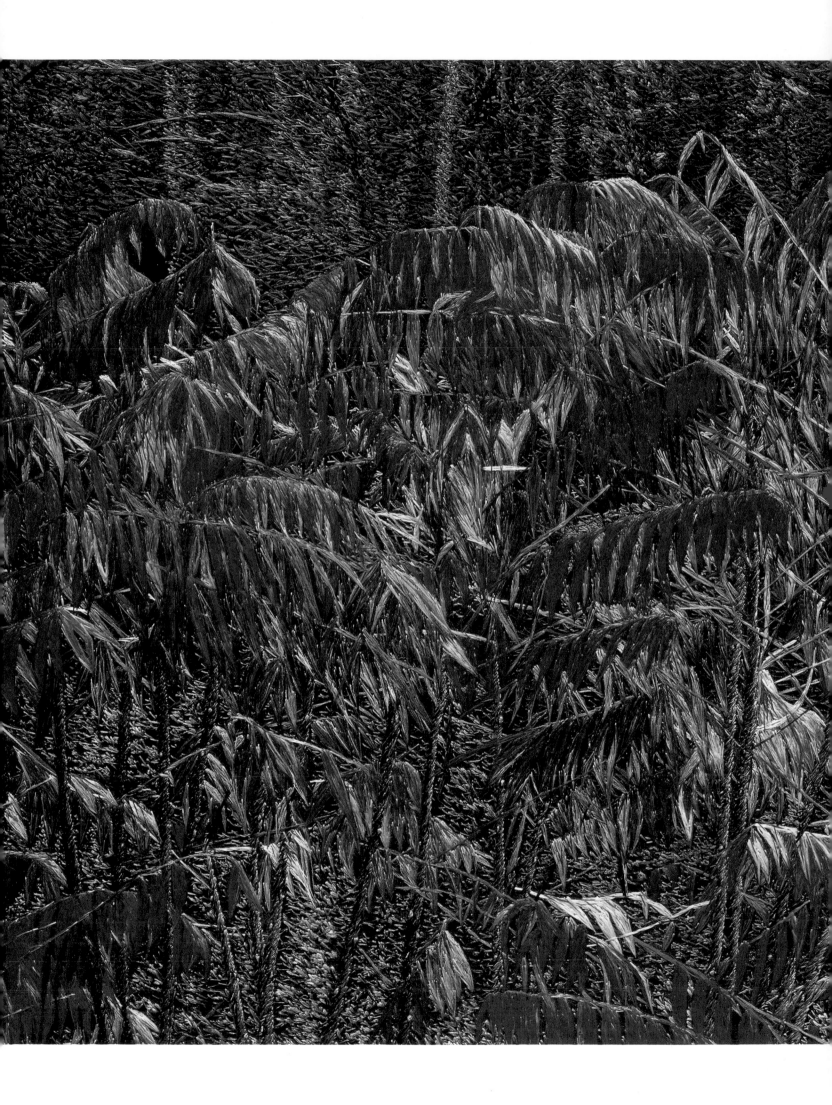

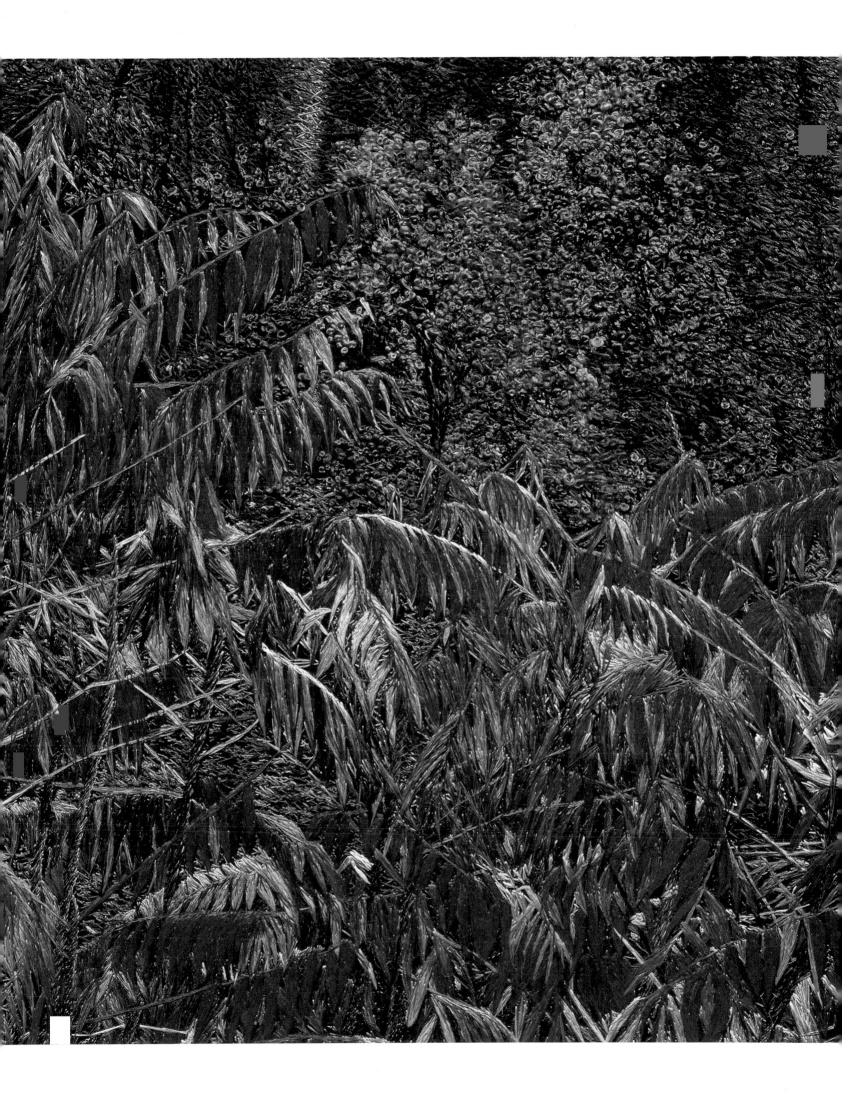

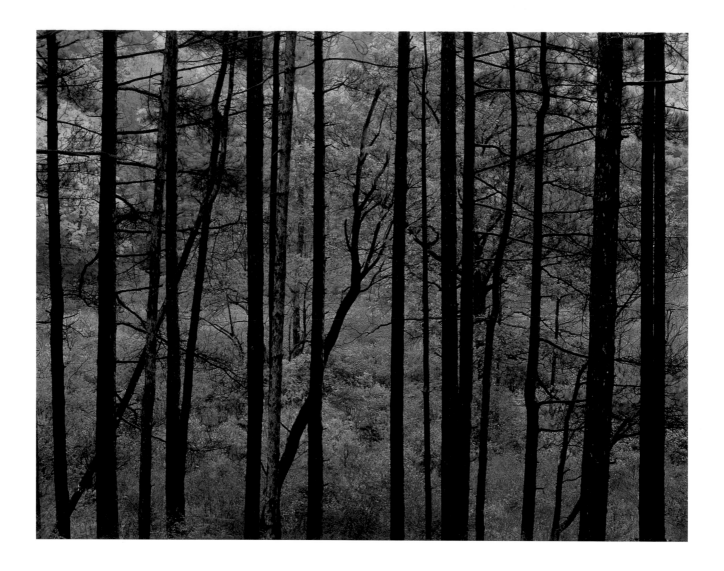

21

**October 24, 1983/2:10 P.M**.
1983
Silver dye-bleach (Cibachrome)
print
75 x 94 cm
Photograph by Robert Glenn
Ketchum
Lent by Robert Glenn Ketchum

After shooting the brilliant colors of fall during his Hudson River project, Ketchum became interested in the more muted effects that emerged as the fall colors faded. As he drove along a road in a drizzling rain, he was struck by the pastel colors of a meadow behind some trees, and he walked through the woods to try to photograph them. When he returned to his car, however, he realized that it was the way the colors of the meadow were set off by the trees that had struck him, and he made this exposure from the shoulder of the road.

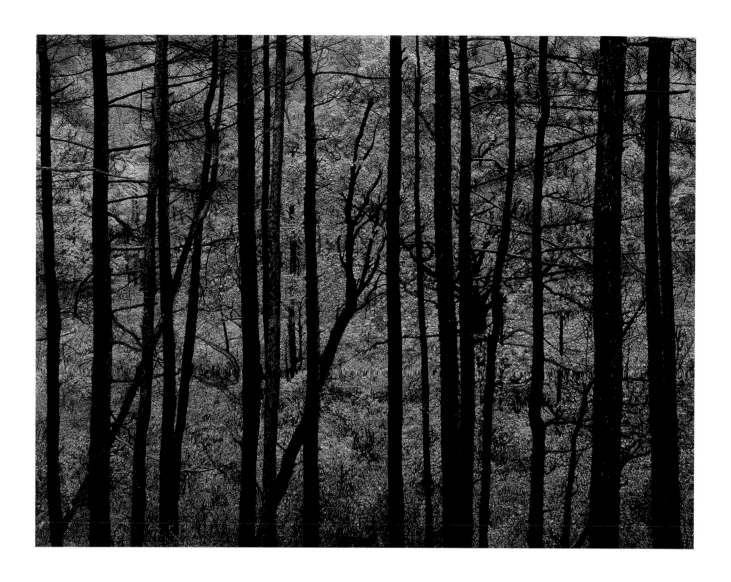

22

**October 24, 1983/2:10 p.m.**

1991

Random stitch embroidery

Silk thread on silk gauze

Imitation embroidery frame

73 x 90.8 cm; 108.6 x 130.8 cm
(mounted)

Based on a silver dye-bleach
(Cibachrome) print by Robert
Glenn Ketchum

Embroidered by
Huang Nanping ( 黃南萍 )
Huang Chunya ( 黃春婭 )
Lent by Robert Glenn Ketchum

After the completion of *Wild Meadow* (cat. no. 18), Ketchum's collaboration with the institute took a new direction with this piece and *Sumac along the Chattahoochee* (cat. no. 20). More detailed and larger in scale than previous pieces, these are also embroiderer Huang Chunya's first pieces for the exchange. Ketchum convinced Zhang Meifang to accept the commission for this piece by comparing the effect of looking through the dark tree trunks onto a well-lit landscape

with the experience of looking through arcade windows onto a Chinese garden (see pp. 72–73). This piece is embroidered on a pale blue fabric. Huang Chunya's finishing touch was the random application of tiny circular stitches of light thread to represent the raindrops standing on leaves in the original image.

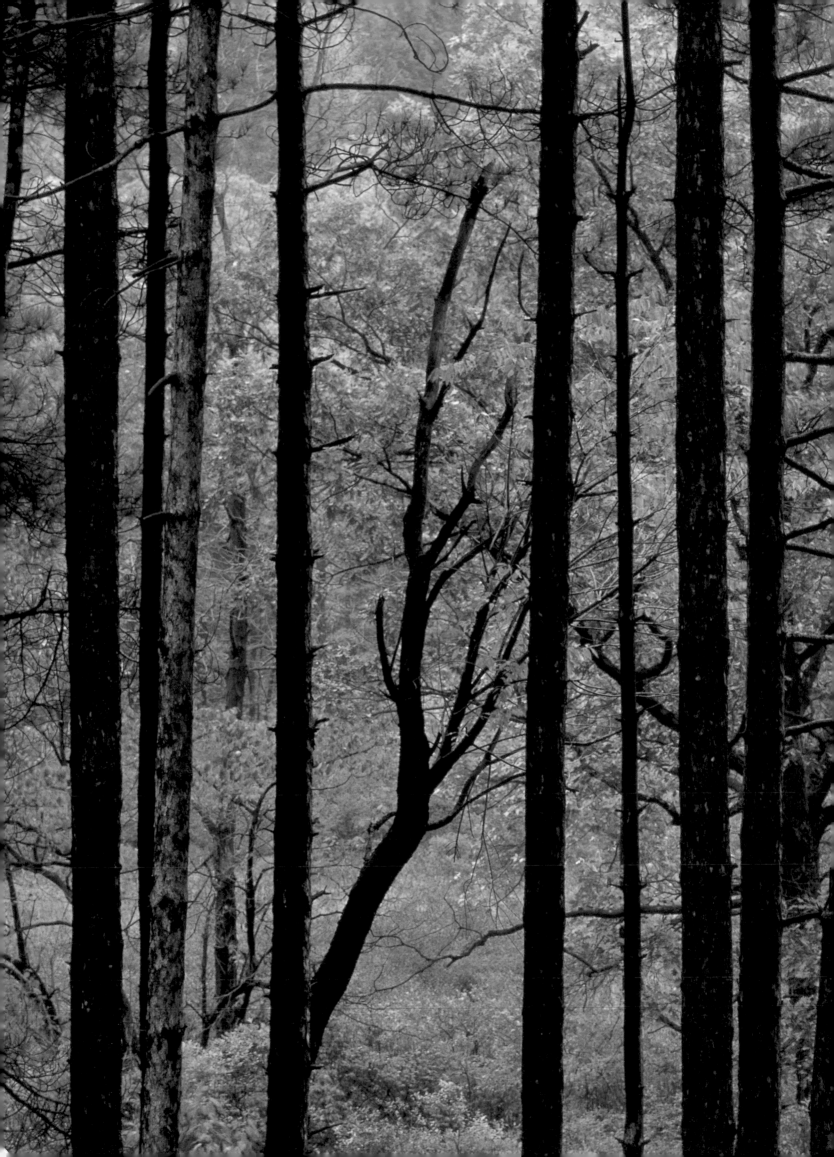

23 a–b
**Untitled**
1988
Two silver dye-bleach
(Cibachrome) prints
39.5 x 49.5 cm each
Photograph by Robert Glenn
Ketchum
Lent by Robert Glenn Ketchum

The embroidery *Double-Wide Wasatch* (cat. no. 24) is based upon two untitled photographs of different forested hillsides in Utah (the one on the right is flopped).

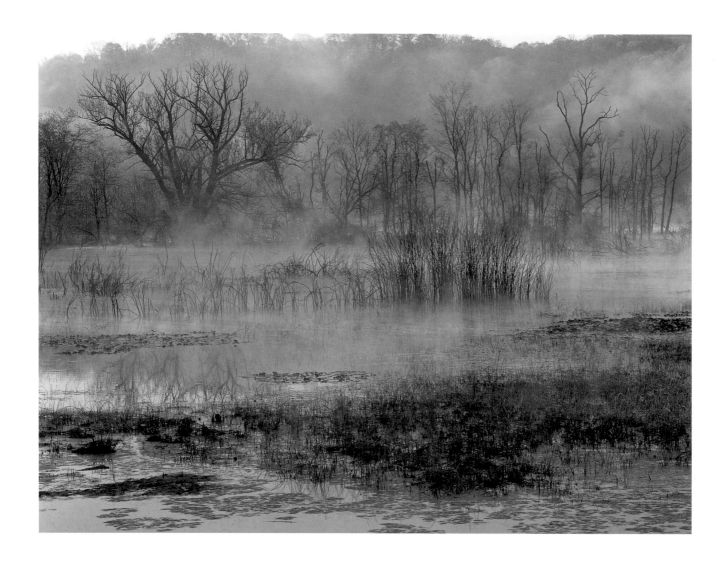

25

**CVNRA #412**

1987
Silver dye-bleach (Cibachrome) print
75 x 94 cm
Photograph by Robert Glenn Ketchum
Lent by Robert Glenn Ketchum

This photograph, like *C73* (cat. no. 19), was made for the book *Overlooked in America: The Success and Failure of Federal Land Management* (1991). This is the only piece in the exhibition in which the finished embroidery was not exactly the same size as the piece on which it was based. Zhang Meifang's positive reaction to this photograph made it a natural choice as Ketchum's first standing screen. A comparison between this photograph and the embroidered screen reveals the refinement Huang Chunya and Guan Peiying brought to their work.

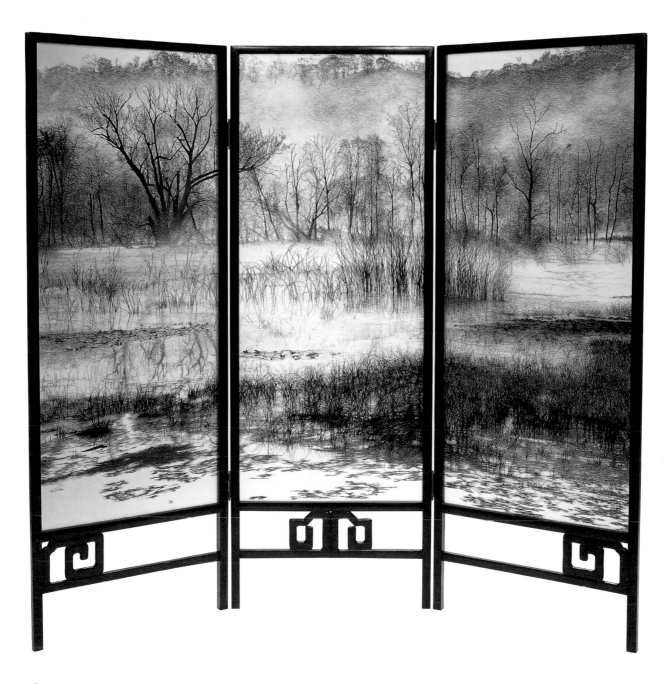

26

**The Beginning of Time**

1994
Random stitch embroidery
Silk thread and watercolor
on silk gauze
Standing screen
Three panels, 151 x 162 cm
overall

Based on a silver dye-bleach
(Cibachrome) print by Robert
Glenn Ketchum

Embroidered by
Guan Peiying (管配英)
Huang Chunya (黃春婭)
Lent by Robert Glenn Ketchum

The success of this remarkable
interpretation of a photograph in
the style of Chinese painting rests
on simplification. Much of the
fabric is left untouched, but parts
of it have been tinted with color to
lend body and tone to the embroi-
dery. The restraint and refinement
of the piece result from the inter-

play between worked and
unworked areas, a device often
used in Chinese painting. The
people involved in this project
believe that this piece epitomizes
the new Suzhou embroidery:
modern and realistic but with a
strong flavor of traditional art.

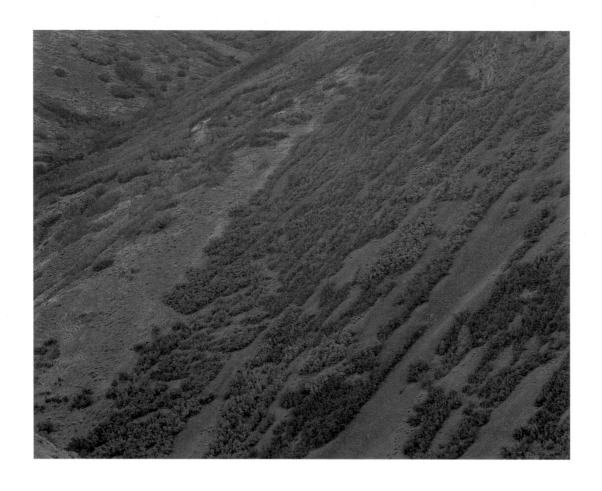

27

**Untitled**

1988

Silver dye-bleach (Cibachrome)
print

39.5 x 49.5 cm

Photograph by Robert Glenn
Ketchum

Lent by Robert Glenn Ketchum

Robert Ketchum reworked this photograph extensively to give the embroiderers a unique piece from which to work. The photograph Huang Chunya worked from (which no longer exists) was hand-tinted to make the brush more colorful. The original exposure was made in Utah's Wasatch Range in the evening, and it captures the spectacular and varied fall colors there. Ketchum recalls, "Here was this landscape with colors that looked as if they had just been poured like paint." This photograph was made some time ago, and only in reviewing his images did Ketchum see its potential as an embroidery.

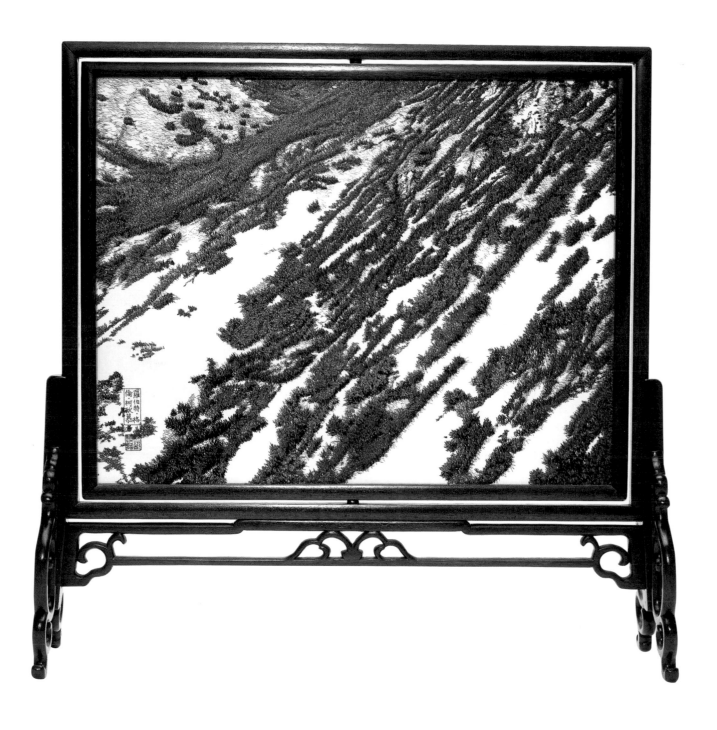

28

**Fall Dream in the High Desert**

1995
Random stitch embroidery
Silk thread on silk gauze
Rotating table screen
40.6 x 50.8 cm

Based on a silver dye-bleach
(Cibachrome) print by Robert
Glenn Ketchum

Embroidered by
Huang Chunya (黃春婭)
Lent by Robert Glenn Ketchum

The most abstract piece to date in the exchange project, this is another exercise in dropping out part of the photographic image to concentrate on a detailed treatment of the more visually interesting parts. Ketchum asked Zhang Meifang to leave the ground as blank gauze and embroider only the trees and brush. While the effect is quite abstract, comparison of the embroidery with the photograph reveals how literal the

treatment was. Huang Chunya's use of the bundling stitch, in which silk floss is separated into individual strands that are then recombined with strands of other colors, helped her to depict gradual transitions.

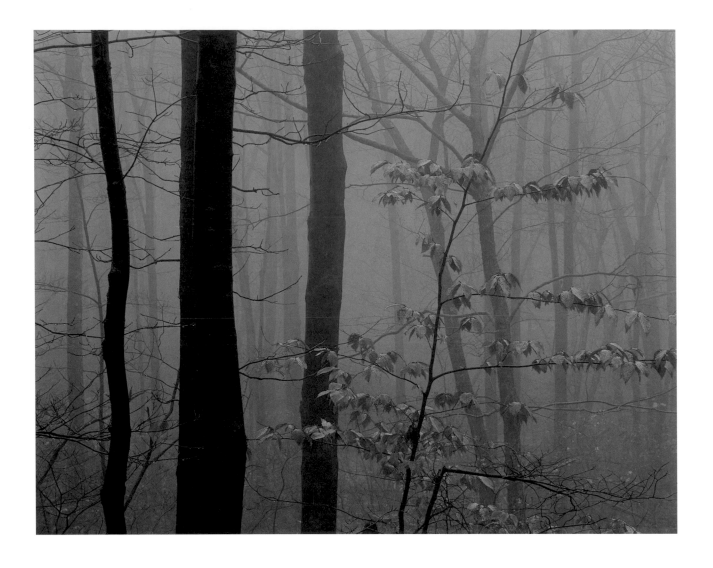

29
**November 11, 1983/9:15 a.m.**
1983
Silver dye-bleach (Cibachrome)
print
59.7 x 75 cm
Photograph by Robert Glenn
Ketchum
Lent by Robert Glenn Ketchum

While working on his book *The Hudson River and the Highlands* (1985), Robert Ketchum was struck by the quality of the blue fog that filled the forest during the colder months of the year. This picture captures that color and sets it off against the pale foliage of the birch, which holds its dead leaves through the winter. While this picture didn't have the brilliance of others in the book, Ketchum wanted it included because of its peacefulness and its sense of depth. "I shot from the best days to the worst," he recalls. "I wanted to catch the entire range of the seasonal changes."

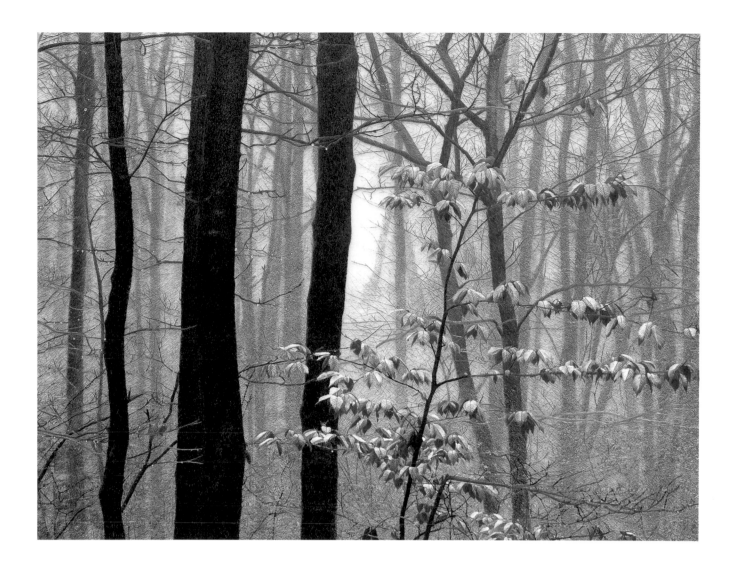

30

**Pale Leaves in Blue Fog**
1996
Random stitch embroidery and
Suzhou fine style embroidery
Silk thread on silk and synthetic
blend
60 x 80 cm

Based on a silver dye-bleach
(Cibachrome) print by Robert
Glenn Ketchum

Embroidered by
Zhao Liya (趙麗亞)
Lent by Robert Glenn Ketchum

Zhao Liya has combined random
stitch embroidery with Suzhou
fine embroidery in this depiction
of fog in a forest. The blue-dyed
fabric allowed her to concentrate
on her treatment of the tree
trunks in random stitch embroi-
dery and of the leaves in Suzhou
fine embroidery. In this piece the
two styles do not contrast, as they
do in *Splashed Ink Lotus* (cat. no.
9), but rather complement each
other. The fineness of the treat-
ment of the leaves—contrasted
with the coarser, distant trunk—

gives the piece both depth and
delicacy. The small white embroi-
dered dewdrops were created
with a newly developed stitch
made by sewing over an extremely
fine acupuncture needle.

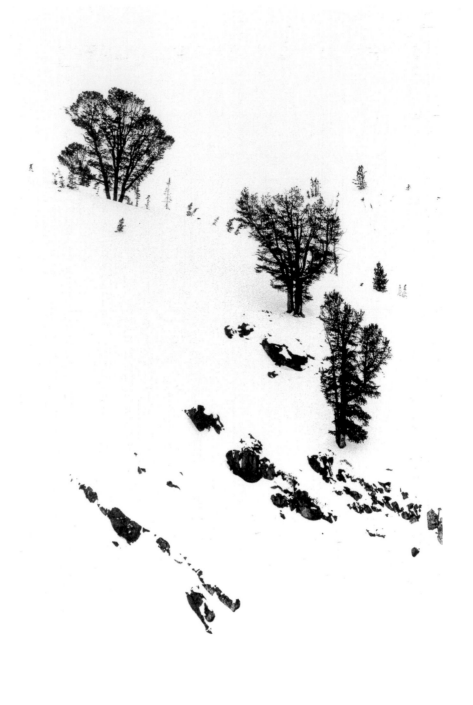

31
**3 Trees**
1978
Ink-jet print on rag paper from
digitally scanned gelatin silver
print
50 x 30 cm
Photograph by Robert Glenn
Ketchum
Lent by Robert Glenn Ketchum

This and the following photograph
are images from the black-and-
white portfolio *Winters, 1970–
1980*. Robert Ketchum explains:
"This was shot in a whiteout, so
there's no depth or space. There's
a hill you can't even see; it's not
just three trees." The abstraction
and simplicity of this print
appealed to Zhang Meifang, and
she selected it for translation into
embroidery.

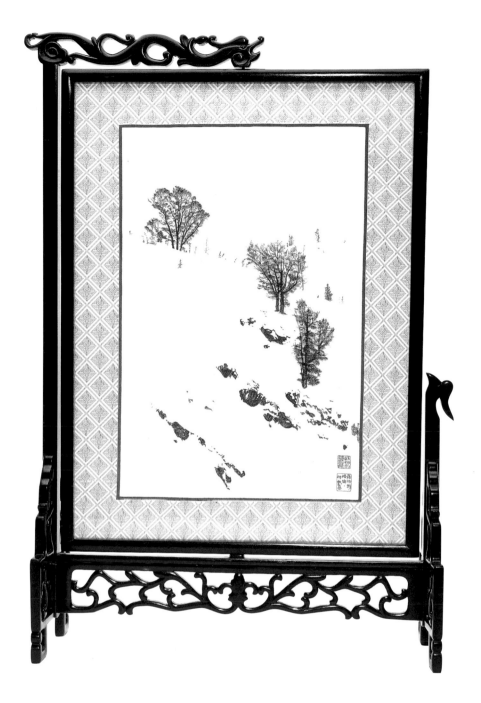

32
**Three Trees**
1996
Random stitch embroidery
Silk thread on silk and synthetic
blend
Rotating standing screen with
pierced silk (*chuo sha*) border
50 x 40 cm

Based on a gelatin silver print by
Robert Glenn Ketchum

Embroidered by
Huang Chunya (黃春媛)
Lent by Robert Glenn Ketchum

This piece too is based on a part
of nature the embroiderers in
Suzhou have never experienced,
heavy snow. (When Zhang
Meifang first saw the photograph,
she couldn't understand why the
trees appeared to have no bot-
toms, and Ketchum had to explain
that it was because of the deep
snow.) Nevertheless, Huang
Chunya has created a singularly
delicate interpretation of the
snow-covered hillside, which
makes excellent use of the poten-
tial of double-sided embroidery.
The border of this piece is an
example of pierced silk, a tech-
nique in which the two pieces of
silk are joined together and
stitched.

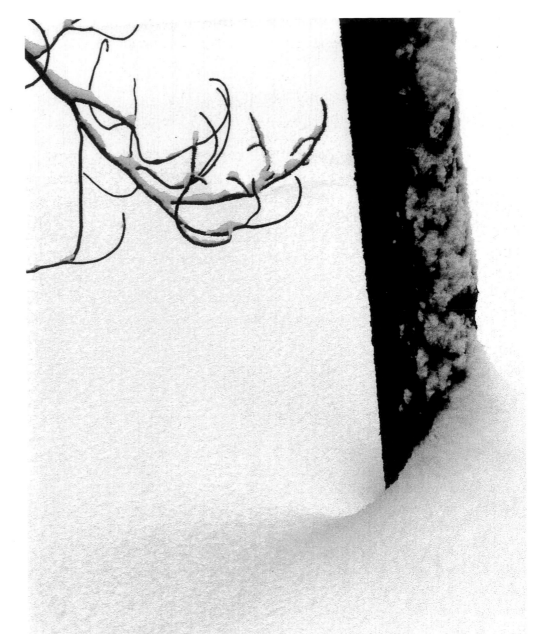

33
**Visual Haiku**

1977
Ink-jet print on rag paper
from digitally scanned gelatin
silver print
50 x 34 cm
Photograph by Robert Glenn
Ketchum
Lent by Robert Glenn Ketchum

Robert Ketchum has observed:
"How few elements in the land-
scape are enough to make it
understandable." This photograph
is about minimalism and the inter-
play of positive and negative
space. It is from the portfolio
*Winters, 1970–1980*, which was
conceived of as a challenge to tra-
ditional American landscape pho-
tography, which emphasizes detail,
comprehensiveness, and technical
perfection. The pictures in this
portfolio reflect a modernist
approach to landscape photogra-
phy in that they were taken with a
thirty-five-millimeter camera
while Ketchum was climbing and
hiking. The photographer com-
ments, "There are some things a
view camera won't see, but they
are still legitimate landscapes."

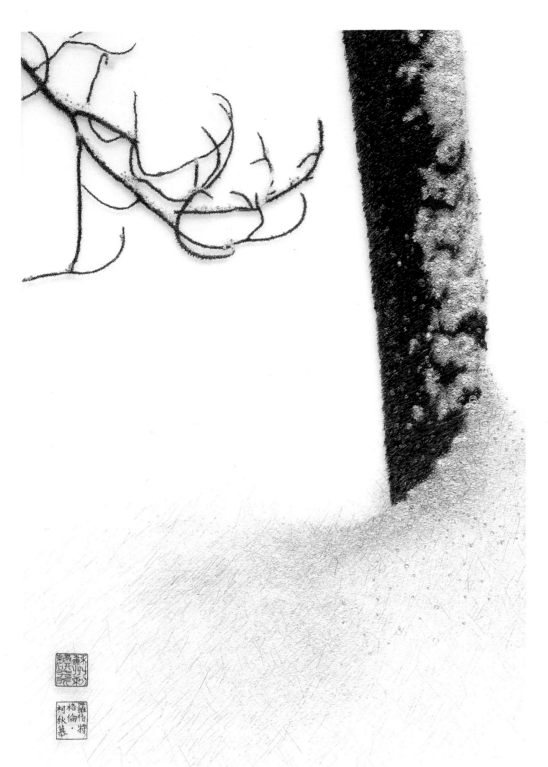

34
**Tree and Branch
in Deep Snow**
1996
Random stitch embroidery
Silk thread on silk and synthetic
blend
50 x 40 cm

Based on a gelatin silver print by
Robert Glenn Ketchum

Embroidered by
Ji Shaoping（季紹平）
Lent by Robert Glenn Ketchum

The black-and-white pieces from
the *Winters, 1970–1980* portfolio
are very close to traditional
Chinese brush and ink painting,
in which simplicity of statement
and economy of means are highly
valued. The abrupt termination
of the trunk and the branch,
however, are purely photographic.
In this piece the embroiderers
employed stitches in widely
varying sizes to create a sense
of depth.

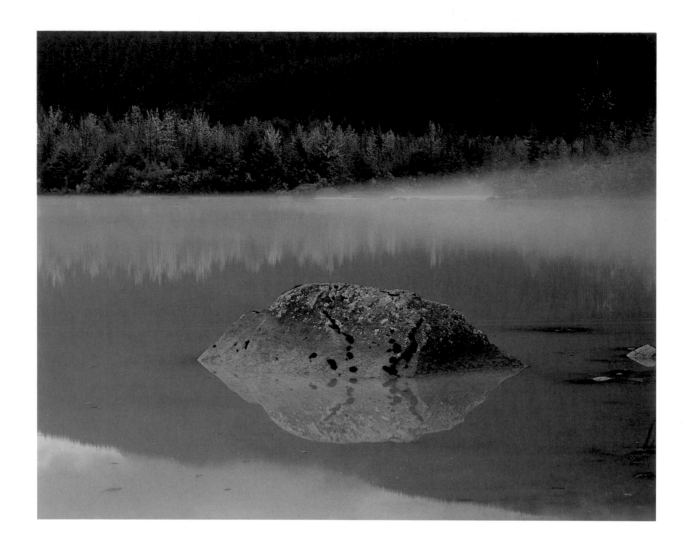

35
**Mendenhall Lake**
1986
Silver dye-bleach (Cibachrome) print
47.4 x 59.4 cm
Photograph by Robert Glenn Ketchum
Lent by Robert Glenn Ketchum

Robert Ketchum: "This was taken standing in front of my car at the Mendenhall Glacier, which is just five miles outside of Juneau—everybody's first glacier. Usually it's mobbed with people, but that day it was raining so hard it was like night, and there wasn't anyone there. I'd been out shooting all day and was soaked and was drinking from a bottle of Grand Marnier. Then the rain let up and the lake got really glassy. The cold air flow coming off the glacier made a fog when it hit the warmer lake water. The camera is in front of the car; the rock, in front of the camera; and the glacier, across the lake. I put on a wider lens and just discovered something in the play."

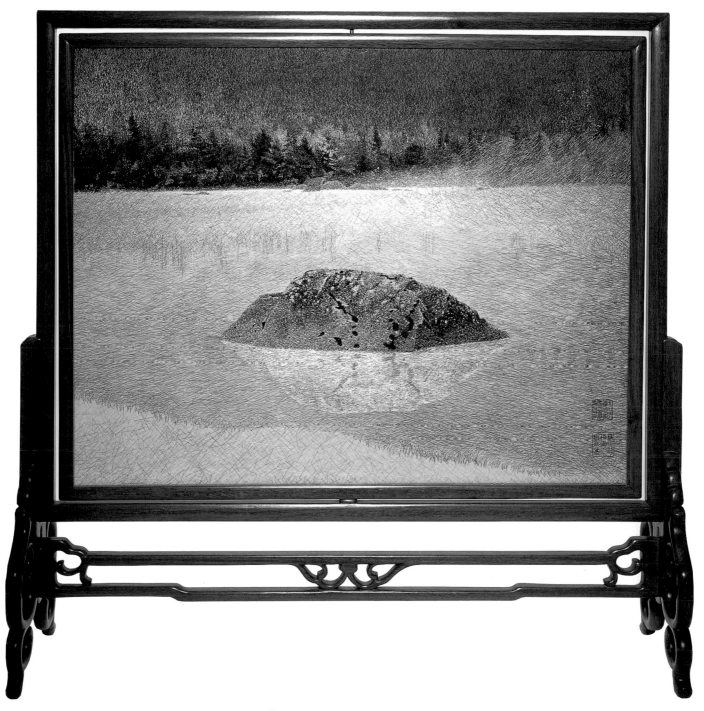

36

**Rock in Lake with Fog**

1997
Random stitch embroidery
Silk thread on silk gauze
Rotating table screen
47 x 59 cm

Based on a silver dye-bleach
(Cibachrome) print by Robert
Glenn Ketchum

Embroidered by
Wu Xi (吳曦)
Lent by Robert Glenn Ketchum

The North American rock at the
focus of this composition presents
a challenge to Chinese pictorial
conventions, which are attuned
to the depiction of a very different
sort of rock. Wu Xi's work on it
(and on its reflection) employs
a range of stitches to capture the
texture and feel of a "rockness"
she has seen only in photographs.
The play of the highly detailed
foreground against the more
loosely rendered background
enhances the sense of depth.

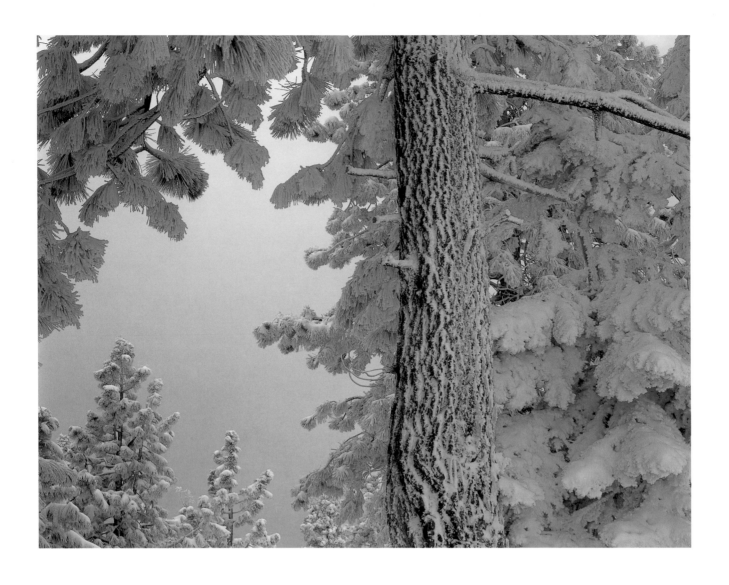

37
**Wet & Wind Driven**
1994
Silver dye-bleach (Cibachrome)
print
59.7 x 75 cm
Photograph by Robert Glenn
Ketchum
Lent by Robert Glenn Ketchum

Robert Ketchum: "I'd been shoot-
ing off a cliff waiting for the fog to
lift so I could frame the view out
between the trees, and suddenly
I realized that the beauty of it was
that everything was the same color
and there was no view; it was just
flat, with a harmony of tones."

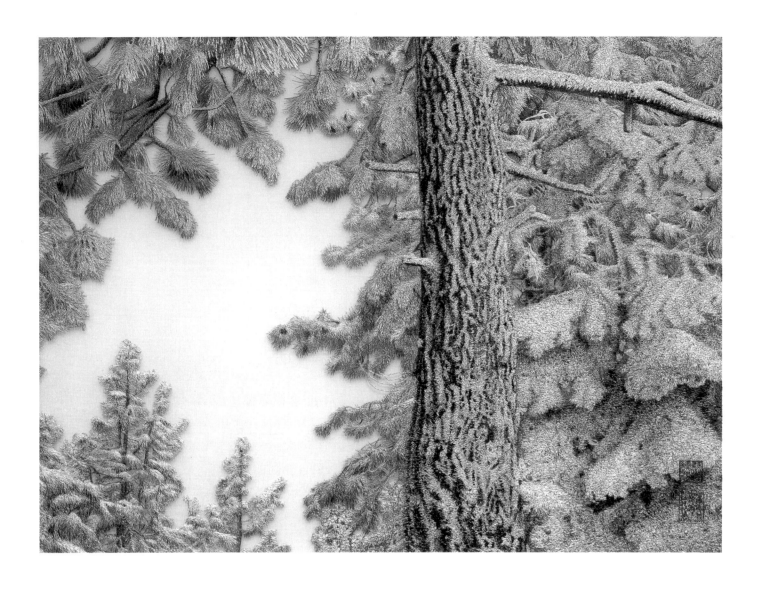

38

**Trees and Branches
with Heavy Snow**

1997
Random stitch embroidery
Silk thread on silk and synthetic
blend
60 x 80 cm

Based on a silver dye-bleach
(Cibachrome) print by
Robert Glenn Ketchum

Embroidered by
Huang Chunya (黃春婭)
Lent by Robert Glenn Ketchum

Random stitch embroidery is ide-
ally suited to this depiction of
snow on pine trees, a topic also
addressed in traditional Chinese
painting. In her exploration of the
textures of the snow-covered tree
trunk and pine needles, Huang
Chunya conveys a sense of wet-
ness and cold. Neither black nor
white, the unembroidered fabric
suggests an undefined distance.

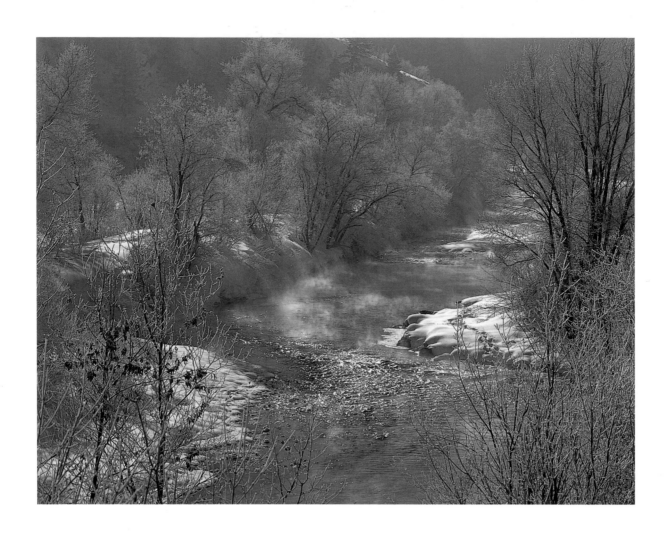

39
**Early Morning, Provo River**
1988
Silver dye-bleach (Cibachrome) print
40.6 x 50.8 cm
Photograph by Robert Glenn Ketchum
Lent by Robert Glenn Ketchum

This photograph was taken in the Wasatch Mountains of Utah in the early morning, following an extremely cold night. The vapor rising from the river froze as soon as it had condensed on the surfaces of nearby trees and bushes; in the morning light the icy branches imparted an almost otherworldly quality to the scene. This was one of the first images that Zhang Meifang selected as a likely subject for embroidery.

164

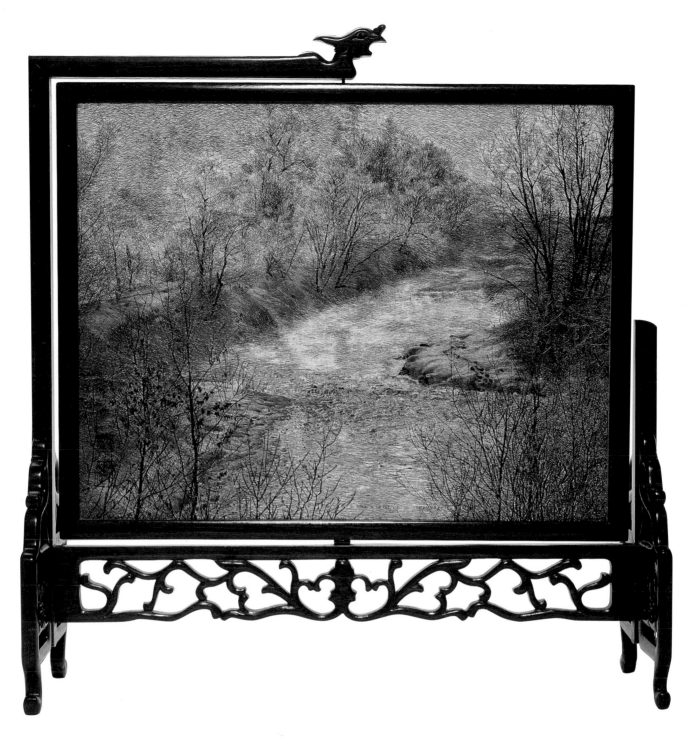

40

**River Scene in Winter**
1998
Random stitch embroidery
Silk thread on silk and synthetic
blend
40.6 x 50.8 cm

Based on a silver dye-bleach
(Cibachrome) print by Robert
Glenn Ketchum

Embroidered by
Huo Xiuling (霍秀玲)
Lent by Ms. Michelle Lund

Sound and motion are strongly
suggested in this piece; one can
almost hear and see the rushing
of cold water over icy rocks. Huo
Xiuling used her skill in embroi-
dery to capture the varied effects
of light reflecting off water and
snow, contrasting those high-key
passages with the dark, stiff
branches of the winter trees.
Variations in the direction of the
stitches help delineate the con-
tours of the snowy riverbanks and
the flow of the water; small "seed

stitches" were used to depict the
broken water in the rapids. Huo
Xiuling recalled that the most
difficult aspect of this embroidery
for her was selecting the thread
colors to create the subtle grada-
tions of blue and white.

# NOTES TO THE TEXT

### Zhang

1. Traditionally the homes of large, wealthy Chinese families had second-floor rooms that were reserved for the use of the family's women, especially the unmarried daughters. I have translated the Chinese word for these rooms as "inner chambers." *Ed.*
2. "Thousand golds of the inner chambers" is a literal translation of a four-word phrase in Chinese indicating that Shen Shou was an embroiderer in the "inner chambers" style who was as good as gold. *Ed.*

### Dowdey

Many of my notes are references to tapes of oral interviews; see, for example, note 1. In such cases information is presented in the following order: subject's name, date of interview, tape number and side, counter number. Unless otherwise indicated, all translations are mine.

1. Robert Glenn Ketchum, 8/12/97, Ib, 102.
2. There are three other important regional styles: those of Hunan, Sichuan, and Guangdong Provinces. Embroidery is practiced almost everywhere in China, and many areas also have important folk traditions. Notable among these are the many sophisticated embroidery styles of southwest China's non-Han nationalities. The best known of these is the embroidery of the Miao, who are known as the Hmong in the West.
3. It was a clipping of one of the institute's portraits of Mao hung at Tiananmen Square in Beijing during the Cultural Revolution that first attracted Robert Ketchum's attention to the possibilities of Chinese embroidery.
4. Over the past year modern heating units have been installed in all of the workshops and reception rooms. Suzhou has a climate similar to that of the American south without the worst extremes. While winters are mild, frosts are common, and as with all of China south of the Yangzi, there is no central heating. Before this year the embroiderers worked in workrooms unheated except by the bright sunlight, keeping their hands warm with tea mugs and hot-water bottles. The economic boom of the 1990s has seen the installation of heating/air conditioning units in many businesses and homes, taking the edge off both the damp cold of winter and what is in fact more oppressive in that area, the sultry humidity of summer.
5. According to one legend, embroidery was created by Madam Zhao, the sister of Emperor Wu Wang's wife during the Warring States Period (475–221 B.C.E.). When Emperor Wu prepared for war, Madam Zhao embroidered a topographical map for him so that it would never fade.
6. Buddhist embroideries have been preserved from as early as the eighth century C.E. Embroideries of this kind were produced in special workshops associated with the court or with monasteries, but as time passed, these workshops became secularized and produced works both for their official patrons and for others as well. Likewise, imperial courts and religious organizations arranged with private workshops for the production of goods. It is likely that a folk tradition developed as well, but we have no record of it at this early date.
7. *Xianhui, qiao, shangliang, wenrou.*
8. 1/10/98, 7. Han Ying is the institute's translator, but this conversation was held in Chinese.

9. This type of apron was worn in other parts of China as well.

10. This was true until fairly recently, especially for working people. These kinds of shoes are generally cloth, and decorated insoles were also used. Shen Guoqing told me that her shoes were homemade when she was young, which would have included the period after Liberation in 1949. As recently as the Cultural Revolution, during the early 1970s, people were forced by poverty to make their own shoes.

11. Shen Guoqing, 1/10/98, 10.

12. Shen Guoqing, 1/19/98, a, 28.

13. Ibid., a, 5.

14. Some authors suggest that Shen Shou was also influenced by Japanese embroidery techniques, but the SERI embroiderers discounted this interpretation.

15. Xueyi is another of Shen Shou's names.

16. Shen Guoqing, 1/10/98, a.

17. Zhang Meifang, 1/19/98, a, 307.

18. Ibid., b, 113.

19. Shen Guoqing, 1/10/98, a, 2.

20. Zhang Meifang, 1/16/98, Ia, 42.

21. Zhang Meifang, 1/12/98, 9.

22. Zhang Meifang, 1/19/98, a, 27.

23. Ibid., b, 30.

24. Zhang Meifang, 1/10–12/98, a.

25. Shen Guoqing, 1/16/98, II, 52.

26. Shen Guoqing, 1/12/98, 10.

27. Zhang Meifang, 1/16/98, Ib, 46.

28. Ibid., 45.

29. The reader can see this in the embroideries of Robert Ketchum's photographs. Compare the work of Huang Chunya (cat. nos. 20, 28, 32, 38) with that of Xu Jianhua (cat. no. 24) and Ji Shaoping (cat. nos. 16, 18, 34).

30. Zhang Meifang, 1/16/98, Ib, 45.

31. Shen Guoqing, 1/10–12/98, a, 10.

32. Zhang Meifang, 1/19/98, b, 31.

33. Zhang Meifang, 1/14/98, II, 19.

34. Zhang Meifang, 1/16/98, Ia, 41.

35. Zhang Meifang, 1/21–25/98, 55.

36. In fact, not all of the embroiderers are as conscientious as their director. While they all had notebooks near their frames, Shen Guoqing told me that they wrote mostly personal things in them.

37. Zhang Meifang, 1/14/98, II, 19.

38. Zhang Meifang, 1/21–25/98, 54.

39. Zhang Meifang, 1/16/98, Ia, 000.

40. Zhang Meifang, 1/14/98, II, 17.

41. Zhang Meifang, 1/10–12/98, a, 7.

42. Zhang Meifang, 1/19/98, b, 31.

43. Zhang Meifang, 1/16/98, Ia, 41.

44. Ibid., Ib, 47.

45. Ibid.

### Ketchum

1. The acupuncture stitch technique is explained in Jo Hill's essay in this volume (see p. 104).

### Hill

1. James Martin, personal communication, 1998; result of infrared spectroscopy analysis.

2. One disadvantage of the otherwise elegant SERI embroidery frame is the excessive tension that is commonly applied to the fabric. The resulting stress on the silk threads hastens the overall deterioration of the textile. Since the author's visits in 1997 and 1998, less tension has been applied on a routine basis.

3. Only one woman in the Random Stitch Embroidery Research Studio used a supplemental light source; the fluorescent light required her to adjust the color balance mentally, but she needed more light than was available at her window station (see fig. 55).

4. James Martin, personal communication, 1998.

5. Initially the embroiderers found the needles difficult to handle; with their natural dexterity and highly developed ingenuity, they quickly found several uses for the variety of sizes donated by a sponsor of the Suzhou project.

6. For lucid and informative descriptions of current and traditional SERI embroidery stitchwork, see the various books published by the institute (Zhang 1989; Suzhou City Embroidery Research Institute 1976).

7. This emphasis on "basics" is evident even in the arrangement of the table of contents of one of the SERI publications (Zhang 1989, 1–4). General topics covered at the beginning of the book include frame selection, needle types, support fabrics, and work table construction. The student then goes on to learn specific concepts and techniques, such as how to maintain the luster of silk and how to split threads. Subsequently the student progresses to a mastery of design selection and transfer, stain removal, and the mounting of single- and double-sided embroideries. Only then are the stitches described (knot stitch, honeycomb stitch, shaping and shading stitch) and the methods of applying them (how to embroider flowers, landscapes, fruits, etc.).

8. James Martin, personal communication, 1998.

# GLOSSARY

| | | |
|---|---|---|
| Cao Qizhen | 曹琦珍 | |
| Cao Kezha | 曹尅家 | |
| *Chan zhen* | 纏針 | Satin stitch |
| Chang Shana | 常沙娜 | |
| Chen Caixian | 陳彩偓 | |
| *Chuo sha* | 戳紗 | Pierced silk |
| *Cixiu zhuang* | 刺繡莊 | Embroidery brokerage shop |
| *Dadian zhenfa* | 打點針法 | A variation on petit point embroidery |
| *Dazi zhen* | 打籽針 | Seed stitch |
| Dong Qichang | 董其昌 | |
| *Duan si* | 緞絲 | Silk satin |
| *Fang zhen xiu* | 仿真繡 | Imitation of reality embroidery |
| *Fu* | 福 | Good fortune |
| Gu Xiu | 顧繡 | Gu embroidery |
| *Guige cixiu* | 閨閣繡 | Inner chambers embroidery |
| *Guo hua* | 國畫 | Chinese painting |
| Han Ximeng | 韓希孟 | |
| Han Ying | 韓英 | |
| He Shanan | 賀善安 | |
| Huo Xiuling | 霍秀玲 | |
| Huang Chunya | 黃春婭 | |
| Ji Shaoping | 季紹平 | |
| *Jie shen zi ai* | 潔身自愛 | To care about one's own reputation |
| *Jiezi zhen* | 結子針 | Knot stitch |
| Jin Jingfen | 金靜芬 | |
| *Jin si* | 錦絲 | Silk brocade |
| *Ju yi fan san* | 舉一反三 | Draw inferences from other cases |
| *Juan sha* | 絹紗 | Silk gauze |
| Lu Wenfu | 陸文夫 | |
| *Luanzhen xiu* | 亂針繡 | Random stitch embroidery |
| *Luo sha* | 絡紗 | A type of silk gauze |
| Mei Guiying | 梅桂英 | |
| *Meide* | 美德 | Virtue |
| *Neng shou* | 能手 | Capable hand |
| *Pobi* | 破筆 | Worn-out brush |
| *Qi* | 綺 | Silk damask |
| *Qiao* | 巧 | Clever |
| *Qiao shou* | 巧手 | Clever hand |

| | | |
|---|---|---|
| *Qing lu shan shui* | 青綠山水 | Green and blue mountain and water |
| *Qing xiuniang* | 請繡娘 | Invited embroidery girls |
| Ren Huijian | 任惠間 | |
| *San tao zhen* | 散套針 | Shaping and shading stitch |
| *Sha* | 紗 | Silk gauze |
| *Shangliang* | 商量 | To discuss |
| Shen Guoqing | 沈國慶 | |
| Shen Shou | 沈壽 | |
| *Shou* | 壽 | Long life |
| *Shuangmian sanyi xiu* | 雙面三異繡 | Double-sided three-difference embroidery |
| *Shuangmian xiu* | 雙面繡 | Double-sided embroidery |
| *Songzi zhen* | 松子針 | Pine nut stitch |
| Suzhou Cixiu Yanjiu Suo | 蘇州刺繡研究所 | Suzhou Embroidery Research Institute |
| Wu Xi | 吳曦 | |
| *Weidou* | 圍兜 | Apron |
| *Wenrou* | 溫柔 | Gentle and soft |
| *Xianhui* | 賢惠 | Virtuous |
| *Xie zhen* | 斜針 | Diagonal satin stitch |
| *Xieyi* | 寫意 | Freehand brushwork |
| Xinqi embroidery | 信期繡 | |
| *Xiuniang* | 繡娘 | Embroidery Girl |
| *Xueyi Xiupu* | 學藝繡譜 | *Xueyi's Embroidery Handbook* |
| Xu Jianhua | 徐建華 | |
| Xu Xiaoqin | 徐肖琴 | |
| Yang Deheng | 楊德衡 | |
| Yang Shouyu | 楊守玉 | |
| *Yi kong zhi jian* | 一孔之見 | Like looking through a hole |
| *Yi tuan he qi* | 一團合氣 | A group together in spirit |
| *Yixing si* | 異形絲 | Silk and synthetic blend |
| Yuan Yunfu | 袁運甫 | |
| Zhang Jian | 張謇 | |
| Zhang Meifang | 張美芳 | |
| Zhao Liya | 趙麗亞 | |
| Zhou Xunxian | 周巽先 | |
| Zhu Feng | 朱風 | |
| Zhuyu veined embroidery | 茱萸紋繡 | |

# REFERENCES CITED

BIRRELL, VERLA
1973
*The Textile Arts.* New York: Shocken Books.

BRAY, FRANCESCA
1997
*Technology and Gender: Fabrics of Power in Late Imperial China.* Berkeley: University of California Press.

BRITTAIN, JUDY
1990
*Needlecraft.* Pleasantville, N.Y.: Reader's Digest Association.

BROWN, PAULINE
1994
*The Encyclopedia of Embroidery Techniques.* New York: Viking Studio Books.

CHUNG YOUNG YANG
1979
*The Art of Oriental Embroidery: History, Aesthetics, and Techniques.* New York: Charles Scribner's Sons.

CLUNAS, CRAIG
1996
*Fruitful Sites: Garden Culture in Ming Dynasty China.* London: Reaktion Books.

1997
*Art in China.* Oxford: Oxford University Press.

DILLMONT, THEODORE DE
1972
*The Complete Encyclopedia of Needlework.* Philadelphia: Running Press.

GASC, NADINE
1977
*Broderie au passé et au present: Catalog et exposition.* Paris: Union Centrale des Arts Décoratifs.

HU, JASON C., ED.
1993
*Embroidery: The Development of Embroidery throughout Chinese History.* Traditional Chinese Culture in Taiwan, no. 25. Taipei: Kwang Hwa Publishing Company.

HUTT, JULIA
1987
*Understanding Far Eastern Art.* New York: E. P. Dutton.

KETCHUM, ROBERT GLENN
1983
*Order from Chaos/New Work.* Los Angeles: Robert Glenn Ketchum.

1984
*New Work, Too.* Baltimore: G. H. Dalsheimer Gallery; La Jolla: The Photography Gallery.

1985
*The Hudson River and the Highlands: The Photographs of Robert Glenn Ketchum.* New York: Aperture.

1987
*The Tongass: Alaska's Vanishing Rain Forest.* New York: Aperture.

1991
*Overlooked in America: The Success and Failure of Federal Land Management.* New York: Aperture.

1993
*The Legacy of Wildness: The Photographs of Robert Glenn Ketchum.* New York: Aperture.

KO, DOROTHY
1994
*Teachers of the Inner Chambers: Women and Culture in Seventeenth-Century China.* Stanford, Calif.: Stanford University Press.

LU WENFU
1986
*A World of Dreams.* Beijing. Panda.

LU XUN
1957
*Selected Works.* 4 vols. Translated by Yang Xianyi and Gladys Yang. Beijing: Foreign Language Press.

MAILEY, JEAN
1978
*Embroidery of Imperial China.* New York: China House Gallery and China Institute in America.

MAQUET, JACQUES
1961
*The Premise of Inequality in Ruanda: A Study of Political Relations in a Central African Kingdom.* London: Oxford University Press for the International African Institute.

PAINE, SHEILA
1990
*Embroidered Textiles: Traditional Patterns from Five Continents.* New York: Rizzoli.

SAINT-AUBIN, CHARLES GERMAIN DE
1983
*The Art of the Embroiderer.* Los Angeles: Los Angeles County Museum of Art.

SHORE, SHARON K.
1997
"Textile Conservation Report, *CVNRA #412 (Steaming Swamp),*" 7 June 1997. Photocopy.

SUZHOU CITY EMBROIDERY RESEARCH INSTITUTE, ED.
1976
*Suzhou Embroidery.* Shanghai: Shanghai People's Publishing House.

n.d.
*Suzhou Emboidery* (color brochure). Suzhou Embroidery Research Institute.

TSANG, GERARD C. C.
1995
"Textile Exhibition: Introduction." Introduction to the exhibition *Heaven's Embroidered Cloths: One Thousand Years of Chinese Textiles*, in association with the 24–25 June 1995 conference "Chinese Textiles: Techniques, Design, and Patterns of Use," organized by the Textile Society of Hong Kong. Available online @ <www.asianart.com/textiles/intro.html>.

VOLLMER, JOHN E., E. J. KEALL, AND E. NAGAI-BERTHRONG
1983
*Silk Roads, China Ships.* Toronto: Royal Ontario Museum.

WANG YARONG
1987
*Chinese Folk Embroidery.* London: Thames and Hudson.

WEIDNER, MARSHA, ED.
1988
*Views from the Jade Terrace: Chinese Women Artists, 1300–1912.* Indianapolis. Indianapolis Museum of Art.

WILSON, VERITY
1986
*Chinese Dress.* London: Victoria and Albert Museum.

ZHANG MEIFANG
1989
*Suzhou Embroidery Stitches and Techniques.* Suzhou: Jiangsu Scientific Technology Publishing House.

## TEXTILE PUBLICATIONS OF THE
## UCLA FOWLER MUSEUM OF CULTURAL HISTORY

**UCLA Fowler Museum
of Cultural History
Textile Series**

*From the Rainbow's Varied
Hue: Textiles of the Southern
Philippines*, no. 1 (1998)

*Wrapped in Pride: Ghanaian
Kente and African American
Identity*, no. 2 (1998)

*Threads of Light: Chinese
Embroidery from Suzhou
and the Photography of Robert
Glenn Ketchum*, no. 3 (1999)

**Forthcoming**

*Walk in Splendor: Ceremonial
Dress of the Minangkabau* (1999)

**Previous Textile Publications
of the UCLA Fowler Museum of Cultural History**

*A Quiet Spirit: Amish Quilts
from the Collection of Cindy
Tietze and Stuart Hodosh* (1996)

*The Women's Warpath:
Iban Ritual Fabrics from Borneo*
(1996)

*Gift of the Cotton Maiden:
Textiles of Flores and the Solor
Islands* (1994)

*Threads of Identity: Maya
Costume of the 1960s in Highland
Guatemala* (1992)

*To Speak with Cloth: Studies
in Indonesian Textiles* (1989)

*Scenes for a Raja: Study of
an Indian Kalamkari Found
in Indonesia* (1986)

*Dance Occasions and Festive
Dress in Yugoslavia* (1984)

*Cloth as Metaphor:
Nigerian Textiles from the
Museum of Cultural History*
(1983; out of print)

*Ply-Split Camel Girths
of West India* (1982)

*Dowries from Kutch:
A Women's Folk Art Tradition
in India* (1979; out of print)

*Fighting with Art: Appliquéd
Flags of the Fante* Asafo (1979;
out of print)

*From the Hands of Lawrence
Ajanaku* (1979; out of print)